MW00576437

ARTS & CRAFTS: The California Home

Schiffer Publishing Ltd®

4880 Lower Valley Road, Atglen, PA 19310 USA

Douglas Congdon-Martin

In Cooperation with the
California Heritage Museum

In Memory of Margaret W. Martin

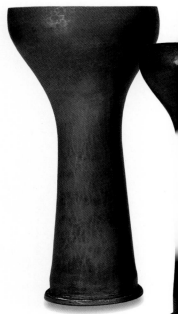

Congdon-Martin, Douglas.
 Arts & crafts : the California home / Douglas Congdon-Martin ; in cooperation with the California Heritage Museum ; & an essay on Batchelder tiles by Robert Winter.
 p. cm.
 Includes bibliographical references.
 ISBN: 0-7643-0629-4 (hardcover)
 1. Arts and crafts movement--California--Catalogs. 2. House furnishings--California--History--19th century--Catalogs 3. House furnishings--California--History--20th century--Catalogs.
 I. Winter, Robert, 1924- . II. California Heritage Museum. III. Title
NK1141.C66 1999
745 ' .09794 ' 07479493--dc21 98-34697
 CIP

Copyright © 1998 by Schiffer Publishing Ltd.

All rights reserved. No part of this work may be reproduced or used in any form or by any means—graphic, electronic, or mechanical, including photocopying or information storage and retrieval systems—without written permission from the copyright holder.
"Schiffer," "Schiffer Publishing Ltd. & Design," and the "Design of pen and ink well" are registered trademarks of Schiffer Publishing Ltd.

Book design by Blair R. Loughrey
Type set in Desdemona/Aldine401 BT

ISBN: 0-7643-0629-4
Printed in China

Published by Schiffer Publishing Ltd.
4880 Lower Valley Road
Atglen, PA 19310
Phone: (610) 593-1777; Fax: (610) 593-2002
E-mail: Schifferbk@aol.com
Please write for a free catalog.
This book may be purchased from the publisher.
Please include $3.95 for shipping.

In Europe, Schiffer books are distributed by
Bushwood Books
6 Marksbury Rd.
Kew Gardens
Surrey TW9 4JF England
Phone: 44 (0)181 392-8585; Fax: 44 (0)181 392-9876
E-mail: Bushwd@aol.com

Please try your bookstore first.

We are interested in hearing from authors
with book ideas on related subjects.

CONTENTS

Acknowledgments 4

Preface: The California Heritage Museum
 & the "California Home" Exhibit 5

Introduction: The Arts & Crafts
 Movement in America 18

Furniture, Lighting, & Accessories: 20
 The Mission Inn 66

Metal Wares 75

Pottery and Ceramics: 104
 "Batchelder Tile" by Robert W. Winter 142

The Printer's Art 157

Fine Art 181

Bibliography 160

ACKNOWLEDGMENTS

Again, I wish to thank the staff and volunteers of the California Heritage Museum for their friendship and help. After our first book together, *The Aloha Spirit,* they were kind enough to invite me back and help with this new project. Tobi Smith prepared the way. Michael Trotter provided an extraordinary amount of help and encouragement as we photographed the exhibit.

Helping me record information and providing support and companionship, was my wife, Beth. I thank all these people for their many efforts.

The Lenders

Over forty lenders to the "California Home" shared from their personal collections for the duration of the exhibit. Their support was greatly appreciated. They include the following people and organizations. We thank them for their generosity in making the "California Home" a success and this book a reality.

Art & Design Twenty
Ron Bernstein
Bradbury & Bradbury
Brandon Allen
Andre and Ann Chaves
Penelope Cloutier
Craftsman Style
Louis F. D'Elia
Dave DeLucca
James and Denise Detelich /
 Detelich Arts and Crafts Gallery
Melville D'Souza
Paul Duchscherer

Adrienne and Steve Fayne
The Gamble House, USC
Peter Hay of Book Alley
Dard Hunter III
Jax Arts & Crafts Rugs
Gary Keith
Patricia Knop and Zalman King
Life Time Gallery
Isak Lindenauer
Caro Tanner Macpherson
Mission Inn Museum Collection,
 Riverside, California
Stephen and Paulette Modiano

Jack Moore's Pasadena Antiques
Roger and Jean Moss
Marjorie Newland
David Nunley and Carol Davis
The Persian Carpet, Inc.
Clare Carlson Porter
Tony Smith
Michael Trotter
Steve and Maryanne Voorhees
Jim and Jill West / Circa 1910 Antiques
Robert W. Winter
and generous private collectors

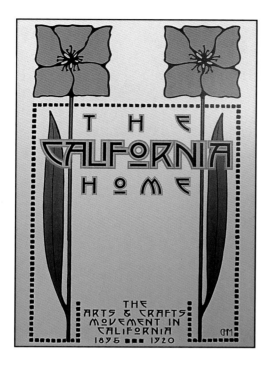

On the stair landing is the poster for the *California Home Exhibit*. It was designed for the museum by Deborah M. Keaton and illustrated by Cathleen Braffet.

THE CALIFORNIA HOME

THE ARTS & CRAFTS MOVEMENT IN CALIFORNIA 1895 ∎∎∎ 1920

The California Heritage Museum & the "California Home" Exhibit

Built in 1894 by the nationally known architect Sumner P. Hunt for Roy Jones, the son of Santa Monica's founder, Senator John P. Jones, the California Heritage Museum has been open to the public since 1980. Rather than commemorate only the life of the Jones family, the Heritage Museum is committed to preserve the entire area's history. Thus the historic landmark building became a California history museum, not just a historic house. Community programming includes unique and innovative rotating exhibitions, lectures, workshops, and concerts.

The exhibition, "The California Home - The Arts and Crafts Movement in California, 1895-1920," was produced by the staff at the California Heritage Museum with assistance from Dr. Robert Weinstein and more than forty generous lenders. The show opened September 20, 1997, and continued through February 1, 1998. There was such a positive response by the public to the arts and crafts furnishings on display in the museum, that we decided to continue the display on the first floor through January 10, 1999.

The exhibition presented an upper-middle class California home at the turn of the century. It is doubtful any "real" family home would have been found with only arts and crafts furnishings. Grandma's Victorian wicker rocker and other family hand-me-downs would certainly have been present. However, the museum had the luxury of a "fantasy" family that lived in a home with items that were only produced during the period from 1895 to 1920, and *all* in the same arts and crafts movement style. It was decided early on in the curatorial process, that few native American items and no Chinese or Japanese articles would be included in the room displays, although those items would certainly be found in a prominent California home. Tourists at that time were purchasing and bringing home native American crafts, and the Pacific rim connection and influence brought many decorative oriental items into the average West coast home.

I would like to thank the lenders to the "California Home" exhibition for willingly parting with their most precious possessions, some for more than one year. Their support was gratefully appreciated. Museum staff, Michael Trotter, Linda Pearson, Juliet Christy, and Steven Stanley, were responsible for the exceptional installation, and the exhibition would not have been possible without our Docent volunteers, who keep the doors open by providing informative tours to all the visitors to the "California Home" exhibition.

Tobi Smith, Executive Director

Entry

Furniture
Gustav Stickley (cat. no. 802) serving table *(part of dining room set)*
Gustav Stickley mirror (cat. no. 910)

Lighting
Batchelder/Donaldson lamp with split bamboo and silk shade

Copper
(On serving table) Heintz peacock vase; period copper and oak book box
with motto: *"Choose an author as you choose a friend"*; Stickley Brothers
copper jardiniere
(Wall) period copper mailbox, maker unknown

Pottery
Batchelder peacock tile

Artwork
Joseph Frey, *Sierra Madre*, 24" x 20", oil on canvas, ca. 1920

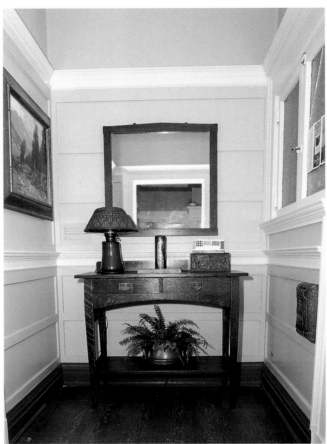

The entry.

Living Room

Furniture
Gustav Stickley settle (cat. no. 222)
Gustav Stickley bow-arm Morris chair (cat. no. 406)
Limbert inlaid arm chair (pewter & copper), ca. 1904
Roycroft solid oak, magazine pedestal with hand carved motto (cat. no.
80)
Lakeside smoking cabinet, oak and stained glass
Gustav Stickley table with twelve Grueby tiles
Limbert oak cellarette (cat. no. 602)
Limbert oak pedestal table (cat. no. 240)
Limbert oak octagonal library table
Greene & Greene fire screen (cast & wrought steel) originally made for
the Thorsen House living room
L & J.G. Stickley mantle clock

Lighting
(Hanging light fixtures), Quezel glass shades, ca. 1900 - 1906
(Standing lamp), Handel palm filigree shade, Griffin floor base, ca. 1912
(Cellarette) Benedict Studios lamp, copper and stained glass
(Pedestal table) Dirk van Erp table lamp, copper and mica

Pottery
(At hearth) large Grueby vase, medium Wheatley vase
(Mantel) small low Rhead dragonfly bowl
(Limbert octagonal table) large green Teco vase
(Magazine pedestal) small Van Briggle poppy bud vase, California Faience
brown bowl, small Van Briggle green vase,
(Cellarette) California Faience brown bowl with frog, C.F. tea tile with iris
(Inside cellarette) Spirit decanter and cups, ca. 1920

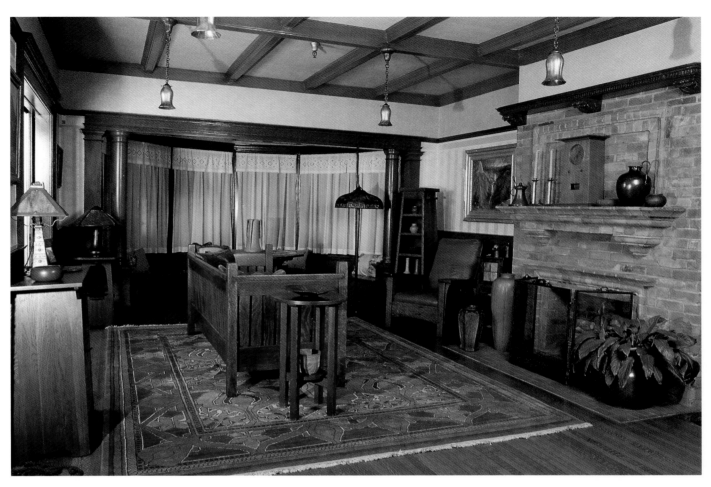

The living room, looking left as you enter it.

Copper
(Mantel) Dirk van Erp pitcher, candlesticks, and bowl with green patina; Old Mission Kopperkraft fireplace starter
(Hearth with plant) Dirk van Erp Jardiniere
(Top smoking cabinet) Roycroft tobacco humidor, cigarette and match cups, matchbox holder and ashtray
(Magazine pedestal) Arts & Crafts cigarette box maker unknown
(Beneath Stickley/Grueby tile table) Harry Dixon low poppy bowl
(Near stairway with plant) Jauchen cylindrical basket
(Top built-in bookcase) Jauchen, Ye Olde Copper Shop letter holder; Fred Brosi, Ye Olde Copper Shoppe eucalyptus vase

Artwork
Hernando Villa, *Self Portrait,* 11" x 14", oil on canvas, ca. 1905
Orrin White, mountain scene, 22" x 28", oil on canvas
Dana Bartlett, California landscape, 20" x 24", oil on canvas
Jack Wilkinson Smith, California coastline, 16" x 12", oil on canvas
Thomas Hill, view of Yosemite Valley, 25" x 30", oil on canvas, ca. 1880

Floor Covering and Textiles
Hand knotted woolen carpet, 8' x 11', (Reproduction of Voysey's *Donnemara* pattern)
(Library table) large round hand embroidered moth design linen
Assorted period hand embroidered pillows

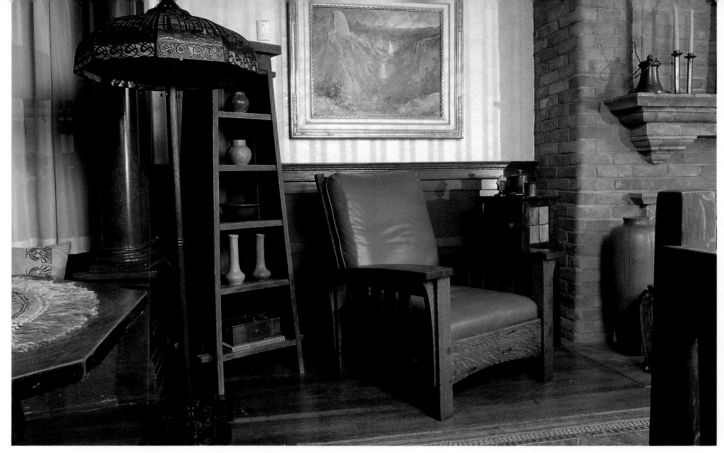

Above: To the left of the fire place is a comfortable reading nook with a Morris chair, a Roycroft magazine pedestal, smoking stand, and a floor lamp.

Left: A view back at the Gustav Stickley settle.

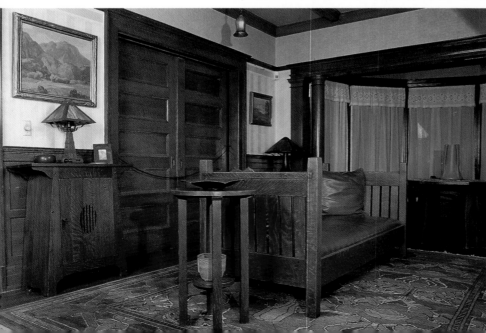

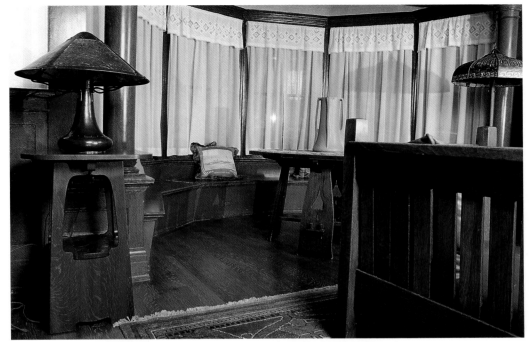

Right & below: The bay window has at its center a Limbert oak octagonal library table. Sitting atop it is a hand-embroidered table linen and a large Teco vase.

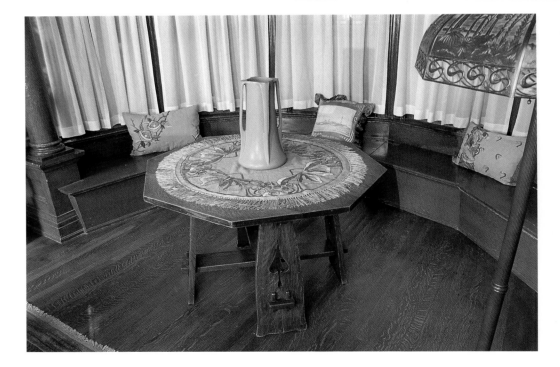

Spirit decanter, with four cups, "Specter of Death" design, ca. 1922. *Courtesy of Michael Trotter.*

Dining Room

Furniture
10 piece Gustav Stickley Dining suite; dining table (cat. no. 632), sideboard (cat. no. 814), china cabinet (cat. no. 815), serving table (in entry) (cat. no. 802), side chairs with rush (cat. no. 353)
Gustav Stickley skirted lamp table, ca. 1904
Arts and Crafts style oak and mahogany birdcage and stand

Lighting
Unsigned, *probably Gustav Stickley,* 5 light iron and copper chandelier with Handel glass
(Mantel) Pair of brass wall sconces with hand-painted Handel shades
(West wall) pair of copper wall sconces with multicolored Handel glass

Pottery
(Dining table) Tiffany floral vase
(Mantel) Three vases - all Van Briggle
(Sideboard) Rookwood hand painted ceramic bowl
(Lamp table) Fulper blue/green flambe and black crystalline bowl
(Hearth) pair of Batchelder planters
(Corner of room) pair of Gladding McBean crystalline blue jardinieres
(China cabinet) Van Briggle pottery - various production dates
(Inside built-in buffet) Roycroft *"Tudor Rose"* design china, Onondaga Pottery Co.

Copper and Silver
(Sideboard) Gustav Stickley copper and oak chafing dish, (center) Roycroft serving tray, (right) Old Mission Koppercraft serving tray, (left) sculpted Stickley Brothers tray (cat. no. 36), pair of Jarvie - Beta candlesticks
(Hearth) Fred Brosi, Ye Olde Copper Shoppe umbrella urn
Dirk van Erp large willow basket with copper legs (with plant)
(Built-in buffet) Shreve's sterling coffee set; Roycroft copper and silver vase; Heintz copper and silver bowls and vases

Floor Covering , Textiles and Wallpaper
Hand knotted woolen carpet, 8' x 10', (Reproduction of William Morris design rug)
(Built-in buffet) period hand embroidered runner
(Table) period hand embroidered round table linen
Bradbury and Bradbury art wallpaper frieze *"Apple Tree"* design.

Artwork
C.B. Currier, desert scene, 6 1/2" x 4 1/2", oil on canvas, ca. 1920
Edward Langley, desert scene, 6 1/2" x 8", oil on canvas, ca. 1920
Anna Hills, seascape, 10" x 13 1/2", oil on canvas
Martin Jackson, lake scene, 30" x 25", oil on canvas, ca. 1915

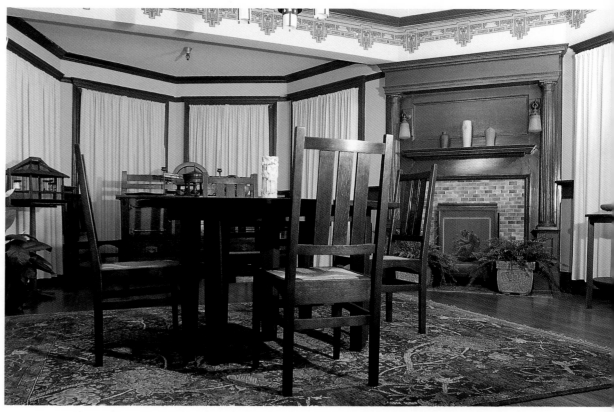

The dining room is furnished with a 10-piece Gustav Stickley suite. On the table is a Tiffany Pottery vase.

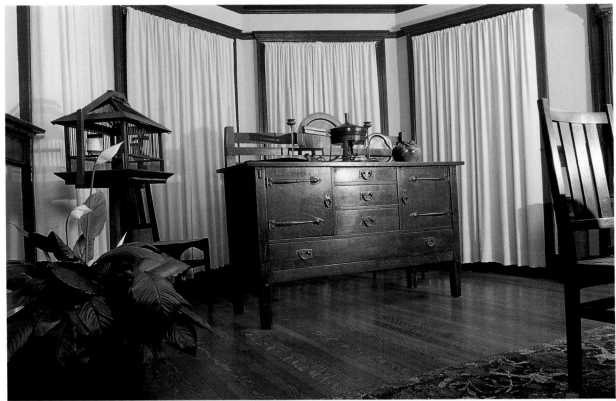

Left: The sideboard and a period mahogany birdcage and stand.

Lower left: The top of the sideboard.

Lower right: An interesting feature of the kitchen is the high chair sitting in the corner.

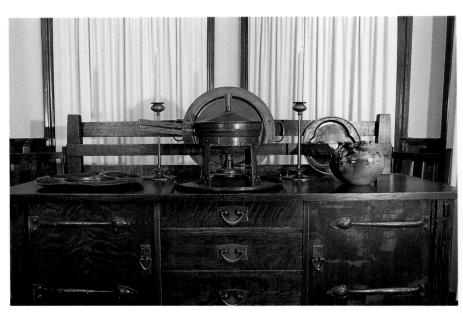

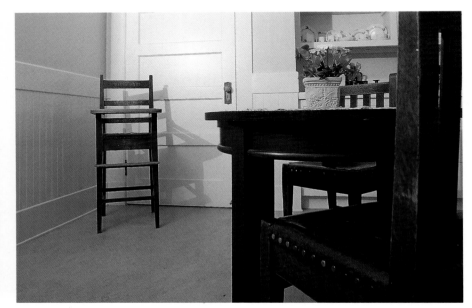

The Roycroft Library/Study

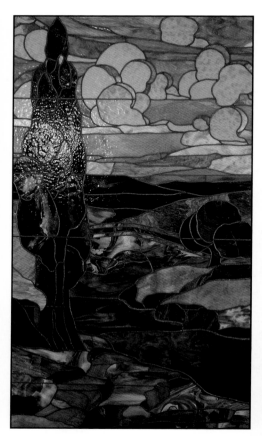

Furniture -
Roycroft ladies desk (cat. no. 090) and chair
Roycroft large 2 door oak bookcase
Roycroft small (cat. no. 86) *"Thirty-third Degree"* oak bookcase
Roycroft oak library table (cat. no. 075 1/2)
Roycroft oak tabouret (cat. no. 050 1/2)
Roycroft oak rocking chair (cat. no. 041)
Roycroft mahogany magazine rack (cat. no. 78)
Roycroft oak wastebasket
Roycroft costumer (hat rack)

Lighting -
(Wall) Roycroft copper sconces
(Desk) Roycroft *"Helmet"* lamp
(Library table) Roycroft lamp with mica shade
(Top large bookcase) Charles Rohlfs candlestick,
 ca. 1902

Rugs and Baskets -
Navajo Indian rugs; Pima Indian baskets

Above: At the top of the stairs is this scenic Arts & Crafts stained glass window, depicting California redwood and oak trees, a river with bridge, and a background mountain range with clouds, 76" high, 43-1/4" wide, *Courtesy of Penelope Cloutier.*

Right: The Roycroft Library fills one end of the upper hallway. In the spirit of the time it blends the fine Roycroft furniture and accessories with Navajo rugs and other native crafts.

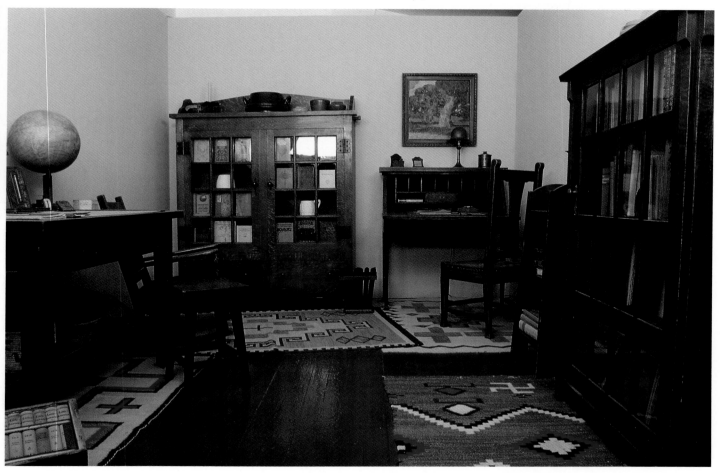

Pottery -
(Top of small bookcase) Rookwood "Rooks" bookends; Chelsea Keramic Art-
 works oxblood vase; California Faience matte ochre bowl; Rhead green 3
 handled urn
(Top of large bookcase) Walrath small green pot; Marblehead large green conch
 shell bowl; Blue Grueby low bowl; Dard Hunter unfired clay mug and
 unfired clay dragonfly vase;
(Library table) Batchelder ashtray "1926"

Copper -
(Top of large bookcase) Stickley Brothers Copper Jardiniere, cat. no. 71
(Library table) Tiffany Studios pine motif desk set; Roycroft incense burner
(Desk) Roycroft desk set with letter holder and humidor
(Magazine rack) Roycroft *"American Beauty"* vase

Artwork -
W.H. Bull, *Oak Trees* , oil on canvas, 20" x 19", ca. 1920
"Society is Very Tolerant . . ." Elbert Hubbard motto
"Here in this Room . . ." Arts & Crafts motto, ca. 1920
Hernando Villa, *Steamer,* oil on board, ca. 1931

Miscellaneous -
New Peerless 12" globe by Rehm Globe Co., 1903
Roycroft *Little Journeys* books (in original crate)

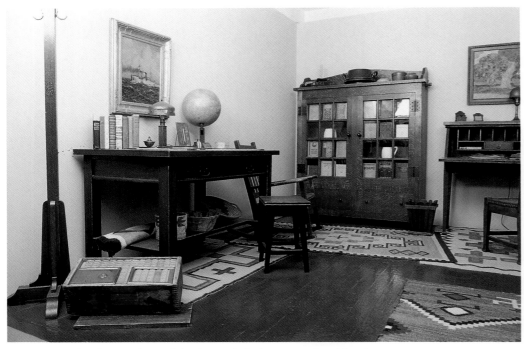

On the floor in front of the Roycroft desk is a set of Hubbard's
Little Journeys books in their original packing case.

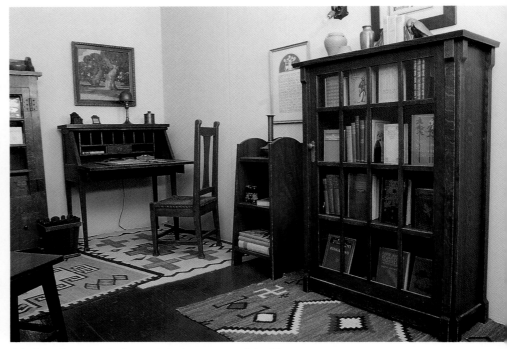

A lady's slant top desk stands in the corner of the library.

Bedroom

Furniture -
Gustav Stickley 3/4 oak bed, (cat. no. 923)
Gustav Stickley chest of drawers with mirror and copper candleholders, (cat. no. 625), ca. 1902
Gustav Stickley chest of drawers, (cat. no. 626), ca. 1902
Limbert oak telephone table and chair
Somno (nightstand), maker unknown
Gustav Stickley scrap basket, (cat. no. 94)
Three panel wood screen with stained red poppies at top
Gustav Stickley costumer (hat rack), (cat. no. 52)
Gustav Stickley willow arm chair

Lighting -
Armenac Hairenian standing bridge lamp
(Telephone table) Dirk van Erp boudoir lamp, shade by Agatha van Erp
(Chest of drawers) Fulper blue flambe lamp with ceramic glass leaded shade
(Wall) California Art copper candle sconce

Pottery -
(Chest of drawers) Fulper pottery bookends, shape of Pala Mission
(Nightstand) California Faience temple jar with lid

Rugs and Linen -
Large Gustav Stickley *"Nile"* drugget
Medium Gustav Stickley *"Scroll"* drugget
Small Gustav Stickley *"Nile"* drugget
Hand embroidered bolster and bedspread
Poppy design hand embroidered pillow
Hand embroidered collar and cuff bag

Artwork -
Ernest Browning Smith, *Mount San Jacinto Sunset,* oil on canvas, 24" x 29", ca. 1925
Alexis Podcherikoff, *California Moonlight,* oil on canvas, 30" x 25", 1919

Miscellaneous -
(Chest of drawers) Shreve's sterling silver men's dresser set
(Chest of drawers) Bronze and copper picture frame, maker unknown

Books -
California the Beautiful, compiled by Paul Elder, 1911
Happy Days in Southern California, Frederick H. Rindge, 1898

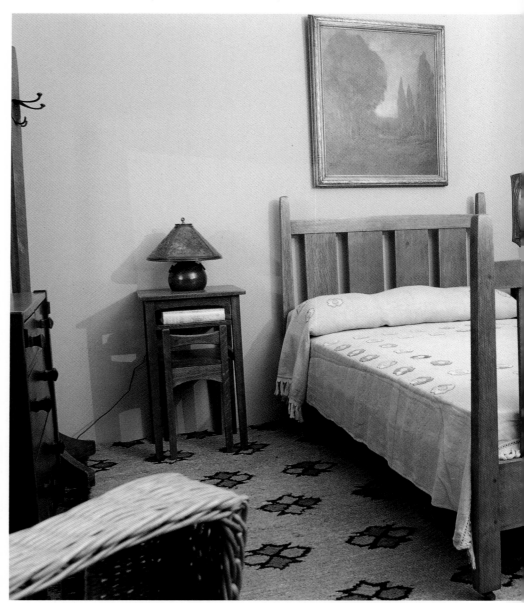

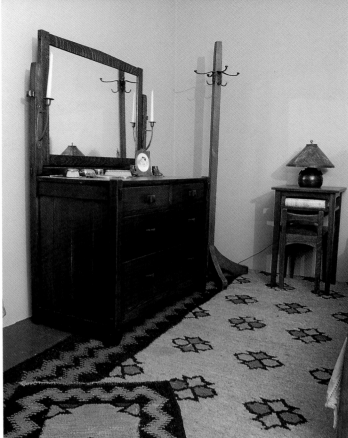

Far left: Off one end of the hallway is the bedroom. It features this Gustav Stickley three-quarter oak bed.

Left: Beside the bed is a Gustav Stickley chest of drawers and a Limbert telephone stand and chair.

Below: Another Stickley chest of drawers is at the other end of the room. Beside it is a three panel screen and a Stickley willow chair.

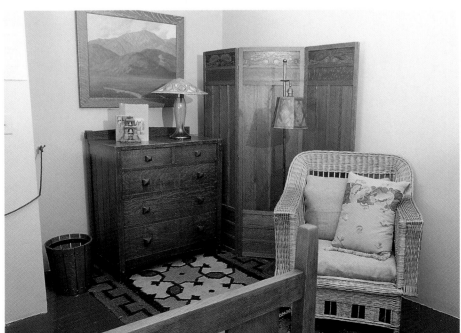

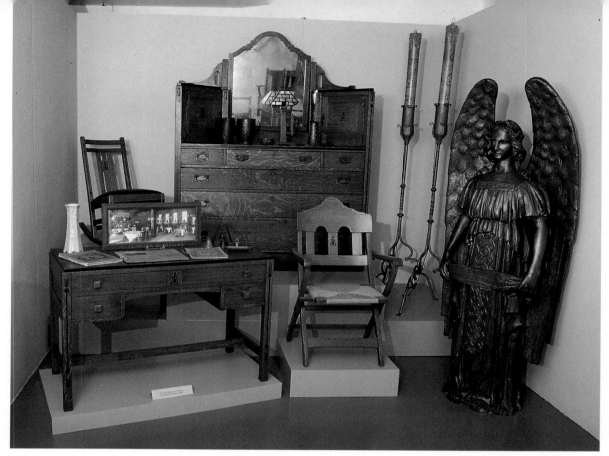

The Front Gallery

Above: One end of the large upstairs room is dedicated to the Riverside Mission Inn, and includes furniture and other mementoes from it.

Left: At the other end of the room is a virtual history of the mission chair, including a Bernard Maybeck chair designed for the Swedenborgian Church in San Francisco, generally considered to be the earliest "Mission"-style chair, ca. 1894.

The Back Gallery

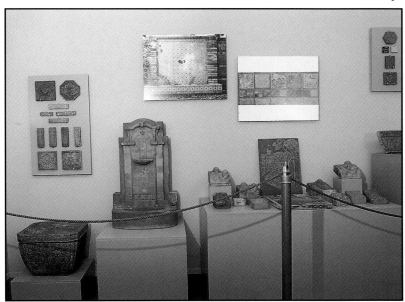

The back gallery is dedicated to pottery and metal work, including a large selection of Batchelder tiles.

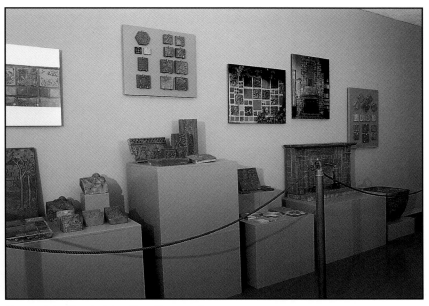

More of the Batchelder tiles. The small fireplace is a salesman's sample.

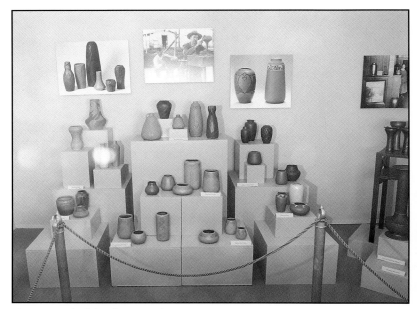

This is wonderful collection of art pottery from a variety of potteries.

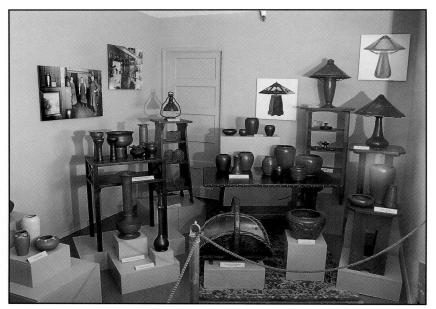

In the back corner is a stunning collection of metal work, many by Dirk van Erp.

The Arts & Crafts Movement in America cannot be understood aside from its predecessor in England, where it had its impetus in the social and aesthetic upheaval caused by the Industrial Revolution. In England and throughout the western world people's lives were experiencing dramatic changes as work moved from farm to factory, homes moved from the country to the city, and in the eyes of many the world deteriorated from a place of beauty to a place of sweat and squalor.

In the midst of this new industrial society and its stark injustices voices were raised in protest. Karl Marx, observing the plight of the workers in this new society, published the *Communist Manifesto* in 1848. This led to the founding of Workingmen's Associations in London and New York in 1864.

Somewhat less radical, but, at the time, more influential were the writings of John Ruskin. This social philosopher and art critic explored the ideal of the craftsman's way of life, a vision which found international acceptance in Europe and the United States as well as in Britain. Looking back to the organization and artistic output of the Medieval Guilds as its model, Ruskin's philosophy gave rise first to the Gothic Revival of the mid-nineteenth century, and later to the Arts & Crafts Movement.

Both Marx and Ruskin were responding to the changing role of the worker in an industrialized age, but for Ruskin, the art critic, the secondary victim of the age was good design. Machines could be made to create ornate carvings ad infinitum, sending designers into a frenzy of foliage unimaginable in the days of hand carving. At the same time, machines were limited in some of the basic areas of construction and finishing, leading designers to adapt to the needs of production rather than the needs of the consumer. This resulted in designs that were excessively gaudy, without the grace and strength of good cabinetmaking.

Ruskin envisioned the artisan as creator, who, with his own hands and only the most basic of tools, created objects that were both beautiful and useful. William Morris, a devotee of Ruskin, embraced his model and carried it forward. A poet, philosopher, designer and artist, Morris became the central figure in the Arts & Crafts Movement. As a young man he journeyed to France in 1856 with his friend, Edward Coley Burne-Jones. Upon their return they both committed themselves to becoming artists. Their collaboration and friendship would continue through the years. Burne-Jones would become the most recognized artist of the Movement. Morris, who trained in architecture, before turning to painting and design, was able to crystallize the principles of the movement in his artistry and in his writing. In the 1860s he helped to found Morris, Marshall, Faulkner & Co., which produced a great variety of decorative items, including tapestries, painted tiles, furniture, wallpaper, and stained glass. By the late 1870s he began to lecture about the decorative arts. An international audience was attracted to his philosophy, a lively mixture of artistic and social ideals that contrasted sharply with the current state of work and creativity.

The impact of Ruskin and Morris spread across England. Study and discussion groups formed to explore the new ideas, and guilds were established to enable artisans to make those ideas concrete. In May 1884 two of these organizations, the St. George Art Society and The Fifteen, joined forces to form a new society, the Art Workers' Guild. Among its members were some of the leading artists and thinkers of the English movement: Morris, Norman

Shaw, Arthur Mackmurdo, C.R. Ashbee, C.F. Voysey, Walter Crane, and Edwin Lutyens. As Isabelle Anscombe describes it:

> The new idiom of Arts and Crafts was strong and simple in form, rich and intricate in craftmanship, with a fresh morality based on fitness for purpose...These elements were combined in a new, eclectic style that stressed simplicity and an honesty of construction based on first-hand understanding of the materials employed...(*Arts & Crafts Style*, p. 54)

The seeds of the Arts & Crafts Movement found fertile ground in the United States. During the last two decades of the nineteenth century the writings of Morris were widely available and, as in England, people organized to study his ideas further and to put them into practice. Craft societies were formed in major cities across the country. In Chicago the Industrial Art League formed in 1899. In Boston, Providence, Detroit, Chicago, and other communities, large and small, Arts & Crafts Societies blossomed and flourished, some of them continuing to this day. Schools were formed for the teaching of crafts. Organizations like the Saturday Evening Girls in Boston put crafts at the center of efforts to prepare young women to be self-sufficient. Hospitals used the crafts both for therapy and as a means for raising necessary funds.

It is in the context of an already thriving Arts and Crafts Movement in America that Gustav Stickley and Elbert Hubbard made their separate pilgrimages to England and William Morris. Upon their return Hubbard would establish the Roycroft Press and its associated industries near Buffalo. Stickley started his United Crafts Guild near Syracuse, New York, producing furniture and metal wares of simple yet functional designs that he hoped would develop into an authentic American Style. Like Morris he lifted the ideal of the craftsman, but did not have the total abhorrence of machines, choosing instead to use them in ways that would reduce labor while having no effect on the design. This was a major factor in Stickley's successful enterprise for a decade and a half.

The other factor was his publication of *The Craftsman*, a periodical devoted to design and the Arts & Crafts Movement. While Hubbard may have been a more prolific writer, his main contribution to the philosophy of the Movement was in the advertising copy he wrote for the Roycrofters. Stickley, however, was a central figure in developing the theory behind the American movement, much as Morris had been in England. Indeed, the first issue of *The Craftsman* was devoted to Morris and his philosophy. Beyond that the magazine contained articles about architecture and design, focusing on the work of major artisans around the country. It featured plans for Craftsman Homes, offering them free to readers, and suggesting designs for everything from curtains to gardens. While Stickley furniture was featured, *The Craftsman* provided various drawings and directions for the home cabinetmaker to make furniture in the Stickley style. Some have suggested that the magazine was a masterful means of promotion, and it surely was. But its impact was much broader than that; it spurred people around the nation to an understanding of good design, that was both beautiful and functional.

One such place was California, and in particular Southern California. At the turn of the century the population was growing exponentially. Initially drawn there by dreams of gold, now other sirens beckoned people to migrate from the East. To house these new residents involved a great building program, and the homes in the Arts & Crafts style of Stickley and others seemed to be particularly well-suited. Indeed the first plan Stickley published in the January, 1904 issue of *The Craftsman*, was for a "Craftsman House founded on the California Mission Style."

But the Arts & Crafts influence on the California home preceded Stickley's work by many years. Ernest Coxhead, an Englishman who was strongly influenced by Voysey's work, brought Arts & Crafts principles to houses he designed in San Francisco in the early 1890s. Bernard Maybeck, who designed what may well be the first "Mission" style chair for the New Jerusalem Swedenborgian Church in San Francisco, was doing architecture in Berkeley in 1895. The Greenes, who had trained at Washington University in St. Louis with Calvin Woodward, a disciple of Morris, settled in Pasadena before 1895, and are generally seen as the masters of the style in California.

These architects and others firmly established the Arts & Crafts Movement in California. In their wake followed potters such as Alexander Robertson, Ernest Batchelder, and Fred Rhead, artists in metal like Dirk van Erp, Fred Brosi, and Hans Jauchen, and countless other artisans whose combined efforts and talents have made the California home synonymous with beauty and grace.

Chapter 1
FURNITURE, LIGHTING, & ACCESSORIES

In 1909 Gustav Stickley wrote that "furniture has so far remained the clearest concrete expression of the Craftsman idea." It remains so. When one thinks of the Arts & Crafts Movement, the image that comes to mind is the warm oak furniture in plain designs. Its rectilinear lines speak of a simplicity that belies its important place in the history of furniture.

The Arts & Crafts style followed on the heels of the industrial revolution. It had its birth in the philosophies of John Ruskin as expressed in the work of William Morris and others philosopher-craftsmen in England during the latter part of the nineteenth century. In part it was a cry against the loss of handicrafts engendered by the machines. Artisans were merely cogs in a greater wheel and designers created with an eye as much to the capabilities of the machine as to the desires of the consumer. On the one hand, those capabilities included the ability to replicate ornate carvings that would have been prohibitively costly in handcrafted furniture. This led to what many critics of the period considered the height of gaudiness. On the other hand, the machines were incapable of some of the traditional methods of joinery, relying instead on inferior but adaptable methods using dowels and screws. Morris and others lifted up the handcrafted ideal and he showed his first furniture in the Gothic Revival style in 1851 at the Great Exhibition in London.

Ironically, the exhibit included other styles of furniture that represented the depths to which the designers of the industrial age had fallen. As Isabelle Anscombe describes it in *Arts & Craft Style* (p. 13), "manufacturers of furniture, ceramics, textiles, and other decorative artefacts attained new heights of vulgarity, imitating every conceivable period and style, and often combining several in one object." It provided a strong incentive for the designers of the Arts & Crafts movement in England to do something very different.

In America, Gustav Stickley and others had similar motivations. Stickley visited Morris in England in 1898, and upon his return became the leading spokesperson for the Movement in America. He sought not to imitate the English Movement, which he thought produced furniture designs that were too individualistic and "showing the eccentricities of personal fancy." In his *Craftsman Homes* (p. 154) he criticized the English for furniture that was "largely for art's sake and had little to do with satisfying the plain needs of the people." Nevertheless, he shared with the English a disdain for the furniture coming out of factories. He wrote that this furniture corresponded with what architects called the "reign of terror." He compares it with the mid-Victorian period in England, which stands for "all that is ugly, artificial, and commonplace in household art."

Stickley's task was to create a new style of furniture, one that was utilitarian yet beautiful, simple yet elegant. He paid close attention to design and what is now called "ergonomics," striving for furniture that served a purpose, was friendly to its users, and pleasing to their aesthetic sensibilities. He made furniture that celebrated the ideal of the Craftsman. At the same time he made reasonable use of the latest machinery when it performed a labor saving function while not dictating the design.

The result of his efforts and those of the other furniture designers and manufacturers who shared his vision is a unique American style of furniture. It represents a radical shift from the past and was a precursor of the designs that would follow in the century.

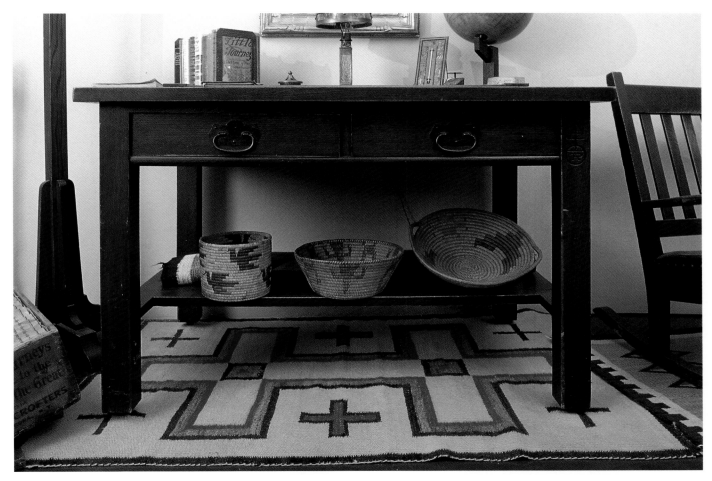

Roycroft oak library table, two drawers with straight legs, cat. no. 075-1/2. Flat iron fixtures, 30" high, 48" wide, 30" deep. Logo top of right leg. *Courtesy of a private collector.*

The Roycroft Shops

Born in Bloomington, Illinois, in 1856, Elbert Hubbard began his business career as a soap salesman. His supplier was his cousin, Justis Weller, who was in business with John D. Larkin of Buffalo. Connections were made, and in 1874 Larkin married Hubbard's sister. In 1875 Larkin formed the John D. Larkin Soap Co. with his new brother-in-law. Elbert Hubbard, the junior partner, was in charge of advertising and promotion, and brought to it all the creativity and innovation he would show later as the founder of the Roycroft shop. In 1892, at the height of his success at Larkin, Elbert Hubbard sold his stock in the firm for $75,000 and retired to take up a career in writing. A novel he had written, *The Man*, was published by J.S. Ogilvie & Co., New York, in 1891, under the pseudonym of Aspasia Hobbs. After leaving Larkin, he spent the next two years writing and studying.

An admirer of John Ruskin and the English Arts & Crafts Movement, he went to England in 1894 in hopes of meeting another Ruskin devotee, William Morris. Morris, a dominant force in thought and design at the end of the nineteenth century, had established Hammersmith, a community of artisans committed to the ideals of the movement. Of particular interest to Hubbard was the Kelmscott Press. His meeting with Morris was brief but influential. The tour of the Hammersmith community enlivened in Hubbard the desire to return to East Aurora and undertake the same grand experiment.

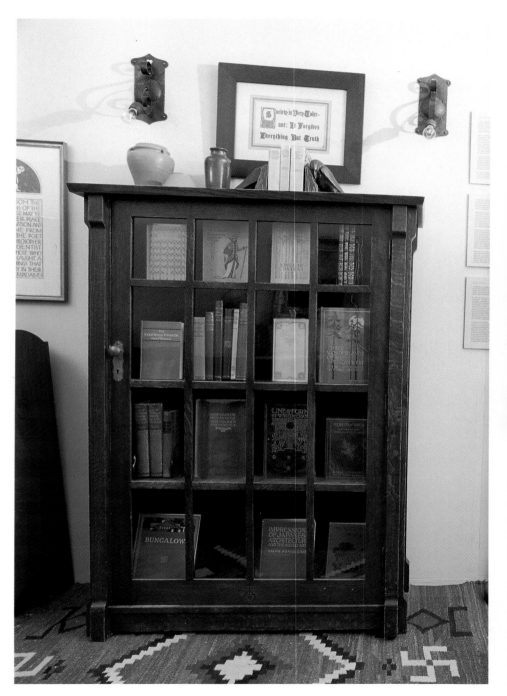

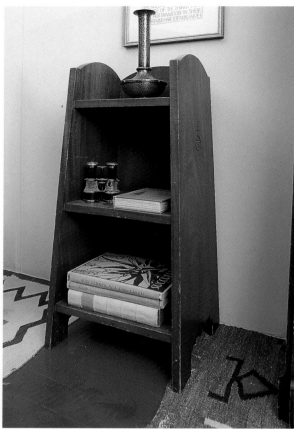

Far left: Roycroft "Thirty-third Degree" bookcase, oak, cat. no. 086, original finish. One door with 16 small panes of glass and four shelves. 55" high, 40" wide, 15" deep. Logo at bottom center of door. *Courtesy of a private collector.*

Left: Roycroft mahogany magazine rack, cat. no. 078. 37" high, 18" wide at the bottom, 14-1/2" wide at the top, 16" deep at the bottom, 12" deep at the top. Roycroft logo on left side. *Courtesy of a private collector.*

In 1895 Hubbard established a press at East Aurora, calling it Roycroft. He once explained that the name was coined from Roi Craft or Royal Craftsman, but it also is the name of two much admired 17th century English printers, Thomas and Samuel Roycroft. The trademark for the new enterprise was the now familiar cross and orb. The orb was divided into three sections for faith, hope, and love, to which is added an R.

The new endeavor was successful, creating a demand for new space, both for manufacturing and for the large number of visitors to East Aurora. Local carpenters were hired in 1896 to create a book bindery, followed by a leather shop, a larger print shop, and, eventually the Roycroft Inn. These same carpenters produced simple furniture for the new buildings. This furniture quickly became popular with the visitors, who often inquired where they could purchase similar pieces. Hubbard saw the opportunity for expanding his range of crafts. Roycroft furniture was born.

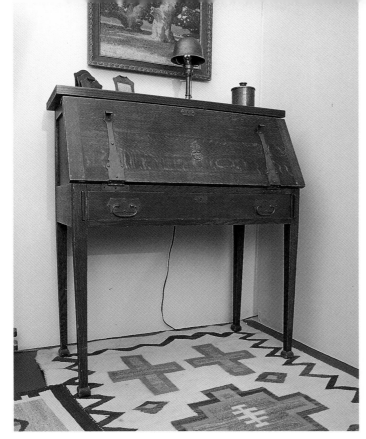
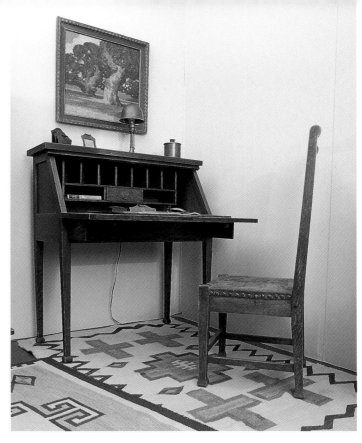

Roycroft oak lady's writing desk and chair, cat. no. 90 for both. The desk is 44" high, 38-1/2" wide, 18" deep, has brass hardware, and an incised logo in center of the lid. Chair 43-1/2" high, 17-1/4" wide, 17" deep, with original leather. *Courtesy of a private collection, Santa Monica.* On the floor is a Navajo rug, with a cross pattern on a light background, 70" x 43". *Courtesy of a private collector.*

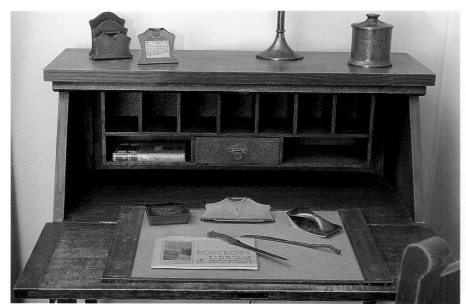
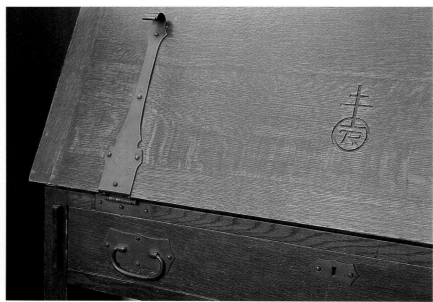

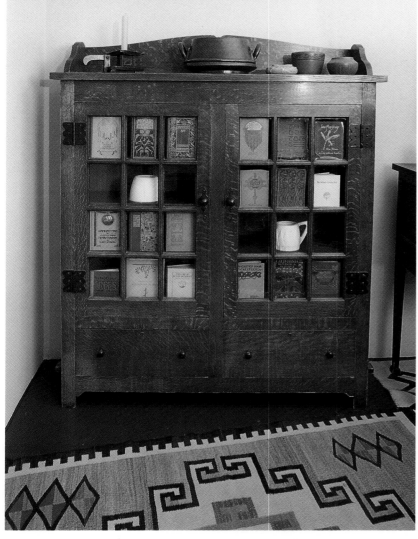

Above & left: Roycroft oak two-door bookcase, unsigned, similar to cat. no. 082. In its original finish, each door has 12 panes of glass. There are two large drawers beneath the doors, adjustable shelving, iron hardware, and key tenon construction. 70" high, 57" wide, 14-1/2" deep. *Courtesy of a private collector.*

Right: Roycroft oak costumer, signed, with copper hardware. 72" high, 20" x 20" base. *Courtesy of a private collector.*

An early advertisement stated: *"No stock of furniture is carried — the pieces are made as ordered, and about two months will be required to fill your order. Every piece is signed by the man who made it."* Hubbard, himself, was probably never involved directly in the design or manufacture of the furniture. His realm was the world of words. The local craftsmen provided much of the original design, but over the years the furniture enterprise attracted many talented people, including Santiago Cadzow, Albert Danner, Victor Toothaker, and Herbert Buffum, all of whom contributed to Roycroft's design and production.

Hubbard, however, most certainly contributed to the promotion of the furniture crafts: His hand can be seen in the following advertisement:

> Roycroft furniture resembles that made by the old monks, in its simple beauty, its strength and its excellent workmanship. We use no nails — but are generous in the use of pegs, pins, mortises and tenons. Our furniture is made of solid wood — no veneer. We use only the best grade of quartersawed oak and African or Santo Domingo mahogany. The oak is finished in our own weathered finish, a combination of stain, filler and wax polish, that produces a satisfying and permanent effect.

Roycroft furniture is distinguished by its exceedingly high quality of materials and workmanship. The furniture is by far some of the heaviest and most massive produced in this era. While Gustav Stickley, trying to gauge the customer's tastes and meet the economic demands of production, found it necessary to reduce both the weight and the cost of his furniture, the Roycrofters continued to use their heavy style to the end.

Elbert Hubbard and his wife, Alice, died when the *Lusitania* was torpedoed by a German U-boat in 1915. The Roycrofters was taken over by his son, Elbert Hubbard, Jr., and continued the traditions until 1938, when having survived the Depression, bankruptcy finally claimed this fine firm.

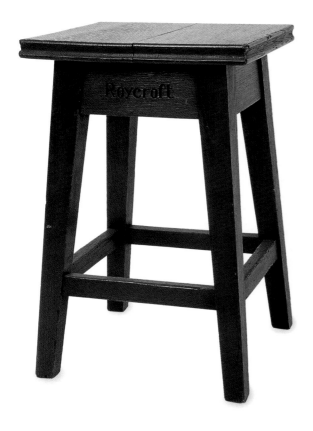

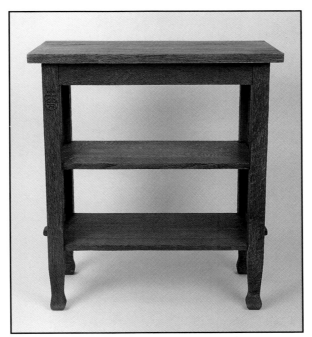

Left: Roycroft oak tabouret, cat. no. 050-1/2, with logo on the apron. 19" high, 11-34" x 11-3/4". *Courtesy of a private collector.*

Above & right: Roycroft oak reading table with book shelves, cat. no. 022. 30" high, 26" wide, 15" deep. *Courtesy of a private collector.*

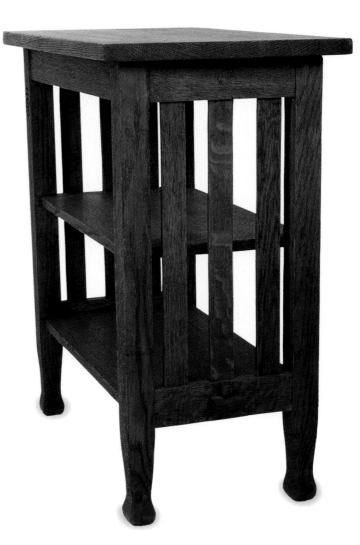

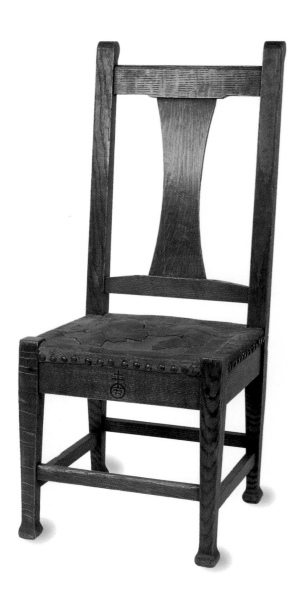

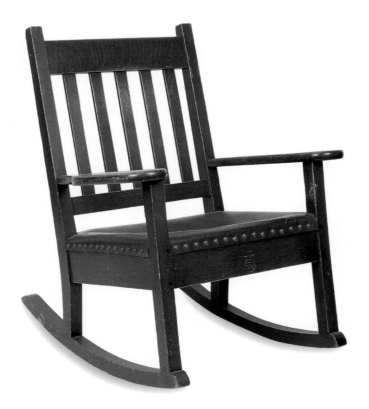

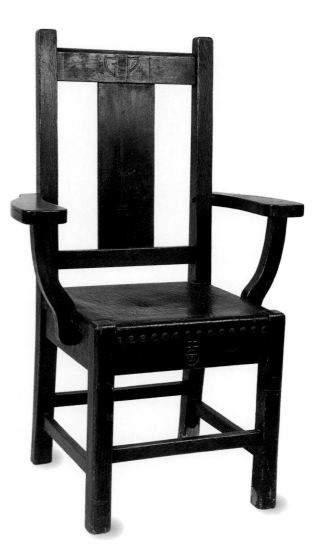

Roycroft chair for desk, leather seat
(shown before with lady's slant top
desk). Logo on front apron. 43-1/2"
high, 17" wide, 17" deep. *Courtesy
of a private collection, Santa Monica.*

Roycroft oak rocking chair with leather seat,
brass tacks, logo in crest rail. Cat. no. 041.
35" high, 26-1/2" wide, 21-1/2" deep at
arms. *Courtesy of a private collector.*

Roycroft Grove Park Inn oak arm chair,
with initials "G P I." All original leather
and brass tacks. 41-1/4" high, 17" wide,
16" deep. *Courtesy of a private collector.*

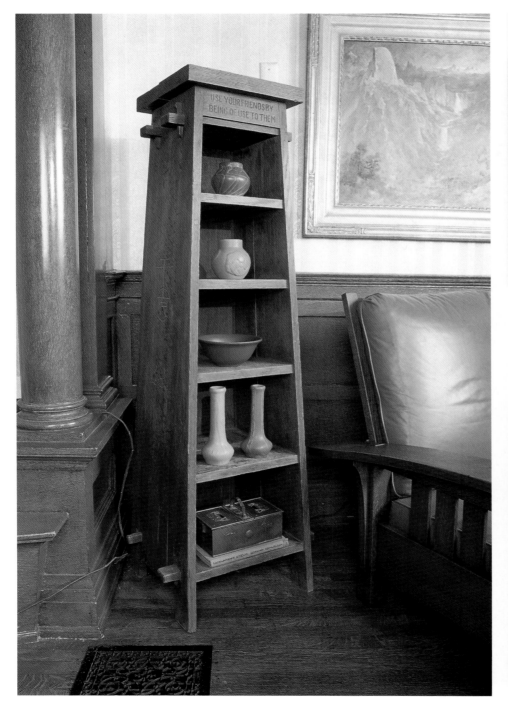

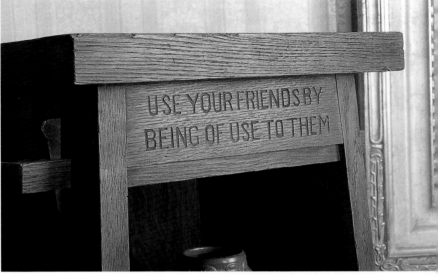

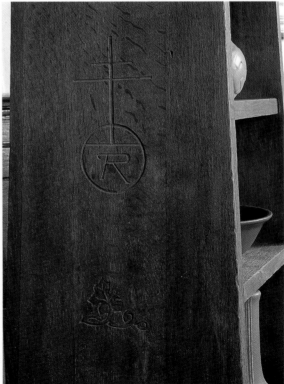

Roycroft oak magazine pedestal, cat. no. 080. It features key tenon construction, and a carved grape motif on the sides with the Roycroft logo. It has five shelves. The top apron has a Hubbard motto: "Use your friends by being of use to them." 63" high, 18" x 18" base, 14" x 14" top. *Courtesy of a private collector.*

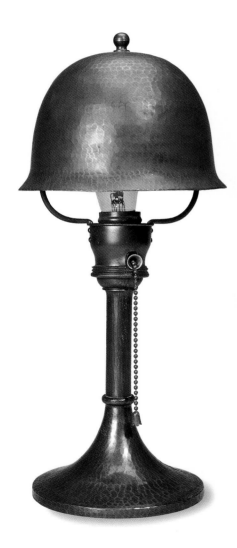

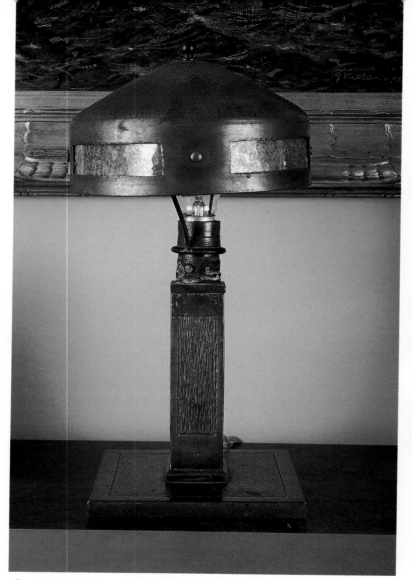

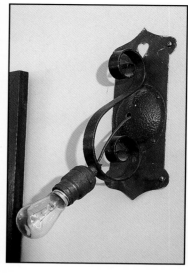

Left: One of a pair Roycroft copper wall sconces, unsigned. These were original furnishings for the Roycroft Inn. 10" high, 5" wide, 5-1/2" deep. *Courtesy of a private collector.*

Below: Roycroft oak and copper wastebasket. 13" high. *Courtesy of a private collector.*

Above: Roycroft brass desk lamp with mica shade, cat. no. 903. 14" high, shade is 7" dia. *Courtesy of a private collector.*

Left: Roycroft "helmet" copper desk lamp, cat. no. 903. 14-1/4". *Courtesy of a private collector.*

The Stickley Brothers

The five Stickley brothers — Gustav, Albert, Charles, Leopold, and John — were all in the business of making furniture. Gustav, Albert, and Charles went to work in their uncle Brandt's Pennsylvania chair factory in 1874. In 1884 these three brothers started their own Stickley Brothers Company in Binghamton, New York. It appears that the other two brothers joined the company in 1888. They continued the company until 1890 when the brothers began separate ventures.

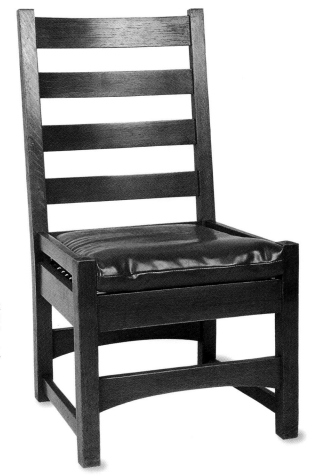

Gustav Stickley oak side chair (replaced seat). 37" high, 19" wide, 17-1/4" deep. *Courtesy of Roger and Jean Moss.*

Above & right: Gustav Stickley oak chair, inlaid with copper, brass, and silver or pewter, original finish, replaced seat. Harvey Ellis was the designer. 43-1/4" high, 17" wide, 16" deep. Courtesy of *Louis F. D'Elia.*

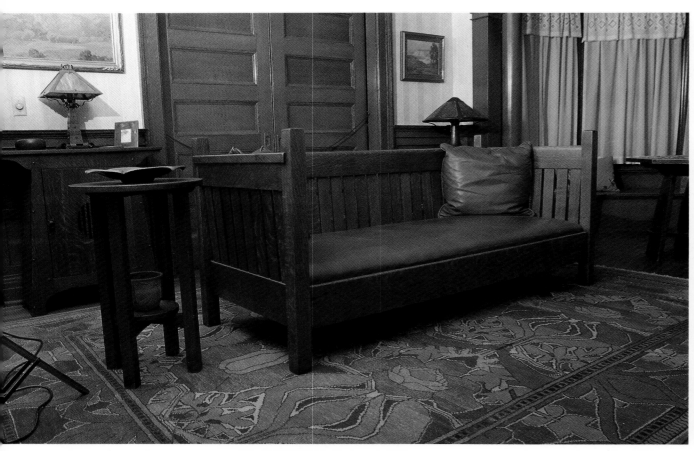

Gustav Stickley oak settle, cat. no. 222, with two leather pillows. 36"
high, 79-1/2" wide, 32-1/2" deep. *Courtesy of Louis F. D'Elia.*

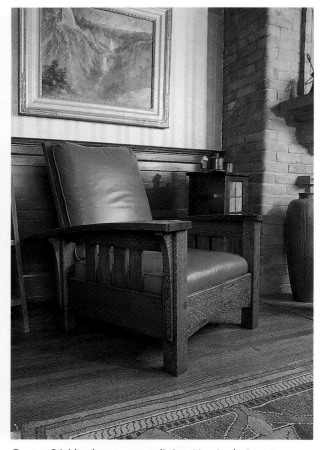

Gustav Stickley bow-arm reclining Morris chair, cat.
no. 406, refinished,with settings for four different
positions. 39-1/2" high, 35" wide, 41" deep.
Courtesy of a private collection, Santa Monica.

Gustav Stickley and The Craftsman Workshops

After leaving the original Stickley Brothers firm, Gustav, the oldest,
had a variety of positions, including a partnership with Elgin A. Simonds,
producing reproduction furniture, and as Director of Manufacturing
Operations for the New York State Prison at Auburn, where inmates pro-
duced furniture. In 1898, he made a sojourn to Europe where he was
exposed to Morris's Arts and Crafts philosophy and some of its practitio-
ners, including C.F.A. Voysey. Returning to America, he established the
United Crafts, in Eastwood, New York, later to be called Craftsman Work-

shops. A gifted designer, his furniture sought to be *"simple, durable, com-
fortable and fitted for the place it was to occupy and the work it had to do."*

Stickley's Craftsman Furniture employed heavy structural features,
including keyed tenons and chamfered boards, as well as pegged joints,
forged or hammered hardware, wide chair stretchers, and flaked
quartersawn oak. The forms were simple and elegant with exposed join-
ery and plain or leather upholstery. Stickley hired architect Harvey Ellis
in 1903. Ellis, strongly influenced by his exposure to the American South-
west, produced some of Stickley's best designs between 1903 and Janu-
ary, 1904. These designs were lighter and revealed more grace than

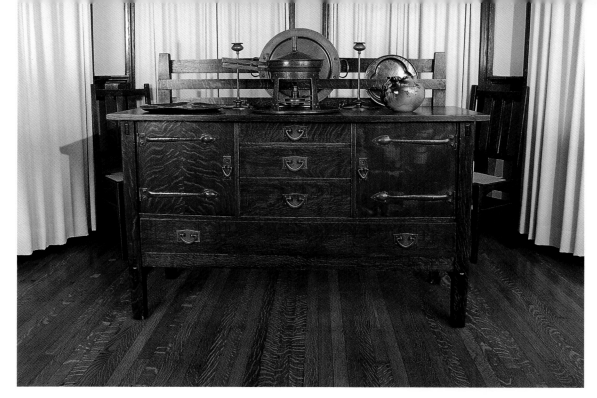

Left: Gustav Stickley oak side board, cat. no. 814. It has copper hardware, and features four drawers and two storage compartments with doors. 47" high overall, 36" high to top, 59-1/4" wide, 21" deep. *Courtesy of Craftsman Style.*

Below: Gustav Stickley oak round dining room table, cat. no. 632 and oak side chairs with rush seats, cat. no. 353. Table: 30" high, 54" dia.; chairs: 40" high, 17" wide, 16" deep. *Courtesy of Craftsman Style.*

Stickley's. In addition, Ellis brought a strong sense of color and proportion to the work, incorporating inlaid work in metals and wood. Tragically Ellis died on January 2, 1904. His influence on Stickley continued.

The period following Ellis's death was an expansive time for Stickley. He bought land in New Jersey to build an Arts & Crafts community. He built the Craftsman Building in New York, a 12-story edifice to house sales rooms and meeting spaces. In time, Stickley's furniture underwent design and manufacturing changes to conform with economic necessities, resulting in what is generally seen as a lessening of the standards of quality for which Stickley was so revered originally.

By 1915 Stickley's catalog only faintly echoed the Arts and Crafts style, interspersed with colonial reproductions and other decorative paraphernalia. In March, 1915, the company filed for bankruptcy.

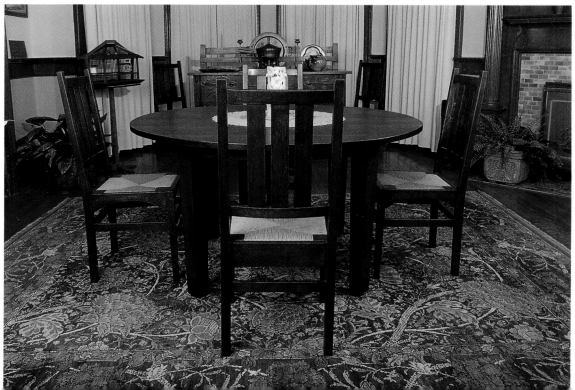

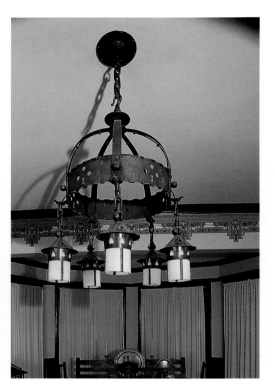

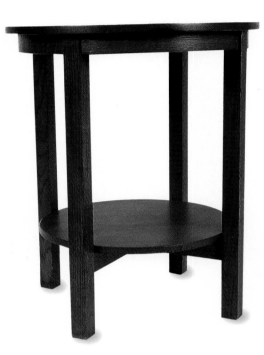

Gustav Stickley oak lamp table with shelf, ca. 1904. 29" high, 24" dia. *Courtesy of Jim & Jill West, Circa 1910 Antiques.*

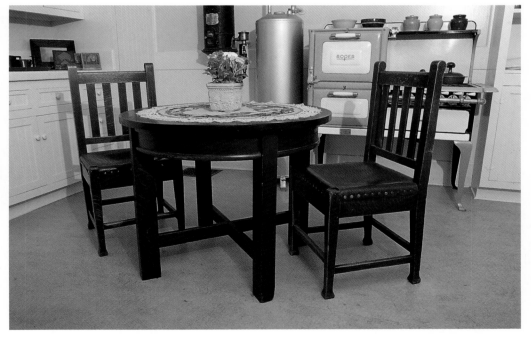

Above: Gustav Stickley oak china cabinet, cat. no. 815, part of 10-piece Stickley dining room suite, two doors, glass panes on three sides, through tenon construction, copper hardware, *Courtesy of Craftsman Style.*

Above center: Copper and iron five light chandelier with Handel glass. Unsigned, it is probably by Gustav Stickley. 40-1/2" high, 23" dia. *Courtesy of Tony Smith.*

Stickley round oak table cat. no. 073. 30" high, 36" dia., and Roycroft oak chairs (cat. no. 025), with leather seats and brass tacks. 17" to seat, 37" high overall, 17" deep. *Courtesy of a private collector.*

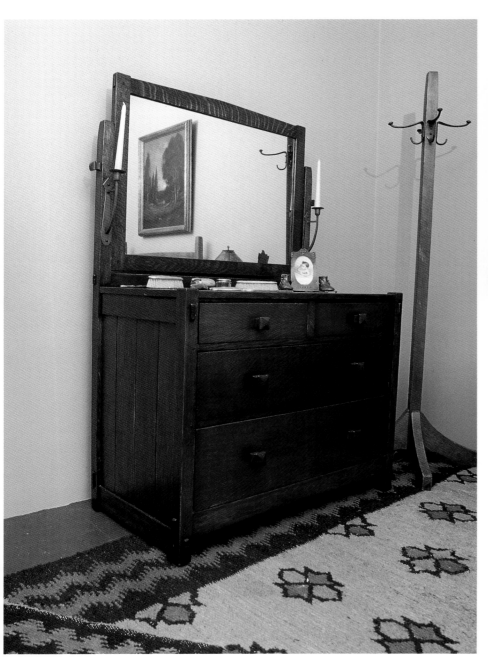

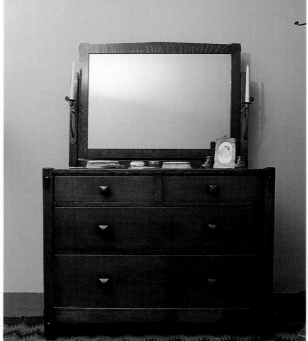

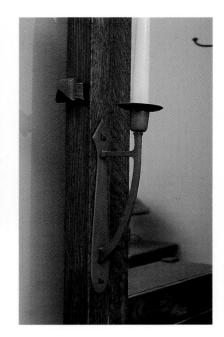

Gustav Stickley oak chest of drawers with mirror, cat. no. 625, ca. 1902 (refinished). It is fitted with a pair of Gustav Stickley candleholders, cat. no. 75, as pictured in an early Gustav Stickley catalog. It has oak pulls and through tenon construction. 63-1/2" high, 42" wide, 22" deep. *Courtesy of David Nunley and Carol Davis.*

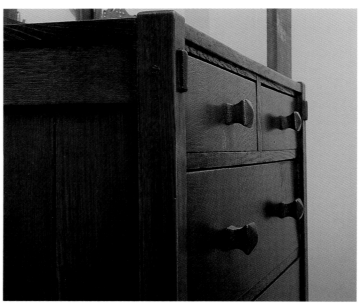

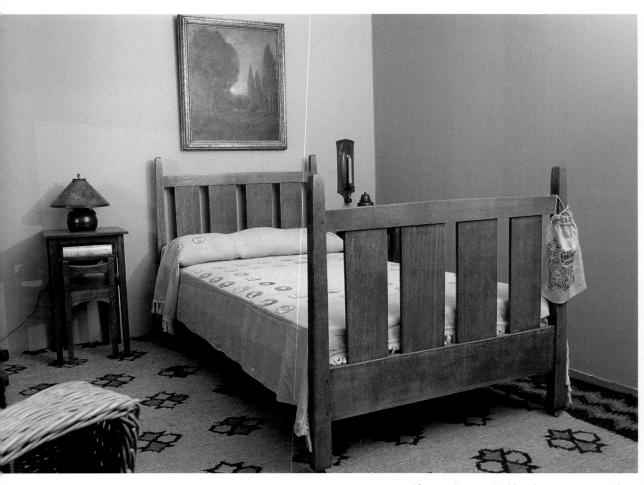

Gustav Stickley willow armchair. 39" high, 31" wide, 26" deep. *Courtesy of Clare Carlson Porter.*

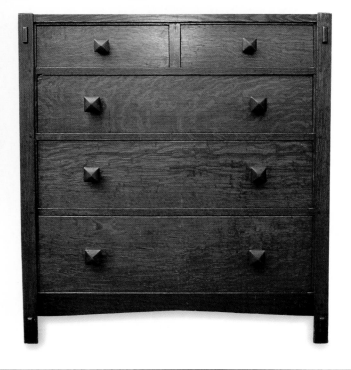

Above: Gustav Stickley three-quarter oak bed. Head board: 47-1/2" high, 45" wide, bed frame: 78" long. *Courtesy of Jack Moore's Pasadena Antiques.*

Right: Gustav Stickley oak chest of drawers, cat. no. 626, ca. 1902. It has oak pulls and through tenon construction. Original finish. 43" high, 36" wide, 20" deep. *Courtesy of David Nunley and Carol Davis.*

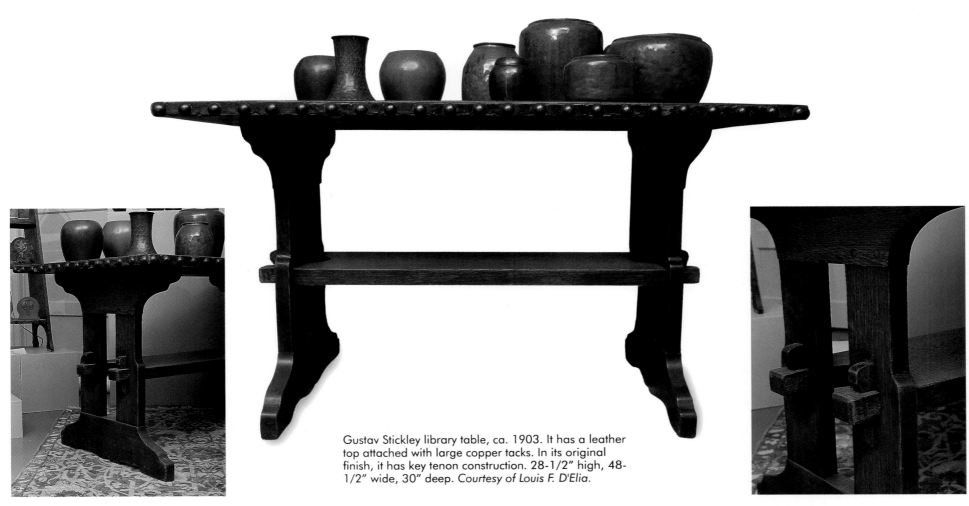

Gustav Stickley library table, ca. 1903. It has a leather top attached with large copper tacks. In its original finish, it has key tenon construction. 28-1/2" high, 48-1/2" wide, 30" deep. *Courtesy of Louis F. D'Elia.*

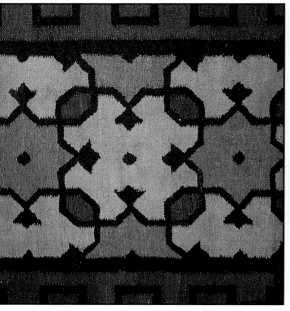

A portion of a Gustav Stickley "Scroll" drugget. 50" x 82". *Courtesy of Jax Arts & Crafts Rugs.*

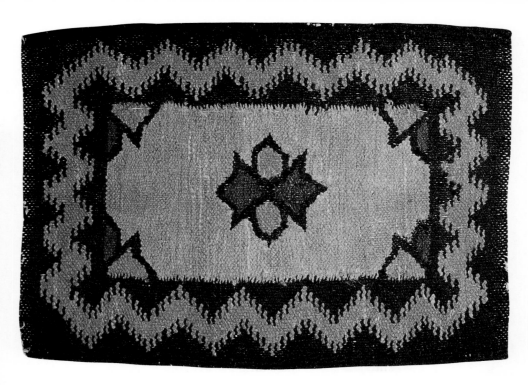

Gustav Stickley "Nile" drugget. 24" x 36". *Courtesy of Jax Arts & Crafts Rugs.*

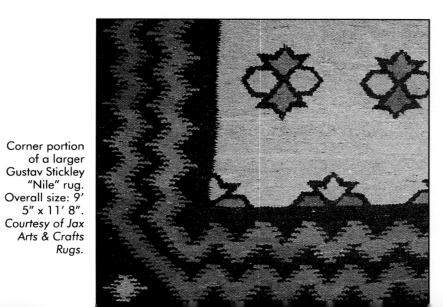

Corner portion of a larger Gustav Stickley "Nile" rug. Overall size: 9' 5" x 11' 8". *Courtesy of Jax Arts & Crafts Rugs.*

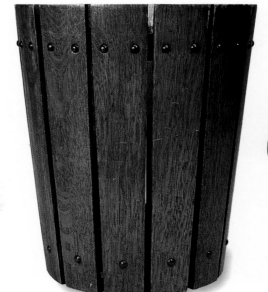

Above: Gustav Stickley oak costumer, iron hardware, 72" high, 19" x 19" base. *Courtesy of Isak Lindenauer.*

Left: Gustav Stickley round oak wastebasket (cat. no. 94). 14" high, 12" dia. at the top. *Courtesy of Roger and Jean Moss.*

36

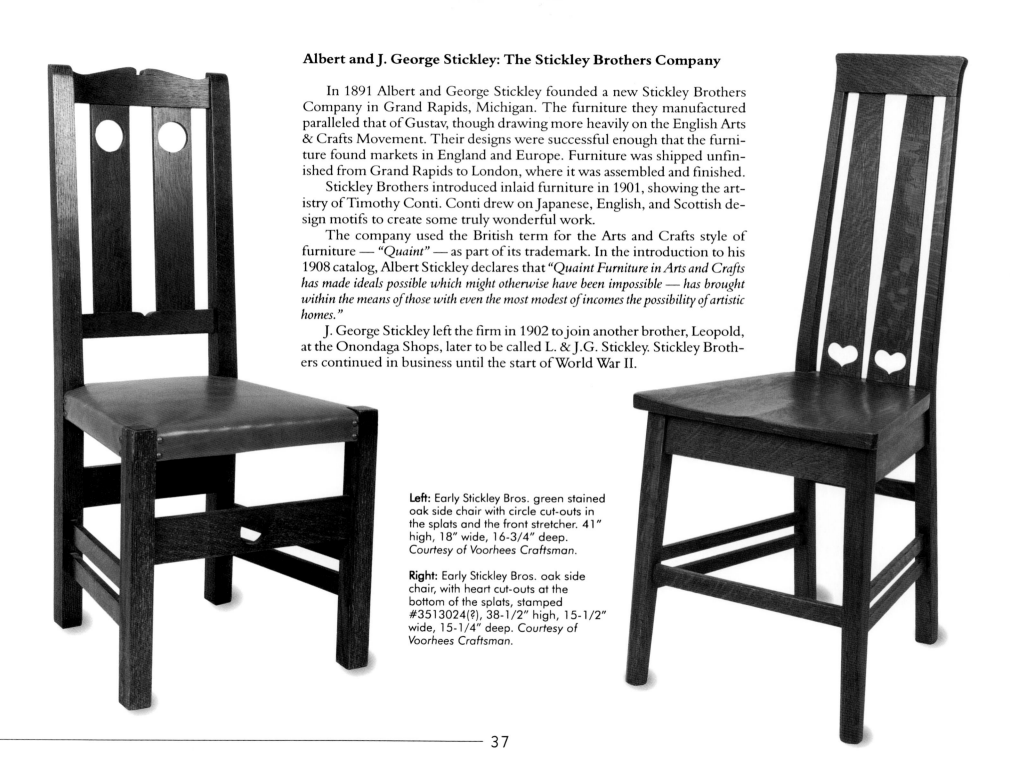

Albert and J. George Stickley: The Stickley Brothers Company

In 1891 Albert and George Stickley founded a new Stickley Brothers Company in Grand Rapids, Michigan. The furniture they manufactured paralleled that of Gustav, though drawing more heavily on the English Arts & Crafts Movement. Their designs were successful enough that the furniture found markets in England and Europe. Furniture was shipped unfinished from Grand Rapids to London, where it was assembled and finished.

Stickley Brothers introduced inlaid furniture in 1901, showing the artistry of Timothy Conti. Conti drew on Japanese, English, and Scottish design motifs to create some truly wonderful work.

The company used the British term for the Arts and Crafts style of furniture — "*Quaint*" — as part of its trademark. In the introduction to his 1908 catalog, Albert Stickley declares that "*Quaint Furniture in Arts and Crafts has made ideals possible which might otherwise have been impossible — has brought within the means of those with even the most modest of incomes the possibility of artistic homes.*"

J. George Stickley left the firm in 1902 to join another brother, Leopold, at the Onondaga Shops, later to be called L. & J.G. Stickley. Stickley Brothers continued in business until the start of World War II.

Left: Early Stickley Bros. green stained oak side chair with circle cut-outs in the splats and the front stretcher. 41" high, 18" wide, 16-3/4" deep. *Courtesy of Voorhees Craftsman.*

Right: Early Stickley Bros. oak side chair, with heart cut-outs at the bottom of the splats, stamped #3513024(?), 38-1/2" high, 15-1/2" wide, 15-1/4" deep. *Courtesy of Voorhees Craftsman.*

Charles Stickley: Stickley and Brandt

Charles Stickley stayed in Binghamton, where he started the Stickley and Brandt Chair Company in December of 1891, with his uncle, Schuyler Brandt. The company offered a broad range of furniture styles, mostly period reproductions, some of which was manufactured by other firms. By 1905 they were producing a line of Arts and Crafts styled furniture, which carried the company's shopmark. Though their company outlived brother Gustav's, it, too, declared bankruptcy in 1919.

L. & J. G. Stickley Inc.: The Onondaga Shops

Leopold and John George Stickley did not have the philosophical base of their older brother Gustav, but they did share his commitment to quality. Their furniture in the Arts & Crafts style was not particularly innovative, but it was well made. They began producing furniture in Fayetteville, New York, in 1902 under the trademark of the Onondaga Shops. Their immediate success led to a rapid expansion of their business.

Never purists, they used machinery in the pursuit of well-designed quality furniture. In their 1914 catalog they wrote:

> The work of L. & J.G. Stickley, built in a scientific manner, does not attempt to follow the traditions of a bygone day. All the resources of modern invention are used as helps in constructing this thoroughly modern product, more suitable...to the house of today – your house, that is – than is the furniture of past centuries or its necessarily machine made reproductions.

The vision was to fade as the public's taste for Arts & Crafts styles waned in the 1910s. Gustav had lost most of the vision by the time of his 1915 catalog, which contained little of the Craftsman style. Gustav filed for bankruptcy in March of 1915, and, in 1918, Leopold and John George bought controlling interest in his factory. They formed, along with Gustav and Albert, Stickley Associated Cabinetmakers, a brotherly reunion that lasted less than a year. L. & J.G. Stickley made the same transformation their brother had, and introduced a line of *"Cherry Valley"* colonial reproductions. They produced their last Arts and Crafts furniture in 1923. Still in existence, they have made quality furniture in period designs since then, and in 1989 the Stickley Company reintroduced a line of Arts and Crafts furniture modeled after authentic examples of both Gustav and L. and J. G. Stickley furniture.

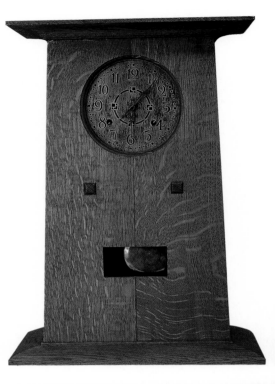

L. & J.G. Stickley oak mantle clock, with pendulum, brass hands, and deeply etched copper dial. 22" high, 12" wide, 6" deep. *Courtesy of Jack Moore's Pasadena Antiques.*

Charles Limbert

Charles P. Limbert was born in 1854 and learned his trade during the Centennial revival of 18th century designs. In 1889 he began producing chairs in Grand Rapids, Michigan, in partnership with Philip J. Klingman, an associate of Gustav Stickley. The partnership dissolved in 1892 and in 1894, Limbert formed Charles P. Limbert and Company. The company produced furniture that combined Art Nouveau and Arts and Crafts elements in a line he called the Dutch Arts and Crafts. Much of his early furniture was experimental, often incorporating elements of Art Nouveau, English Medieval, Japanese, Glasgow School, and Austrian Secession styles.

The years from 1904-1910 produced an increasingly sophisticated look, expressive of Limbert's vision. The influence of Art Nouveau gave way to other influences including Charles Rennie Mackintosh and the Glasgow School and Josef Hoffman of Vienna. In 1906 the company moved from Grand Rapids to Holland, Michigan, and continued to grow.

While the Stickleys were feeling the change in public tastes and the sting of imitators during the 1910s, Limbert introduced a new line of Arts and Crafts styled furniture in 1915. It was lighter in color and construction, and made extensive use of colored fabrics to relieve the dullness of leather's predominance. He also reintroduced a line of inlaid furniture called "Ebon-Oak" and featuring fine geometric designs of ebony inlay, sometimes combined with metals.

Limbert suffered a stroke in 1921 while on a Hawaiian vacation. He sold his holdings in the company in 1922 and died in 1924. The company however continued on until 1944.

Limbert oak telephone stand with matching chair. 30-1/4" high, 18" wide, 15" deep. *Courtesy of Voorhees Craftsman.*

Charles Limbert oak cellarette, cat. no. 602. Cut-out door, brass hardware. 36" high, 34" wide, 14-1/4" deep. *Courtesy of Louis F. D'Elia.*

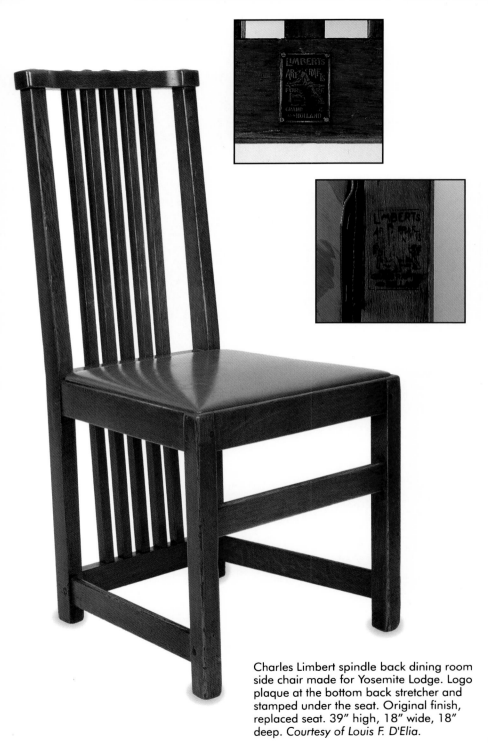

Charles Limbert spindle back dining room side chair made for Yosemite Lodge. Logo plaque at the bottom back stretcher and stamped under the seat. Original finish, replaced seat. 39" high, 18" wide, 18" deep. *Courtesy of Louis F. D'Elia.*

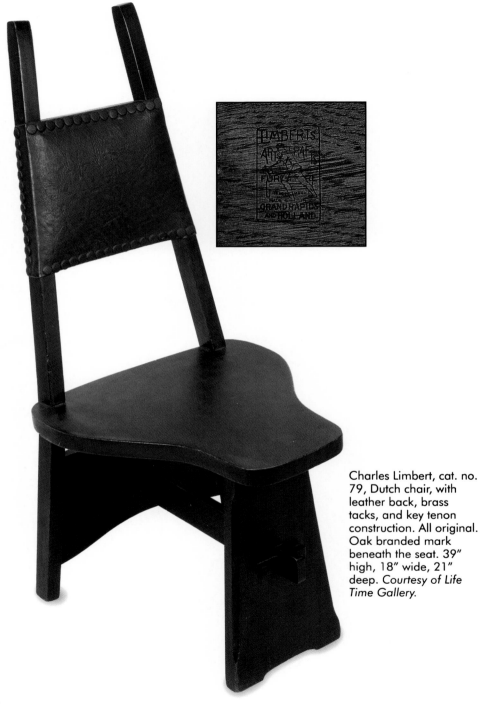

Charles Limbert, cat. no. 79, Dutch chair, with leather back, brass tacks, and key tenon construction. All original. Oak branded mark beneath the seat. 39" high, 18" wide, 21" deep. *Courtesy of Life Time Gallery.*

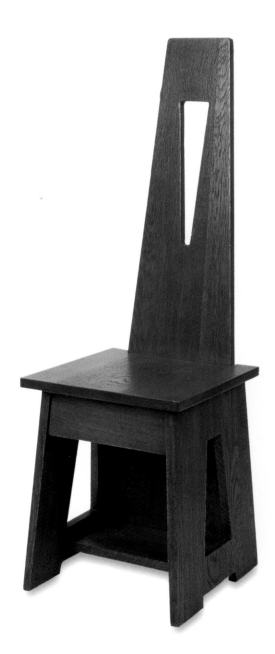

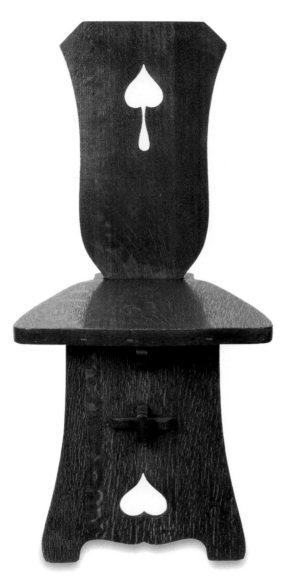

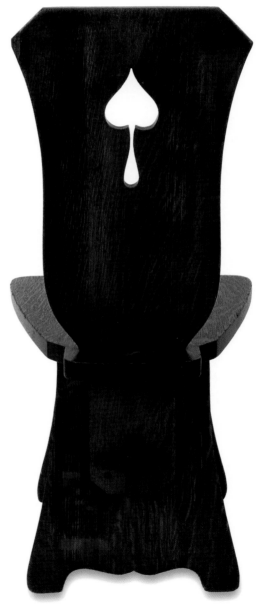

Charles Limbert, cat. no. 81, oak hall chair, with elongated "V" cut-outs in the back and sides. 45-1/2" high, 14" wide, 14" deep. *Courtesy of Louis F. D'Elia.*

Above & right: Charles Limbert, cat. no. 80, oak hall chair, with spade cut-outs in back and front leg piece. Key tenon construction, 38-1/2" high, 18" wide, 21-1/2" deep. *Courtesy of Voorhees Craftsman.*

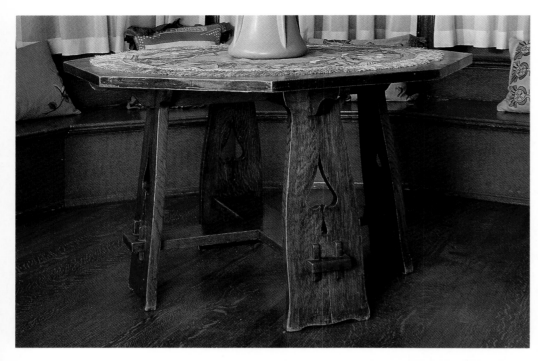

Left: Charles Limbert octagonal oak library table. It features spade cut-outs in the legs and key tenon construction. Original finish. 29" high, 44-1/2" x 44-1/2". *Courtesy of Craftsman Style.*

Lower left & right: On top of the octagonal table is a round linen table scarf, with an embroidered moth design and a fringe. 41" dia. *Courtesy of Voorhees Craftsman.*

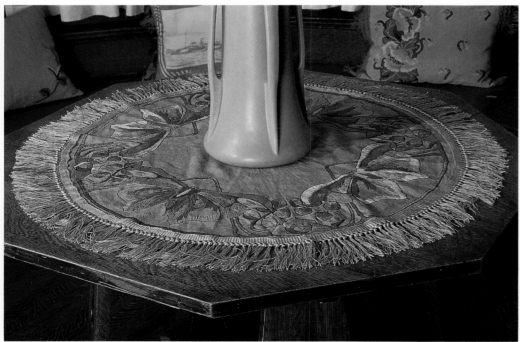

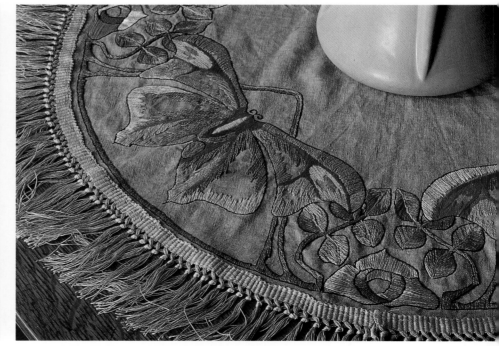

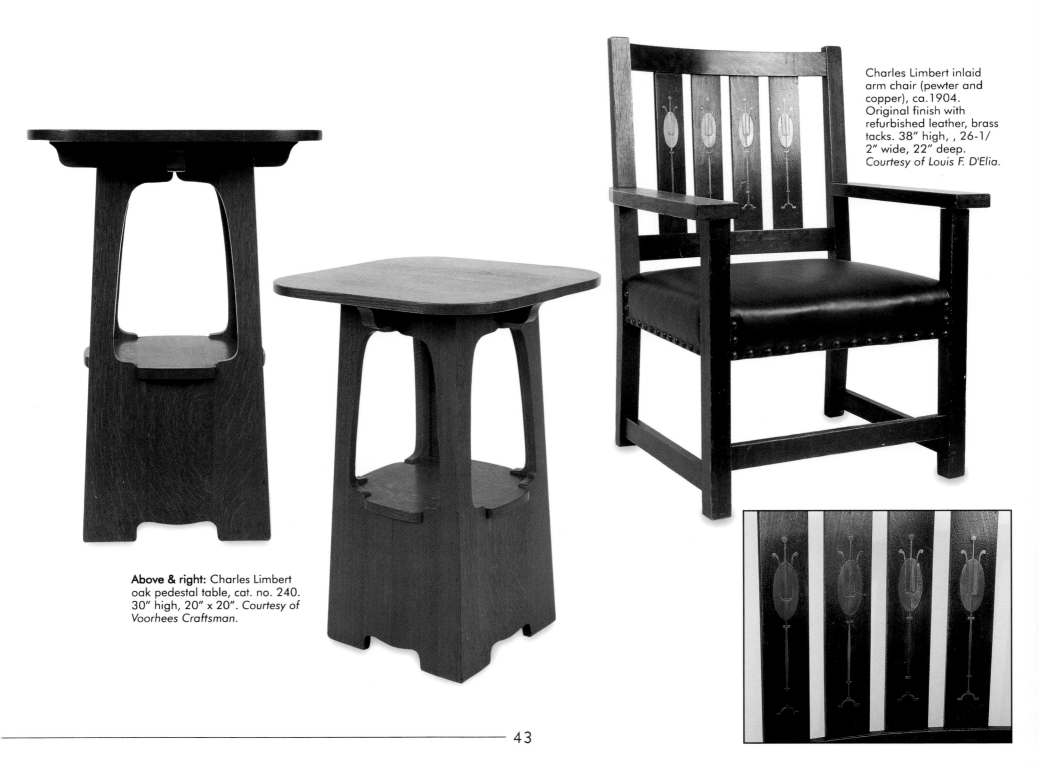

Charles Limbert inlaid arm chair (pewter and copper), ca.1904. Original finish with refurbished leather, brass tacks. 38" high, , 26-1/2" wide, 22" deep. *Courtesy of Louis F. D'Elia.*

Above & right: Charles Limbert oak pedestal table, cat. no. 240. 30" high, 20" x 20". *Courtesy of Voorhees Craftsman.*

Oscar Onken
and the Shop of the Crafters

Oscar Onken, the founder of The Shop of the Crafters, had been a successful retailer in Cincinnati for the twenty years leading up to 1904. Starting in the picture frame business, he had grown into the manufacture of moldings and the sale of mirrors, etchings, and artwork. Onken, visiting the Louisiana Purchase International Exposition in 1904, was impressed by the creativity shown in the Austro-Hungarian Secessionist furniture being exhibited there. In particular he was stuck by the inlaid designs of Paul Horti of Budapest. Horti received numerous awards and recognition at the Exposition for his avant-garde furniture designs. Onken introduced himself to Horti and the two agreed that Horti would come to work for him designing furniture.

In a few months a new venture was born, The Shop of the Crafters, featuring Arts and Crafts furniture in oak and mahogany. Horti's inlaid designs were a prominent design element, but so, too, were design features from other Arts and Crafts manufacturers, and occasional touches of Art Nouveau and even Victorian influences. Ads appeared in the *Saturday Evening Post* for The Shop of the Crafters, promoting them as *"Makers of Arts and Crafts Furniture, Hall Clocks, Shaving Stands, Cellarettes, Smokers' Cabinets and Mission Chairs."*

Arts and Crafts furniture production had ceased by 1920, though the Oscar Onken Company remained in business until 1931.

Shop of the Crafters inlaid side chair (replaced seat). 42-3/4" high, 19" wide, 18-1/2" deep. *Courtesy of Robert W. Winter.*

44

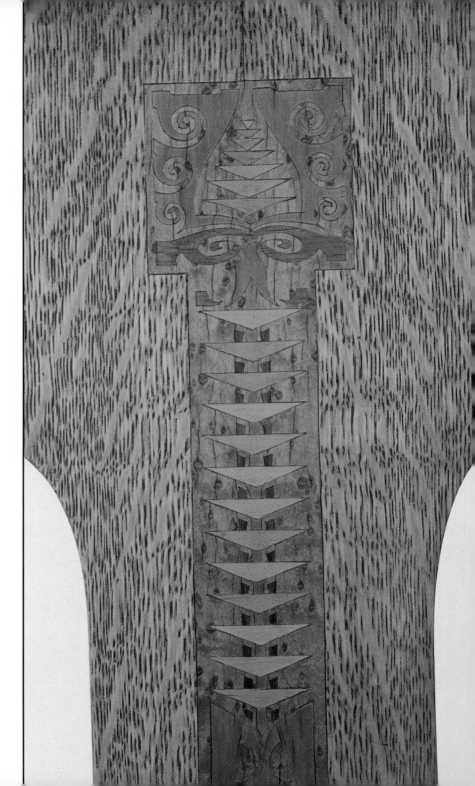

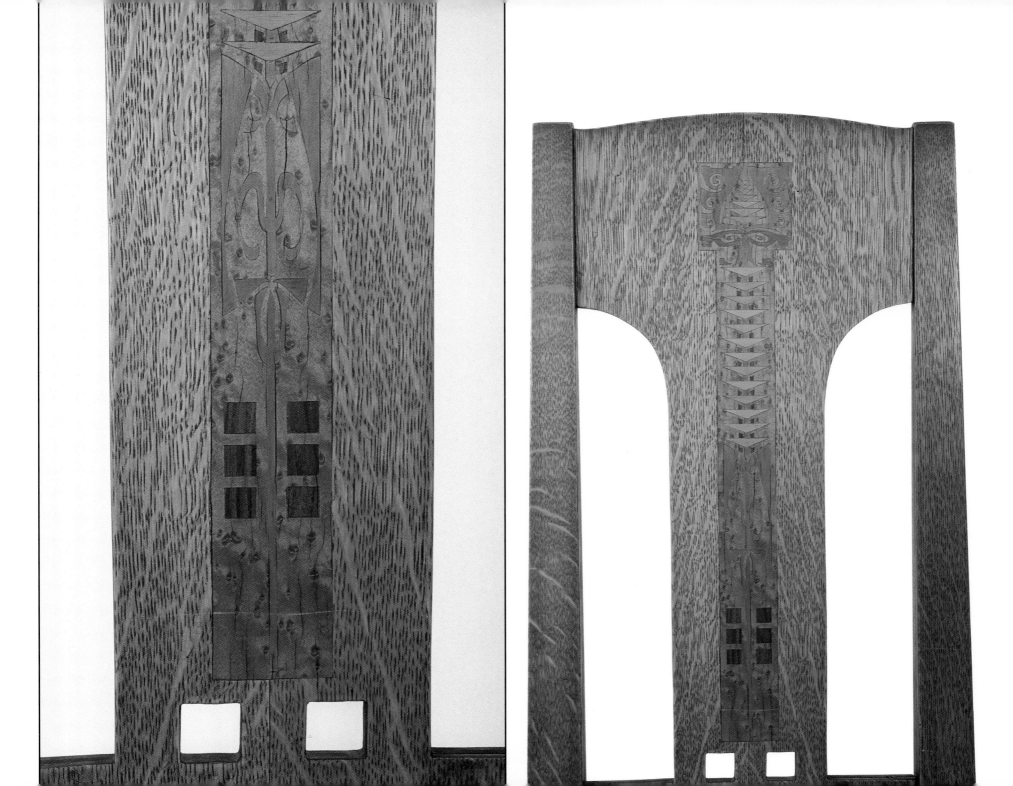

Greene and Greene

The brothers Charles and Henry Greene grew up in St. Louis and attended Washington University's Manual Training High School. They continued their studies in Cambridge, Massachusetts, at the Massachusetts Institute of Technology School of Architecture, graduating in 1891. In 1893 they established an architectural practice in Pasadena, California.

They designed a number of private homes ranging from bungalows to large estates. Like Frank Lloyd Wright and others they designed every aspect of the house including the furniture and decoration. Seeing the work of Gustav Stickley in *The Craftsman* magazine in 1900, they ordered pieces for their next client from the magazine.

Peter and John Hall were Swedish immigrants doing renovation work in Pasadena in 1905, when the Greenes encountered them and admired their craftsmanship. They helped the Halls set up their own woodworking shop, out of which the Greenes' furniture and woodworking designs became realities. The furniture they designed used mahogany as the principal wood with square ebony pegs replacing the oak dowels. The oriental influence was evident.

The most important buildings from Greene and Greene were executed before 1910. They include: the Robert Blacker house (1907), the David Gamble house (1908), the Freeman Ford house (1909) in Pasadena, California; the William Thorsen house (1909) in Berkeley, California; and the Charles Pratt house (1909) in Ojai, California. After 1910 the commissions diminished. Fewer clients were ready or able to invest the great sums required by the exquisite designs, and the pubic's taste tended back toward period-influenced reproduction furniture.

Charles moved his family to Carmel in 1916 and became associated with a community of artists centered there. The partnership was officially ended in 1922 though both men continued working until their retirement in the early 1930s.

Greene & Greene designed, Hall and Orr manufactured side chair, ca.1909-1910. Inlaid mahogany, ebony, oak, brass, fruitwood, abalone. It has its original leather, seat. 42-1/4" high, 21" wide, 20-1/2" deep. *Courtesy of The Gamble House, USC.*

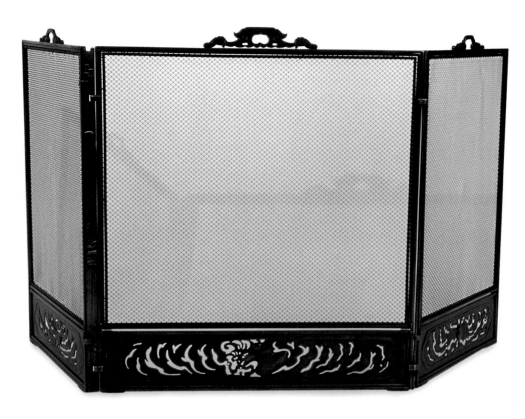

Cast and wrought steel fireplace screen, ca. 1911-1914 originally made for the Thorsen House living room. Designed by Greene & Greene. Its pierced bottom piece features bas relief designs of a mourning dove, phoenix, and bat. 30-1/2" high, 61" wide. *Courtesy of The Gamble House, USC.*

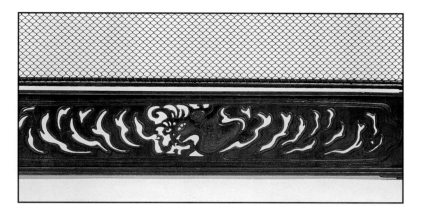

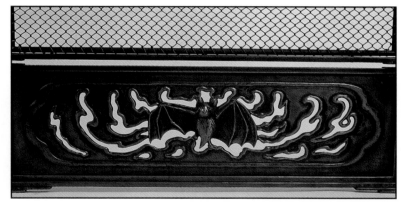

Bernard Maybeck

Bernard Ralph Maybeck was bon in New York in 1862, the son of a German woodworker. He attended school in Paris at the École des Beaux Arts, and worked as an architect for John Merven Carrere and Thomas Hastings on the design of the Ponce de Leon Hotel in St. Augustine, Florida. He moved to San Francisco in 1890 and went to work for A. Page Brown who was designing the New Jerusalem Swedenborgian Church. His significance to the Arts and Crafts movement is the attribution of the first "Mission" style chair, which he designed for the church.

Charles Keeler

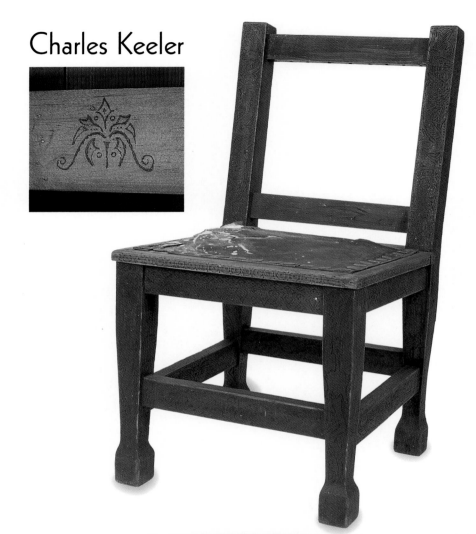

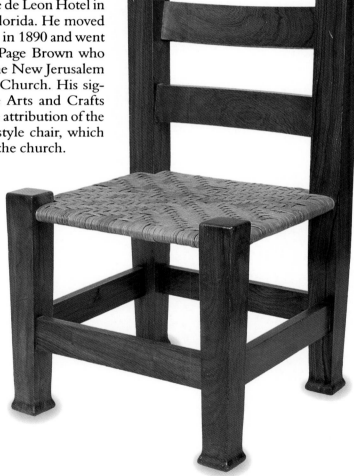

Bernard Maybeck side chair. 80 were made for Swedenborgian Church, San Francisco. The split reed seat is not original. Circasian walnut. 36-1/2" high, 21" wide, 19-1/2" deep, ca. 1894. *Courtesy of Caro Tanner Macpherson.*

Charles Keeler redwood side chair, with wood-burned dragons and other symbols. The original leather seat has many of its iron tacks in place. It is marked on the bottom. Tack holes across back indicate that there was once a leather or fabric backing. 35-3/4" high, 19-1/2" wide, 19" deep. *Courtesy of Caro Tanner Macpherson.*

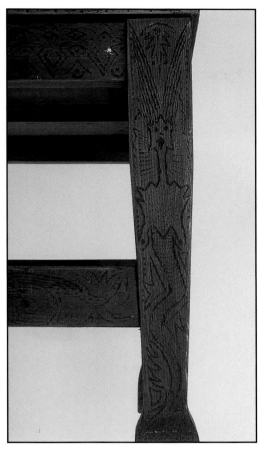
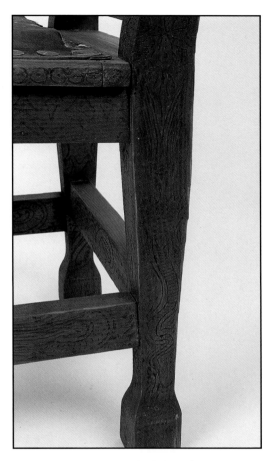

Harold Doolittle

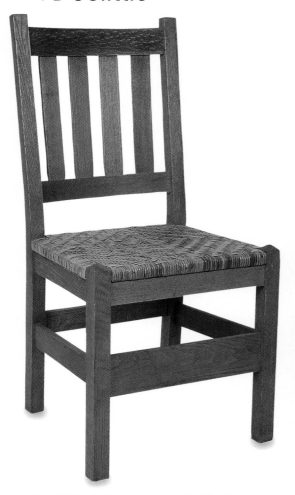

Harold Doolittle cane seat, oak side chair. 38" high, 18" wide, 16" deep. *Courtesy of Jack Moore's Pasadena Antiques.*

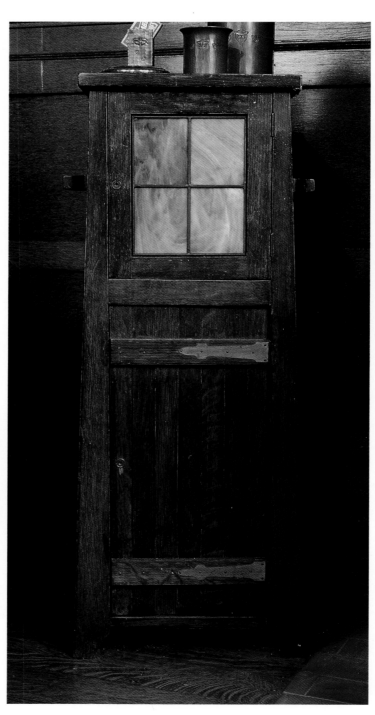

Lakeside

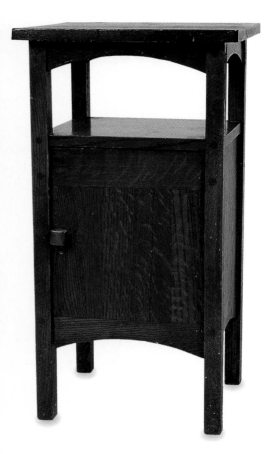

Above: Oak somno (night stand), maker unknown. 27" high, 14" wide, 12" deep. *Courtesy of a private collector.*

Left: Lakeside oak smoking cabinet, with Handel stained glass panel in the door. It has two locking cupboards and features brass hardware. 34" high, 12" square. *Courtesy of a private collection, Santa Monica.*

Miscellaneous Furnishings

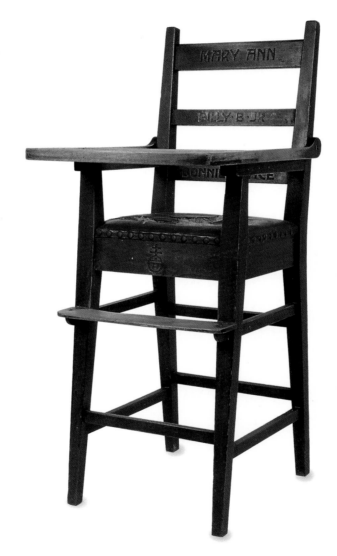

Arts & crafts style oak and mahogany birdcage and stand. Stand: 4' high and 21" wide; mahogany cage: 15-1/2" high, 19" wide, 13" deep. *Courtesy of Clare Carlson Porter.*

Roycroft mahogany highchair, cat. no. 036, with leather seat brass tacks intact. The names of the children who used the chair could be ordered carved into the back slats. 42" high, table 16-1/2" x 21". *Courtesy of a private collector.*

Oak telephone stand with low shelf. 29" high, 18" dia. at the top. *Courtesy of Craftsman Style.*

Three panel oak screen with stained red poppy design at the top, original finish. Each panel is 68" high, 19-1/2" wide. *Courtesy of Caro Tanner Macpherson.*

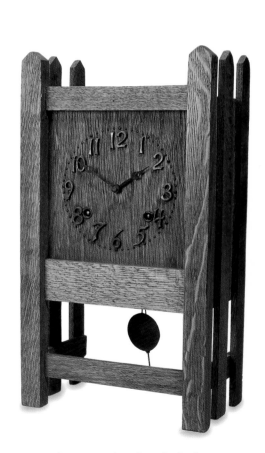

An arts and crafts oak clock.
17-1/2" high, 9-1/2" wide.
Courtesy of Life Time Gallery.

Fire place screen, mahogany
with tapestry insert.

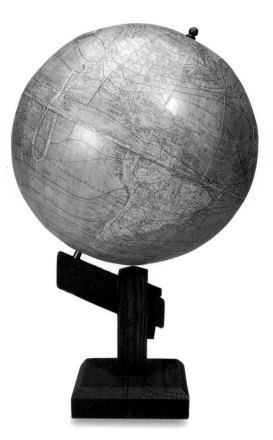

Globe on oak base made by New
Peerless, 12". The globe itself was
by Rehm Globe company, ca.
1903. *Courtesy of Clare Carlson
Porter.*

Hand knotted woolen carpet made in Voysey's *Donnemara* pattern, color red/green, inventory #L23332, origin India, 9' x 12'. Contemporary. *Courtesy of The Persian Carpet, Inc., Durham, N.C.*

Hand knotted woolen red carpet made in William Morris thistle fabric design. Contemporary construction inventory #L23411, 8' x 10'. *Courtesy of The Persian Carpet, Inc., Durham, N.C.*

Charles Rohlfs

Born in 1853, Charles Rohlfs entered the Cooper Union for the Advancement of Science and Art from a career as a Shakespearean actor. Around 1890 he established a shop in Buffalo, New York. He created work ranging from simple Arts & Crafts styles to more intricate Art Nouveau designs, for which he is best known. A friend of Elbert Hubbard, he was a frequent lecturer at the Roycrofters until his retirement. Rohlfs died in 1936.

Charles Rohlfs oak candleholder with a copper insert, ca. 1902. The maker mark is shown. *Courtesy of Melville D'Souza.*

Embroidery

While the English Arts & Crafts movement produced wonderful textiles designed by Morris and others or imported from Asia by Liberty House, few in America could afford these luxuries. Instead a great value was placed on embroidered goods, often in combination with stenciling. They were available from a number of companies, including Stickley's United Crafts, in completed form or as kit to be completed by the homemaker herself. The pillows shown below were probably made using the same kit, and owe their variation to the creativity of the needleworker.

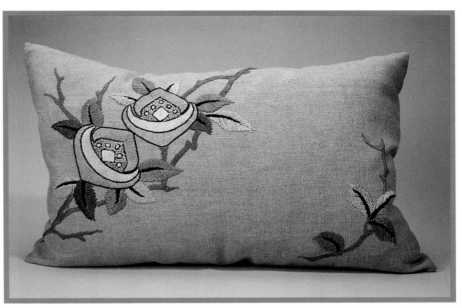

Hand embroidered pillow in a stylized branch design. 24" x 16". *Courtesy of Ron Bernstein.*

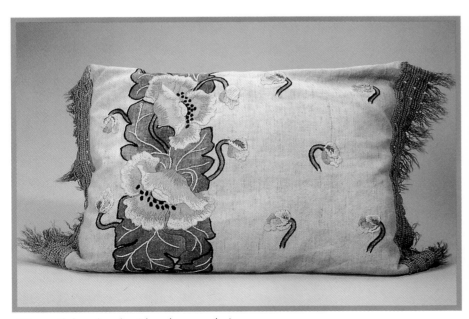

Pillow with hand embroidered poppy design, 21" x 15". *Courtesy of Ron Bernstein.*

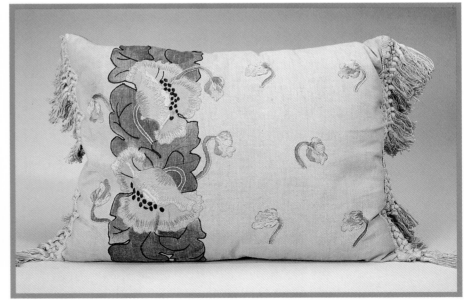

This design is obviously from the same pattern as the previous pillow, but the variations point to the artist's own creativity when working with the pattern. 21" x 15". *Courtesy of Ron Bernstein.*

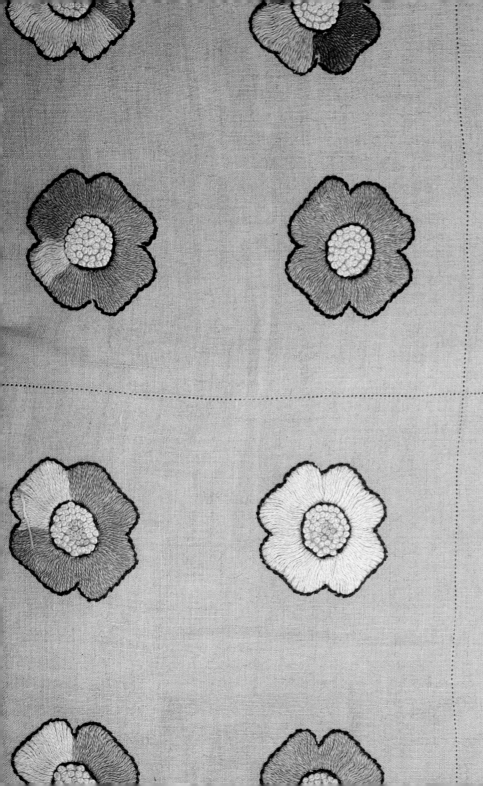

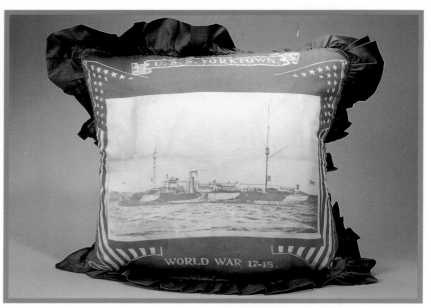

Photo pillow, commemorating the "U.S.S. Yorktown, World War, 17-18." 21" x 17". *Courtesy of Ron Bernstein.*

Above: Pillow, hand embroidered, 20" x 15". *Courtesy of Ron Bernstein.*

Left: Linen bedspread and bolster, with hand embroidered blue flower motif. *Courtesy of Ron Bernstein.*

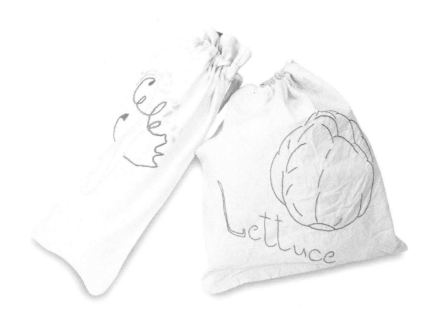

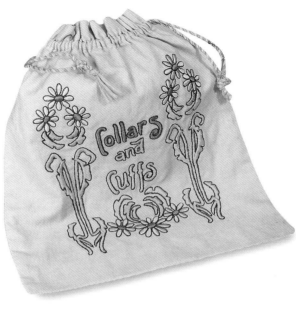

Far left: The urge for art in every aspect of life even extended itself to these embroidered cloth vegetable bags. *Courtesy of Ron Bernstein.*

Left: "Collars and cuffs" drawstring bag, hand embroidered. *Courtesy of Ron Bernstein.*

Round linen table scarf seen on the dining room table. Embroidered stylized pattern pink and green, with lace trim. 26" dia. *Courtesy of Voorhees Craftsman.*

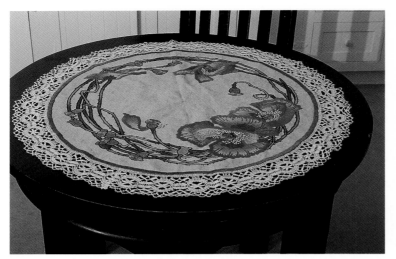

Round linen table scarf seen in the kitchen, with embroidered poppy design and lace trim. 31" dia. *Courtesy of Voorhees Craftsman.*

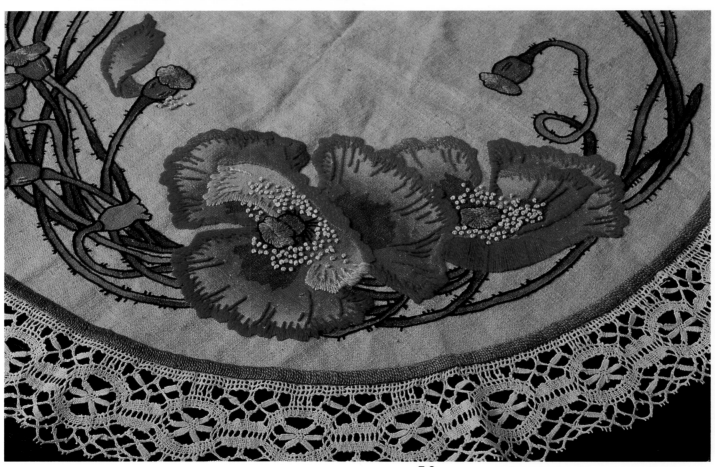

Native American Influences

After the hostilities of the nineteenth century, a new appreciation of the Native American culture was born. Improved rail and road transportation brought tourists to the Southwest in great numbers around the turn of the century, introducing them and the country at large to the beauty of their crafts. Stickley's and other Arts & Crafts designers also took notice. *The Craftsman* magazine suggested that Navajo rugs and blankets were perfect complements to an Arts & Crafts decor, and the patterns from Indian crafts were echoed in the textiles and pottery of other designers as well. For Native Americans, the orders for their rugs were so numerous in the 1910s that they could scarcely keep up with demand.

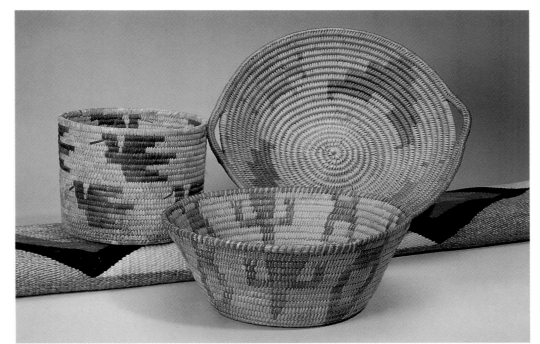

Indian baskets on a Navajo rug. *Courtesy of Louis F. D'Elia, Michael Trotter, and a private collector.*

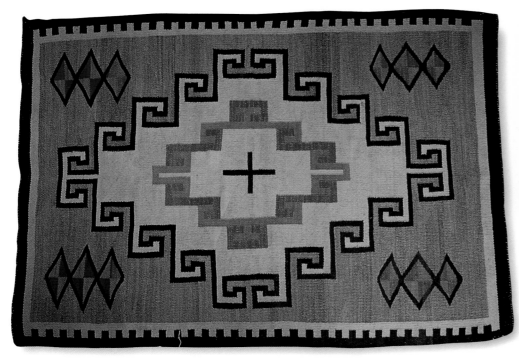

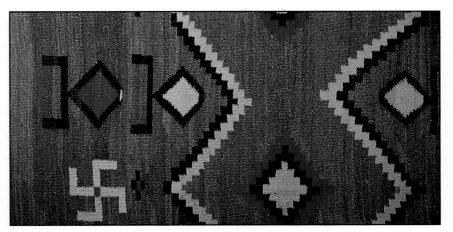

Above: The Navajo rug design includes, four winds, diamond and geometric shapes, light brown background, red, white and dark brown accents, 63" x 44". *Courtesy of a private collector.*

Left: Navajo rug, light background, brown edging, cross in center. 71" x 51". *Courtesy of a private collector.*

Lighting and Accessories

Benedict Art Studio

The Benedict Art Studio was active beginning around 1904, succeeding the Onondaga Metal Shops, which were in operation from about 1901. Onondaga may have produced copper goods for Gustav Stickley and L. and J.G. Stickley. Principals in the company were Harry L. Benedict and George N. Couse, and their goods included lamps, trays, desk sets, and other metal wares.

Benedict Art Studio lamp, copper and stained glass. 20" high. *Courtesy of Louis F. D'Elia.*

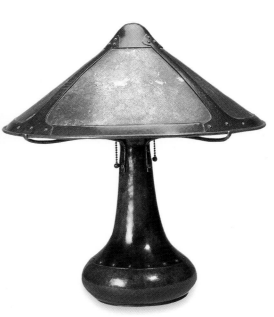

Dirk van Erp

For more information on Dirk van Erp, refer to the Metal Wares chapter.

Above & right: Dirk van Erp copper and mica table lamp, 22" high. *Courtesy of Louis F. D'Elia.*

Dirk van Erp copper lamp with copper and mica shade. 18-1/2" high; shade: 18" dia. *Courtesy of a private collection, Santa Monica.*

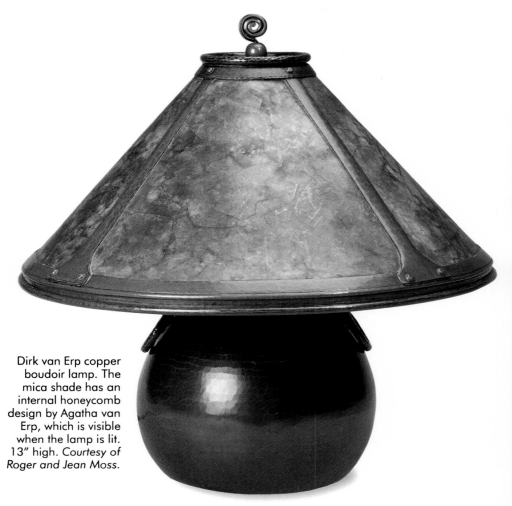

Dirk van Erp copper boudoir lamp. The mica shade has an internal honeycomb design by Agatha van Erp, which is visible when the lamp is lit. 13" high. *Courtesy of Roger and Jean Moss.*

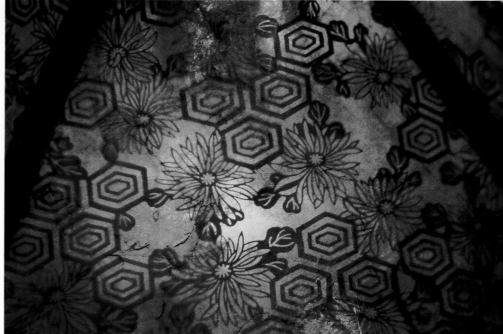

Ernest Batchelder and Douglas Donaldson

Extensive information about Ernest Batchelder is found in the Pottery & Ceramics chapter, where there is a special section on his tiles. Douglas Donaldson was born in Detroit in 1882. He studied with James H. Winn and exhibited at the both the Boston and the Detroit Societies for the Arts and Crafts. He moved to California in 1909 and taught metalworking at the school founded by Batchelder. From 1912 to 1919 he taught at the Manual Arts High School in Los Angeles as head of the art department. He and his wife, Louise, started a Hollywood metalworking and enameling studio in 1921.

Batchelder/Donaldson copper lamp with peacock motif inscribed around the base. The shade is split bamboo and silk. This was originally a kerosene lamp. Base: 10-1/2" high. Courtesy of *Tony Smith*.

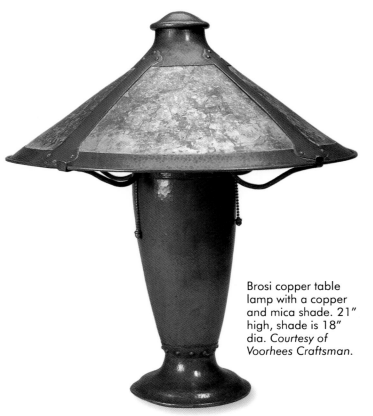

Brosi copper table lamp with a copper and mica shade. 21" high, shade is 18" dia. *Courtesy of Voorhees Craftsman.*

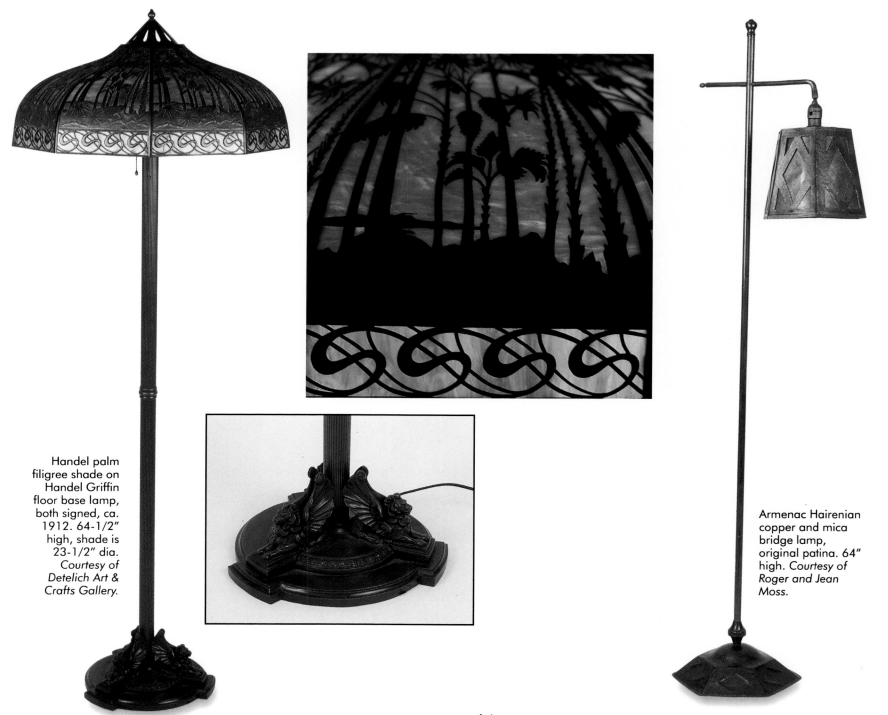

Handel palm filigree shade on Handel Griffin floor base lamp, both signed, ca. 1912. 64-1/2" high, shade is 23-1/2" dia. *Courtesy of Detelich Art & Crafts Gallery.*

Armenac Hairenian copper and mica bridge lamp, original patina. 64" high. *Courtesy of Roger and Jean Moss.*

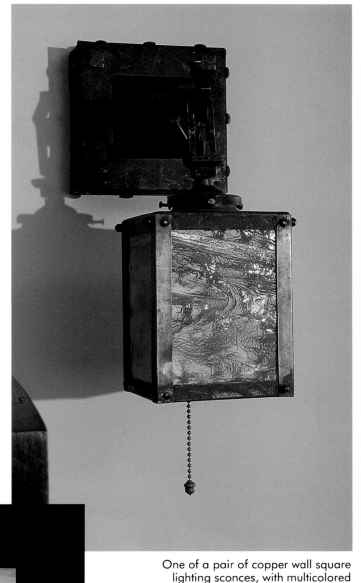

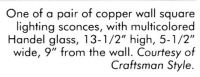

One of a pair of copper wall square lighting sconces, with multicolored Handel glass, 13-1/2" high, 5-1/2" wide, 9" from the wall. *Courtesy of Craftsman Style*.

One of a pair of brass wall sconces with hand painted, molded Handel shades. 12-1/2" high, 4" wide, 6-1/2" from wall. *Courtesy of Tony Smith*.

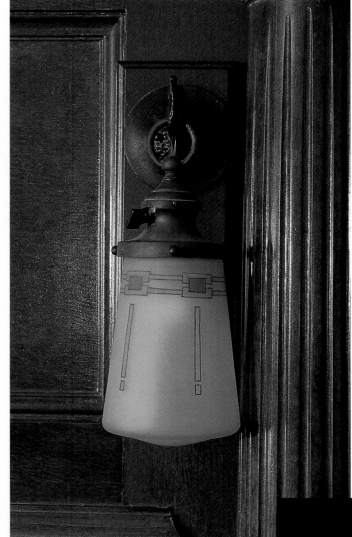

The Mission Inn

Adapted from the Mission Inn brochure

What is now the Historic Mission Inn began, in 1876, as the Glenwood. It was built by Christopher Columbus Miller as a two-story, 12-room adobe boarding house, as well as his family's home. The land came to him in payment for his services as civil engineer to the city. The Miller women, his wife, Mary, and daughters, Emma and Alice, ran the Inn while Mr. Miller continued work as a surveyor.

Their eldest son, Frank, meanwhile tried to find his way in the world through a number of entrepreneurial ventures. In 1880, however, he purchased the Inn from his father for $5000, and began his career as the "Master of the Inn."

The warm climate and rich opportunities of California began to lure people from around the world. Some were rich tourists, others serious investors in search of a dream. By 1900 Riverside was a major tourist attraction. Frank Miller tried for a number of years to get the funding necessary to move the Glenwood into a more auspicious hotel. In 1902 his work began to bear fruit. With a plan by Arthur B. Benton and the financial underwriting of Henry E. Huntington a four-story hotel in the Mission Revival style was built, open on one side and surrounding a central courtyard. Success added upon success, and over the next three decades three more additions were made.

In 1910 the Cloister Wing was built, adding guest rooms and public spaces. The Spanish Wing, designed by Myron Hunt, was added in 1913-1914, including the Spanish Patio, a large Spanish Art Gallery to exhibit parts of Miller's collection, and some guest rooms. Additional guest rooms and Miller's private suite were added in the 1920s. The addition of the International Rotunda Wing in the 1931 took the Inn to the limits of the city block on which it was situated.

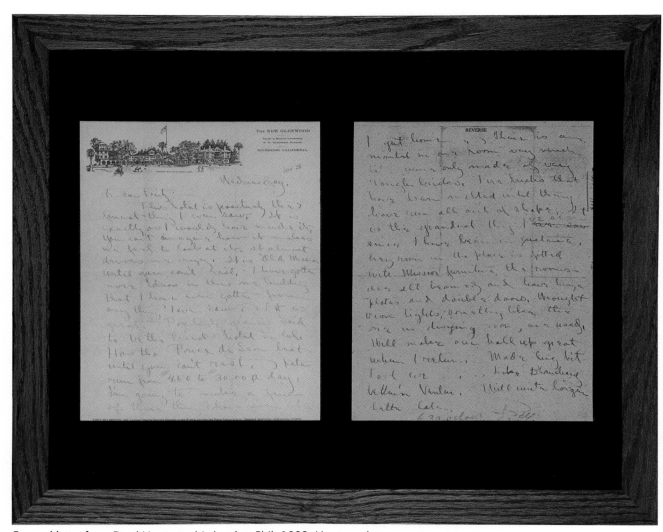

Framed letter from Dard Hunter to his brother Phil, 1903. Hunter writes in part: "This hotel is possibly the finest thing I ever saw. It is exactly as I would have made it. You can't imagine how it makes me feel to look at it. It almost drives me crazy." *Courtesy of Dard Hunter III.*

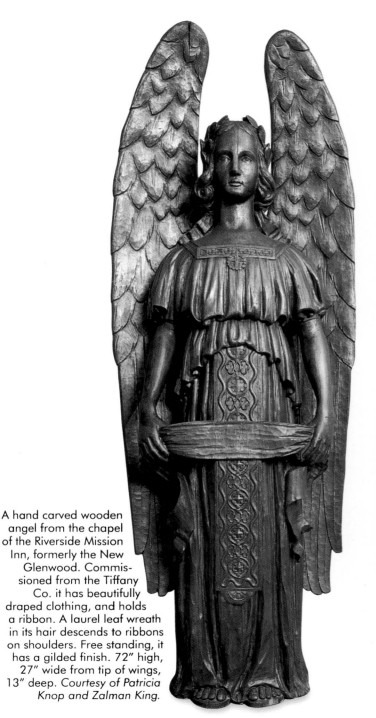

A hand carved wooden angel from the chapel of the Riverside Mission Inn, formerly the New Glenwood. Commissioned from the Tiffany Co. it has beautifully draped clothing, and holds a ribbon. A laurel leaf wreath in its hair descends to ribbons on shoulders. Free standing, it has a gilded finish. 72" high, 27" wide from tip of wings, 13" deep. *Courtesy of Patricia Knop and Zalman King.*

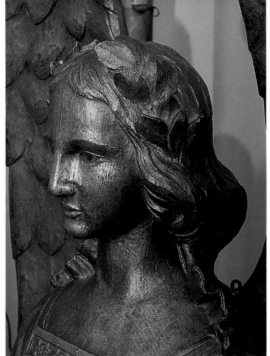

These were glory days for the Inn, bringing national and international recognition and praise. In 1929 Miller received the Order of the Rising Sun in recognition of his work in support of Riverside's Japanese American community and his work to bridge the gaps between Japan and the United States.

The decline set in after Frank Miller died in 1935. The hard realities of the Depression took their toll on tourism and despite the efforts of his daughter and son-in-law, Allis and DeWitt Miller, the business had a difficult time staying profitable. When they died in the early 1950s, their heirs were uninterested in maintaining the Inn and sold it in 1956. A series of owners during the next twenty years oversaw its continuing deterioration.

In 1976 the Riverside Redevelopment Agency purchased the Inn and consigned its operations to the Mission Inn Foundation, which was incorporated for that purpose. The hotel closed for renovations in 1985, a project that was expected to take two years. Two weeks before its completion in late 1988, the owner/developer Carley Capital of Madison, Wisconsin, filed for bankruptcy. An exhaustive search was undertaken to find an appropriate buyer during the following years. Finally, in 1992, Duane R. Roberts, a long time Riverside resident, formed the corporation that completed the purchase. On December 30, 1992, The Historic Mission Inn Corporation opened the hotel doors to the public once again.

The Foundation and its curatorial staff operate the Mission Inn Museum within the hotel. Assisted by volunteers, the Museum is open seven days a week, 9:30 a.m. to 4:00 p.m., and features permanent exhibits from the Mission Inn Collection, as well as frequent temporary exhibits.

Dard Hunter, a renowned designer of the Arts and Crafts Movement, worked at Roycroft before going off on his own. In 1903 he visited the Glenwood and wrote this letter to his brother Phil in 1903

Dear Fritz:

This hotel [The New Glenwood in Riverside, California] is positively the finest thing I ever saw. It is exactly as I would have made it. You can't imagine how it makes me feel to look at it. It almost drives me crazy. It is "Old Mission" until you can't rest. I have gotten more ideas in this one building than I have gotten from anything I ever saw. It is great. Positively grand . . . I'm going to make a few of these things I have seen when I get home. There is a mantel in one room very much like mine only made of very rough bricks. Fire bricks that have been melted until they have run all out of shape. It is the grandest thing I've seen since I have been in existence. Every room in the place is fitted with Mission furniture, the rooms are all beamed and have hinge plates and double doors. Wrought iron lights, something like the one in the dining room, are used. Will make our hall up great when I return 6:30 o'clock.

Bill, 1903.

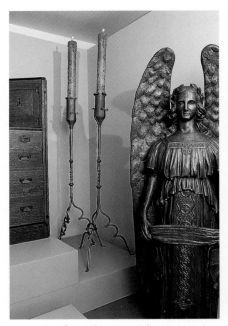

Also from the Riverside Mission Inn is this pair of floor lamps. The wooden candlesticks are painted gold with vine design (red and green), on a gilded iron candle holder, The three feet have an interesting design of repeating arches. 82" high. *Courtesy of Jerry Harrington Antiques.*

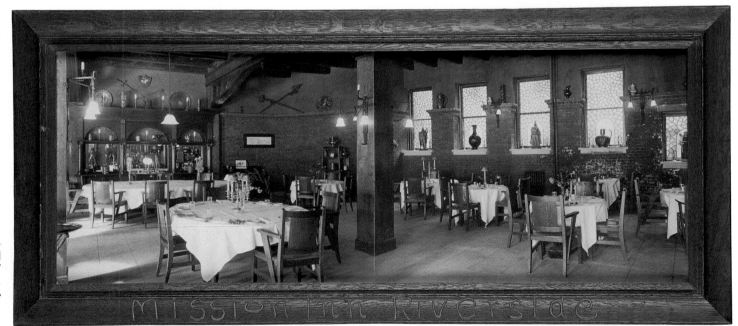

Mission Inn photograph in original frame, ca. 1900. 10" high, 22" wide. *Courtesy of Clare Carlson Porter.*

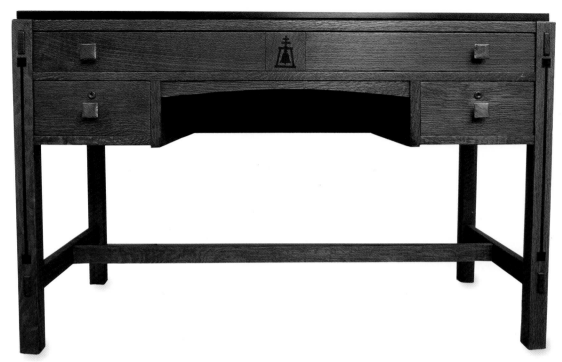

Limbert, New Glenwood (before Riverside) Mission Inn three-drawer oak writing desk. The Mission logo is inlaid into the center of top drawer and on the legs with ebony. It has copper pulls and through tenon construction. 29" high, 42-3/4" wide, 20-1/2" deep. *Courtesy of Voorhees Craftsman.*

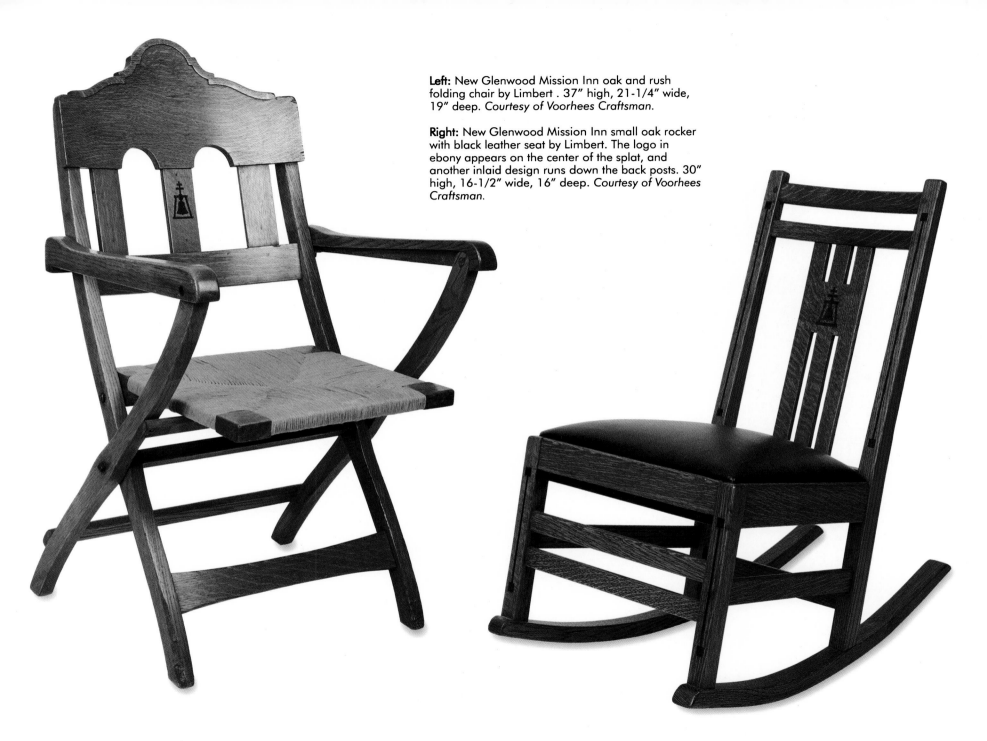

Left: New Glenwood Mission Inn oak and rush folding chair by Limbert . 37" high, 21-1/4" wide, 19" deep. *Courtesy of Voorhees Craftsman.*

Right: New Glenwood Mission Inn small oak rocker with black leather seat by Limbert. The logo in ebony appears on the center of the splat, and another inlaid design runs down the back posts. 30" high, 16-1/2" wide, 16" deep. *Courtesy of Voorhees Craftsman.*

The Craftsman, December 1912, Volume XXIII, Number 3, featuring a drawing of the Bell Court of the Mission Inn on its back cover. Beneath the drawing is a quote from David Starr Jordan, the President of Stanford at the time: "It has been left for you, Frank Miller, a genuine Californian, to dream of the hotel that ought to be, to turn your ideal into plaster and stone, and to give us in mountain-belted Riverside the one hotel which a Californian recognizes as his own." *Courtesy of Voorhees Craftsman.*

California Mission Architecture by Julius J. Hecht, published in Los Angeles, ca. 1920. *Courtesy of Clare Carlson Porter.*

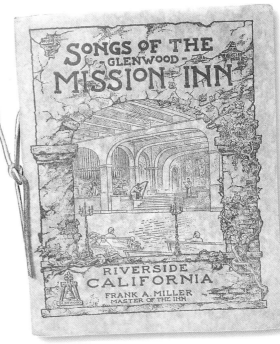

Songs of the Glenwood Mission Inn, Frank A. Miller, Master of the Inn, Riverside, California, 1913. Courtesy of Clare Carlson Porter.

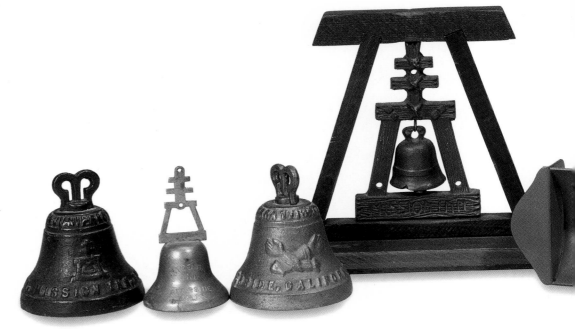

Above: Left: three Mission Inn bells, in brass; center: a Mission Inn door knocker in wood stand; right: Heintz bronze small tray with sterling Mission Inn logo. 6-1/4" wide. *Courtesy of Clare Carlson Porter and a private collection, Santa Monica.*

Below: Mission Inn bronze nut bowl. 2" high by 5" dia. *Courtesy of David DeLucca.*

Riverside Mission Inn pottery vase, Camino Real symbol, 10-1/4" high. *Courtesy of Jim & Jill West, Circa 1910 Antiques.*

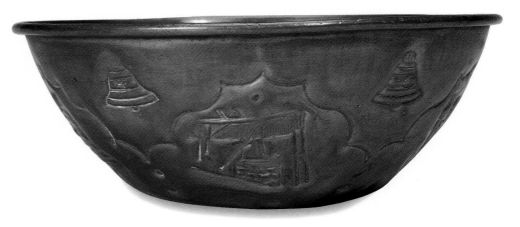

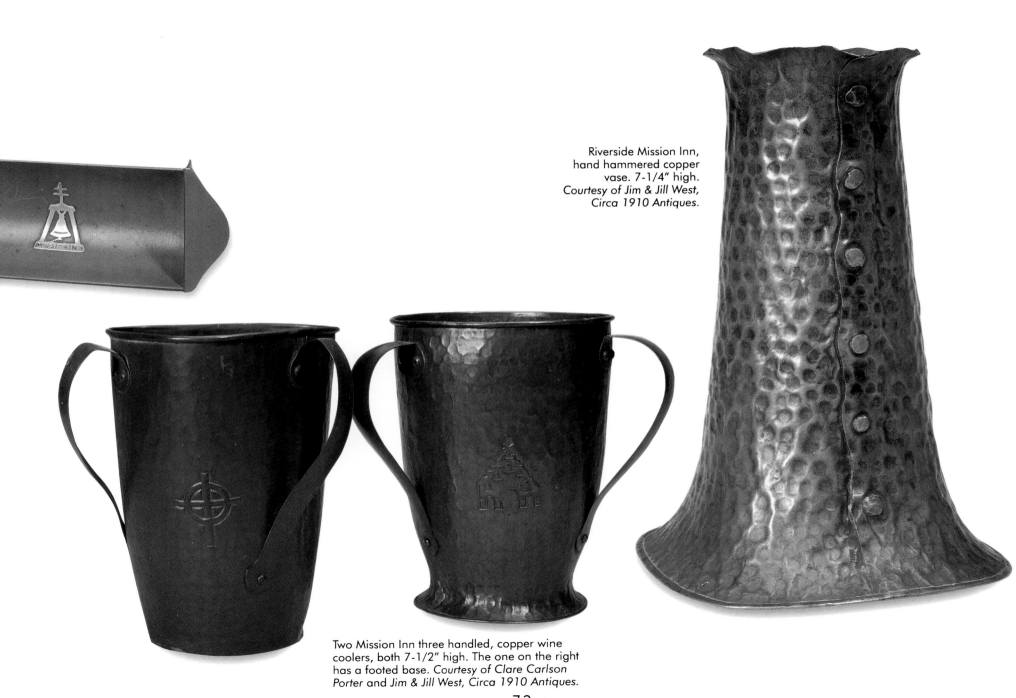

Riverside Mission Inn,
hand hammered copper
vase. 7-1/4" high.
*Courtesy of Jim & Jill West,
Circa 1910 Antiques.*

Two Mission Inn three handled, copper wine
coolers, both 7-1/2" high. The one on the right
has a footed base. *Courtesy of Clare Carlson
Porter and Jim & Jill West, Circa 1910 Antiques.*

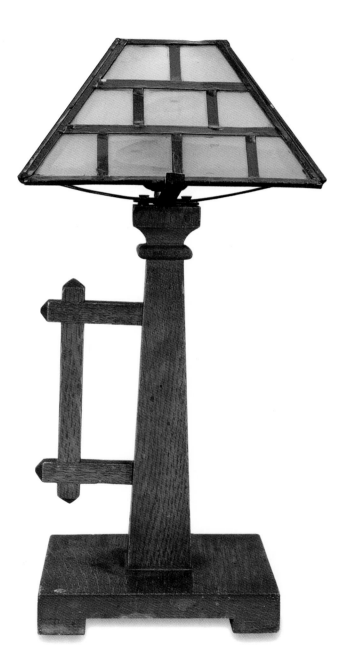

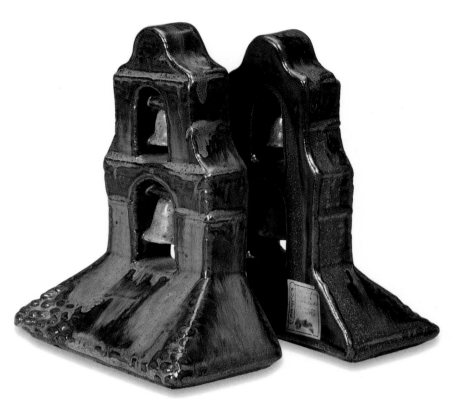

Fulper Pottery bookends in the shape of Pala Mission, high glaze, 7-1/2" tall. *Courtesy of David Nunley and Carol Davis.*

Riverside Mission Inn oak table lamp, with faux leaded glass shade, 16" high. *Courtesy of the Mission Inn Museum Collection, Riverside, California.*

Chapter 2
METAL WARES

Though in retrospect the richly patinated copper of a van Erp vase seems to epitomize the Arts & Crafts Movement, in truth the medium of metal work was a latecomer to the creative mix. In England, C.R. Ashbee established metal work as one of the crafts in the Guild of Handicrafts, which he founded as early as 1888. In America, most of the training and manufacturing of metal wares took place in large factories, such as Gorham.

That slowly changed as the new century approached. At Hull House, founded in 1889 by Jane Addams and Ellen Gates Starr after a visit to Ashbee's guild and school, metal smithing was taught beginning in 1899. In the early years of the twentieth century formal classes began in the art schools. Pratt Institute and the Rhode Island School of Design both introduced programs in early 1901, followed by the Art Institute of Chicago and the Pennsylvania Museum School of Industrial Arts, both in 1903.

Two of the more productive sources of metal wares, Gustav Stickley and Roycroft, both entered the field out of necessity. Stickley's work began with the heavy copper and brass hardware for his furniture. It was expanded to include a wide range of lighting fixtures, dishes, vases, plates and more, as well as iron work for fireplace equipment and architectural pieces. In the 1910 catalog, Stickley writes,

...in the Craftsman scheme of interior decoration and furnishing there is a well-defined place for the right kind of metal work. In fact, the need for following out Craftsman designs in making all manner of household articles soon became as great as the original need for making furniture trim...[R]ooms finished with beams and wainscot in the Craftsman style needed the mellow glint of copper and brass here and there in lighting fixtures, lamps, and the like. As the glittering lacquered surfaces and more or less fantastic designs of machine-made fixtures were entirely out of harmony, we began to make lanterns of copper and brass after simple structural designs...and such articles as chafing dishes, trays, jardinières, umbrella stands and desk sets, our effort being all the time to keep articles within the bounds of the useful, letting their decorative value grow out of their fitness for that use and the quality of the design and workmanship.

In the case of Roycroft, metal work was produced by local craftsmen to provide the hardware needed for the construction of the Roycroft buildings and the pulls and hinges needed for the furniture manufactured there. Strictly utilitarian, the design of Roycroft metal wares did not blossom until the arrival of Karl Kipp in 1908.

On the West Coast, Dirk van Erp settled in San Francisco in 1886 to work in the shipyards. In 1900 he began to create unique vessels from brass shell casings. The San Francisco galleries showed his work and by 1908 he had established his own studio.

Following 1910, art metal had become an established craft, with a broad patronage. The product of these artists continues to command the respect and admiration of today's collectors.

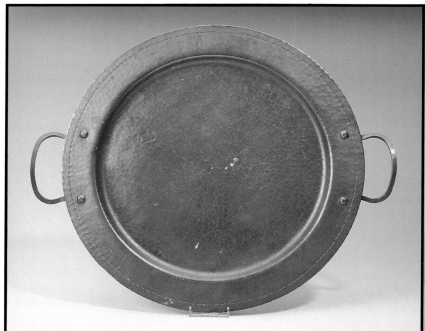

Top left: Roycroft serving tray, cat. no. 806. 16" dia. *Courtesy of a pri-vate collector.* **Above:** Roycroft copper tray, cat. no. C601G, 9" x 13". *Courtesy of a private collector.* **Below Left:** Roycroft copper tray, 8" dia. *Courtesy of a private collector.*

Roycroft

The beginnings of metalcraft at Roycroft were strictly utilitarian. At the turn of the century, the community that Elbert Hubbard was building needed hardware. To meet this need, Hubbard brought in local craftsmen to manufacture hinges, andirons, lighting, and hardware for the furniture. Having brought together a group of talented individuals, Hubbard, with his keen eye for business opportunities, began to offer their goods for sale. A rather thick and crudely fashioned copper tray and a letter opener appear in the 1906 furniture catalog, the first in a large line of copper items. The Copper Shop continued to turn out similar items until 1909 when Karl Kipp and Walter U. Jennings moved from the Roycroft book bindery to begin designing metal wares. Kipp was innately talented as a designer, and is generally credited with bringing a new creative energy to the copper shop. Jennings, formerly the manager of a knitting mill, who was drawn to Roycroft by Hubbard's writings, added organizational skills to the effort. Together they built the Copper Shop into a formidable enterprise with a broad list of creative products.

Both Kipp and Jennings left for a time to start their own company, the Tookay Shop. They returned, however, in 1915, after Hubbard's death. In the years that followed, a national marketing strategy by Elbert Hubbard II distributed Roycroft to retailers in virtually every major community.

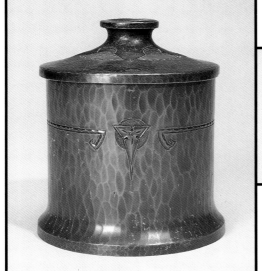

Roycroft copper humidor.
*Courtesy of Adrienne and
Steve Fayne.*

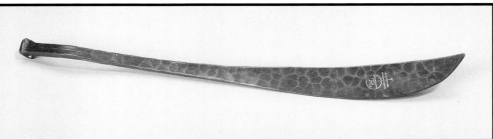

Roycroft copper letter
opener, cat. no. 507,
made from a copper
spike, 9-1/4" long.
*Courtesy of a private
collector.*

Roycroft desk set: desk pad,
calendar, letter rack, stamp
box, pen tray, letter opener,
and blotter. *Courtesy of a
private collector.*

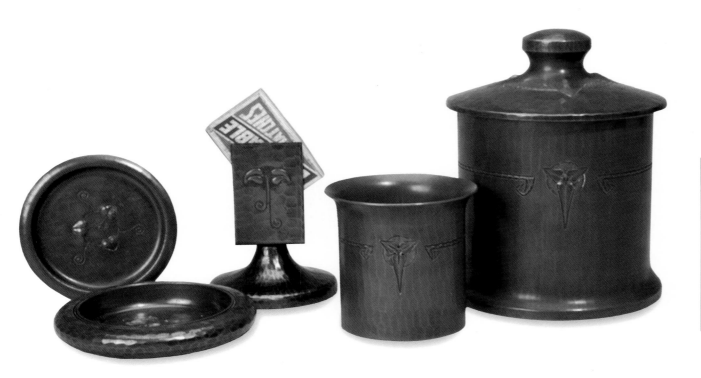

Left: Roycroft set of four copper nesting ashtrays with pattern cat. no. 614A, matchbox holder, cigarette cup, tobacco humidor number C601E. *Courtesy of a private collector.*

Lower left: Copper Roycroft incense burner and card tray. *Courtesy of a private collector.*

Lower right: Roycroft copper book-ends, cat. no. 301. *Courtesy of a private collector.*

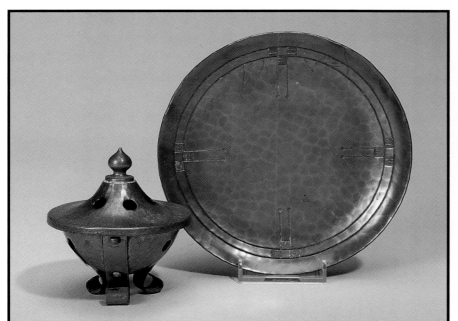

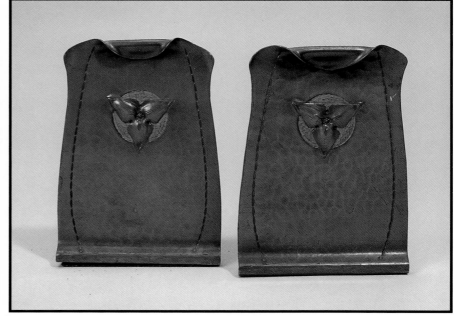

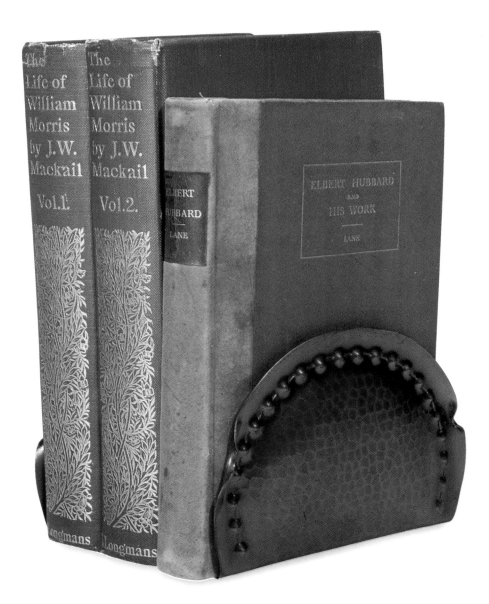

Roycroft copper bookends, cat. no. 335. The books include *Elbert Hubbard and His Work*, by Lane, 1901, and *The Life of William Morris* by J.W. Mackail, volumes 1 & 2, 1899. *Courtesy of a private collector.*

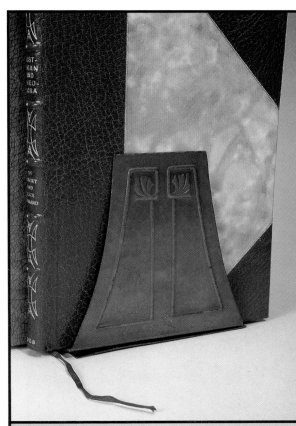

Left: Roycroft copper bookends. *Courtesy of a private collector.*

Below: Roycroft copper bookends, peacock design. 4" high, 6" wide, 3" deep, cat. no. 307. *Courtesy of a private collector.*

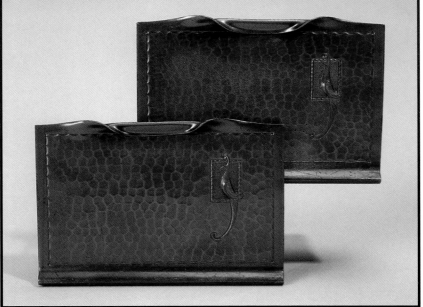

Right: Roycroft copper bookends, cat. no. 316. *Courtesy of a private collector.*

Below: Roycroft copper bookends for the *Little Journeys* books. *Courtesy of a private collector.*

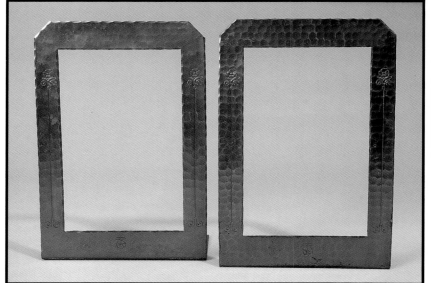

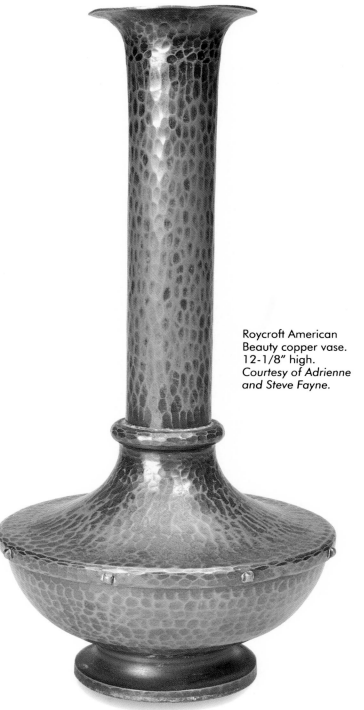

Roycroft American Beauty copper vase. 12-1/8" high. *Courtesy of Adrienne and Steve Fayne.*

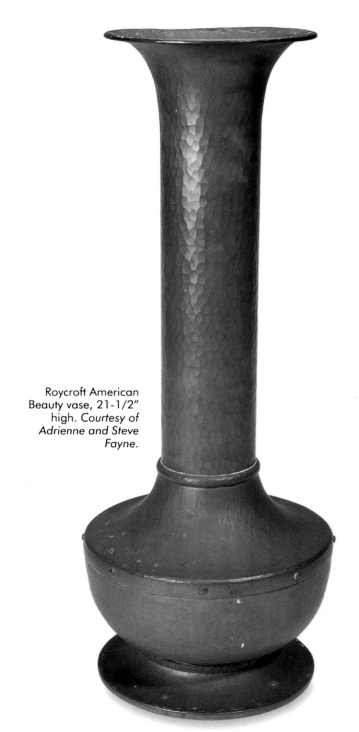

Roycroft American Beauty vase, 21-1/2" high. *Courtesy of Adrienne and Steve Fayne.*

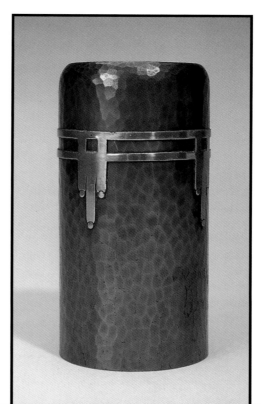

Left: Roycroft copper vase with applied German silver, 6-1/2" high, marked (cat. no.) 203. *Courtesy of a private collector.*

Below: *Left:* Roycroft copper bowl. 2-5/8" high, 6-1/2" dia. *Center:* Roycroft copper bowl. 3-1/8" high, 4" dia. *Right:* Roycroft copper bowl. 4-3/4" high, 4-3/4" dia. *Courtesy of a private collector.*

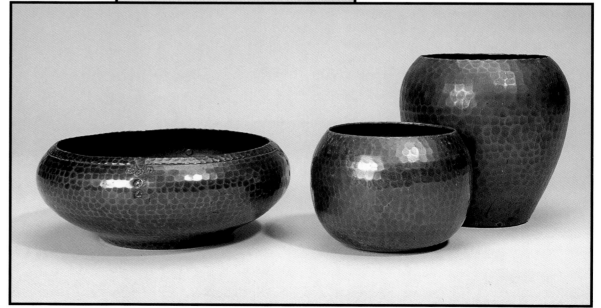

Stickley Brothers

Albert Stickley had opened a copper workshop near Grand Rapids by 1904. Like his brother, Gustav, his designs reflected the English crafts. Unlike Gustav or the Roycrofters, the origin of the copper shop was not utilitarian. According to Bruce Johnson (*The Official Price Guide to Arts and Crafts,* p. 372) he continued to outsource his furniture hardware to commercial firms. He employed Russian immigrant craftsmen to make decorative pieces such as lamps, trays, ewers, and vases.

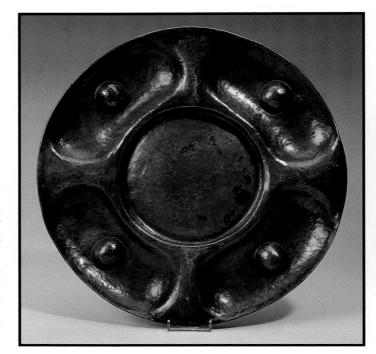

Sculpted Stickley Bros. copper plaque or tray, cat. no. 36. 14-1/2" dia. *Courtesy of Clare Carlson Porter.*

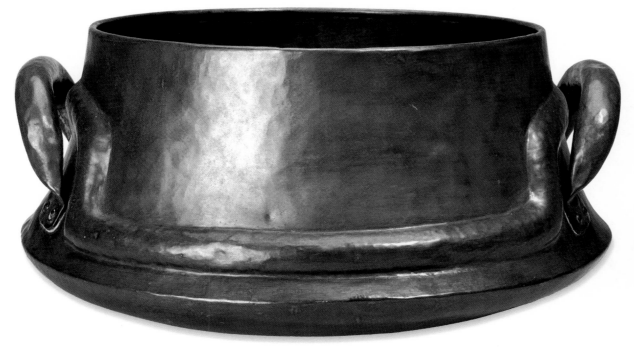

Stickley Brothers copper jardiniere with handles, number 71. 18" dia. *Courtesy of Jack Moore's Pasadena Antiques.*

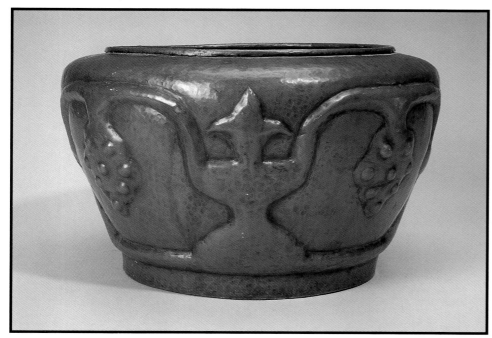

Stickley Bros. copper jardiniere. 6-1/2" high, 10" dia. *Courtesy of Clare Carlson Porter.*

Stickley Bros. copper jardiniere, 7-3/4" high, 13-3/4" dia. *Courtesy of Isak Lindenauer.*

Dirk van Erp

Dirk van Erp was born in Leeuwarden, the Netherlands in 1859, the oldest of seven children. His first exposure to metalwork was in the family hardware business. At 26 he left for America, settling in San Francisco, where he used his skills as a metalworker in the Navy shipyards on Mare Island.

At home his interests were more creative. In 1900 he began to produce art metal wares from brass shell casings. Art dealers in the San Francisco were impressed enough by his art to carry it in their shops.

In 1908 van Erp opened the Copper Shop in Oakland, which had moved to San Francisco by 1910. In 1908 Harry Saint John Dixon, who later would open his own shop, apprenticed with van Erp. Elizabeth Eleanor D'arcy Gaw, a Canadian, worked in the San Francisco studio for a period of 11 months. Their names appear together on a windmill trademark that he adopted. Though of short duration, Gaw has been credited with bringing a new level of sophistication to van Erp's work that continued for years. She returned to interior decorating in 1911.

Van Erp's work was all hand-wrought, the hammered surface being the only decorative feature. His "warty" textured vases are highly sought after, and especially with the red finish achieved by the annealing process.

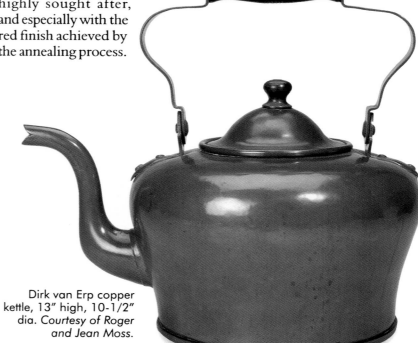

Dirk van Erp copper kettle, 13" high, 10-1/2" dia. *Courtesy of Roger and Jean Moss.*

85

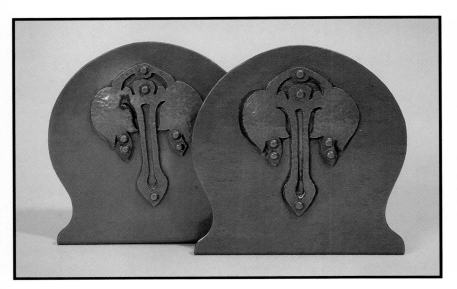

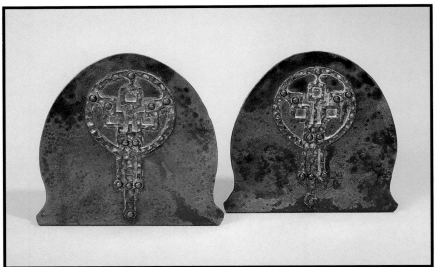

Far left: Dirk van Erp bookends with applied, floral design. 5" high, 5" wide. *Courtesy of Roger and Jean Moss.*

Left: Dirk van Erp bookends with applied, abstract design. 5-1/2" high, 5-1/2 wide. *Courtesy of Roger and Jean Moss.*

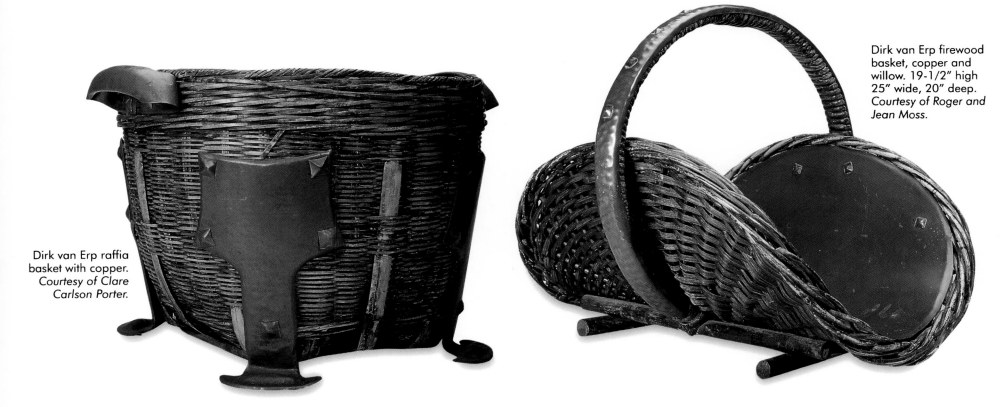

Dirk van Erp raffia basket with copper. *Courtesy of Clare Carlson Porter.*

Dirk van Erp firewood basket, copper and willow. 19-1/2" high 25" wide, 20" deep. *Courtesy of Roger and Jean Moss.*

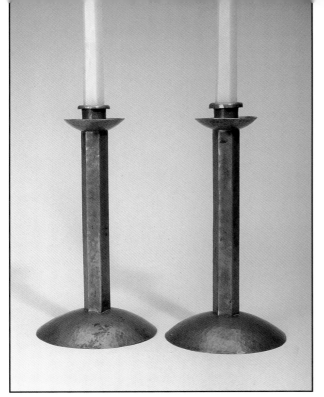

Right & far right:
Dirk van Erp copper candlesticks with open bottoms, unmarked. An anecdote is told that the hollow shaft was the original design, but after a church fire caused by the candle burning down, van Erp filled the hole. 10" high. *Courtesy of Caro Tanner Macpherson.*

Below right:
Left: Dirk van Erp brass shell casing vase, 8" high. *Courtesy of Roger and Jean Moss.*
Center: Dirk van Erp brass shell casing vase, 5" high. *Courtesy of a private collector.*
Right: Dirk van Erp brass shell casing vase, 6-1/2" high. *Courtesy of a private collector.*
All ca. 1905

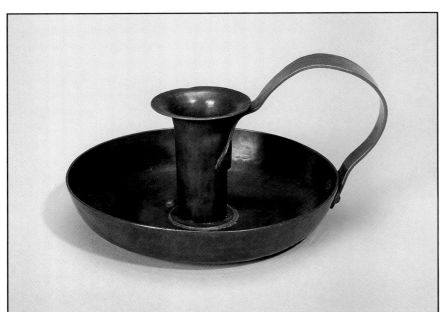

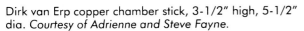

Dirk van Erp copper chamber stick, 3-1/2" high, 5-1/2" dia. *Courtesy of Adrienne and Steve Fayne.*

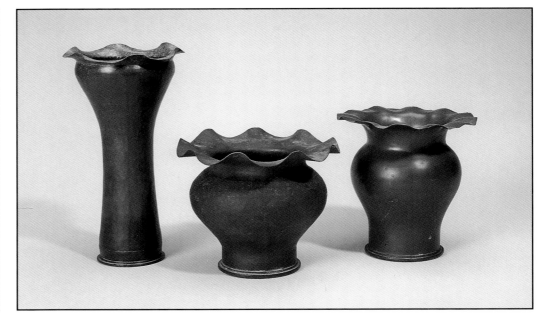

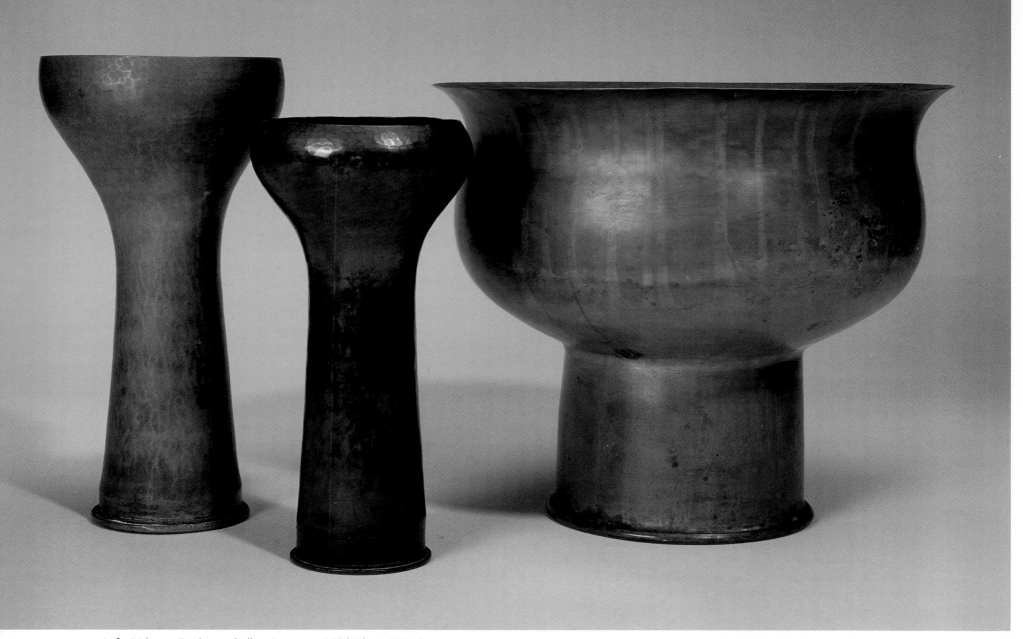

Left: Dirk van Erp brass shell casing vase, 10" high, 4-1/4" dia. ca. 1909. *Courtesy of Jack Moore's Pasadena Antiques.*
Center: Dirk van Erp brass shell casing vase, 8" high, 4" dia. *Courtesy of Voorhees Craftsman.*
Right: Dirk van Erp brass shell casing vase, 8-3/4" high, 10" dia. *Courtesy of Jack Moore's Pasadena Antiques.*

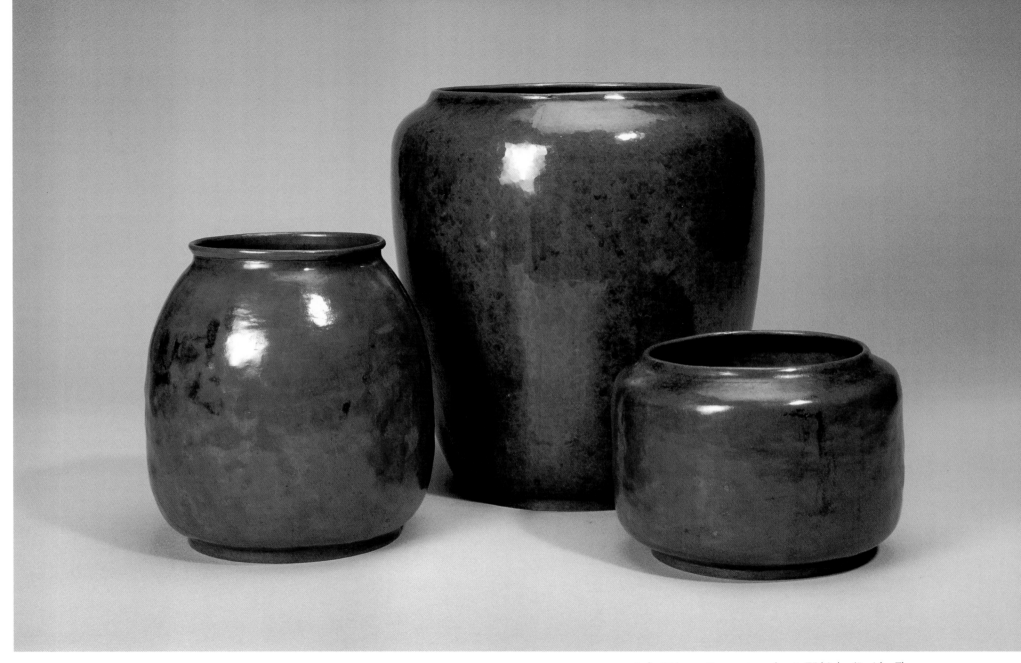

Left: Dirk van Erp warty red pot, 7" high, 6" wide. The mouth is off-round with a dip in the rim.
Center: Dirk van Erp vase. 10" high, 9-1/2" wide.
Right: Dirk van Erp warty red pot. 4-1/2" high, 6" wide.
Courtesy of Roger and Jean Moss.

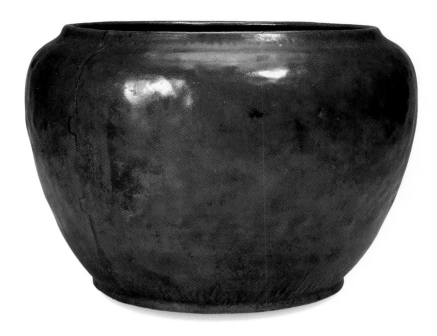

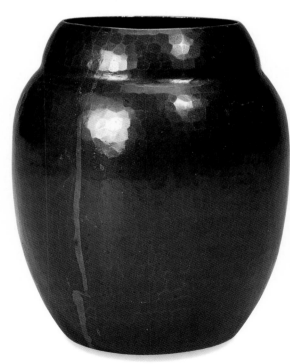

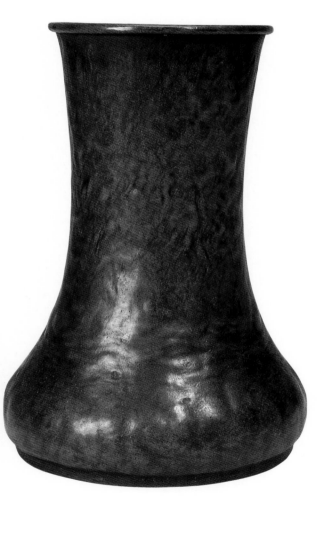

Above: Dirk van Erp warty red bowl. 7-1/2" high, 10-1/2" wide. *Courtesy of Adrienne and Steve Fayne.*

Right: Dirk van Erp ginger jar. 4-1/2" high, 3-3/4" wide. *Courtesy of Roger and Jean Moss.*

Far right: Dirk van Erp warty vase. 7" high, 5" wide. *Courtesy of Roger and Jean Moss.*

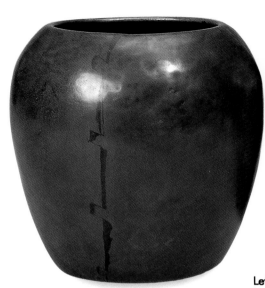

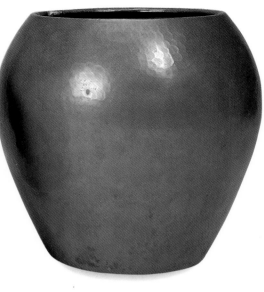

Left: Dirk van Erp copper bowl. 6-1/2"
high. *Courtesy of a private collection,
Santa Monica.*
Right: Dirk van Erp copper bowl. 7-1/4"
high. *Courtesy of Roger and Jean Moss.*

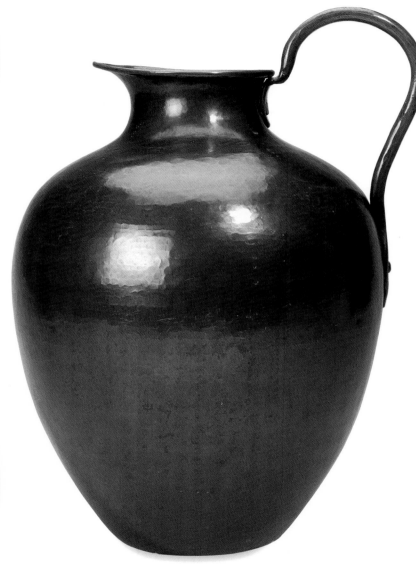

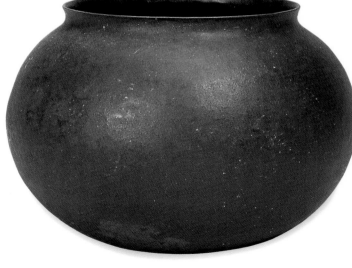

Dirk van Erp, copper bowl with patina. 3-1/2" high,
5-1/2" wide. *Courtesy of Clare Carlson Porter.*

Dirk van Erp ewer. 12-1/2" high.
Courtesy of Roger and Jean Moss.

Old Mission Kopper Kraft
Jauchen's Ye Olde Copper Shop
Brosi's Ye Olde Copper Shoppe

Hans W. Jauchen, born in Germany, and Fred T. Brosi, an Italian native, worked together in the Old Mission Kopper Kraft from about 1922 to 1925. Before and after, they were involved in a number of other metalsmith businesses, including the two similarly named companies represented here. Old Mission manufacturing was located in San Jose, with the retail outlet in San Francisco. Brosi died in 1935, Jauchen in 1970.

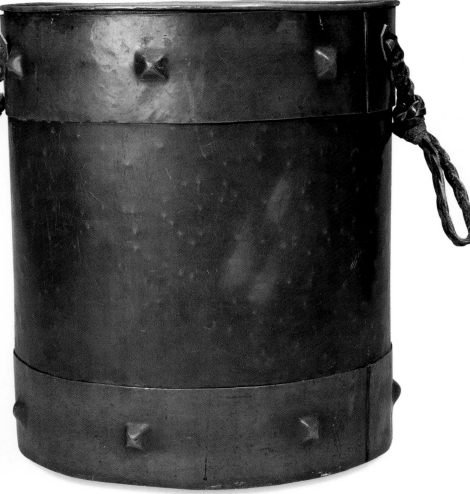

Above: Jauchen copper basket, 14" high, 11" dia. *Courtesy of Clare Carlson Porter.*

Left: Jauchen's Ye Olde Copper Shop, letter holder with applied eucalyptus leaf motif, 4-1/4" high, 6-1/4" wide. *Courtesy of Gary Keith.*

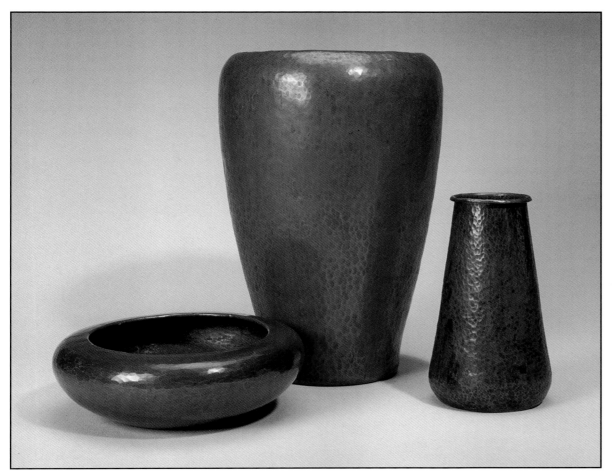

Hans Jauchen's Ye Olde Copper Shop, vases
Left: 3" high, 8-1/2" wide, marked Stock #20/204. *Courtesy of Roger and Jean Moss.*
Center: 12" high. *Courtesy of Adrienne and Steve Fayne.*
Right: 7" high. *Courtesy of a private collection, Santa Monica.*

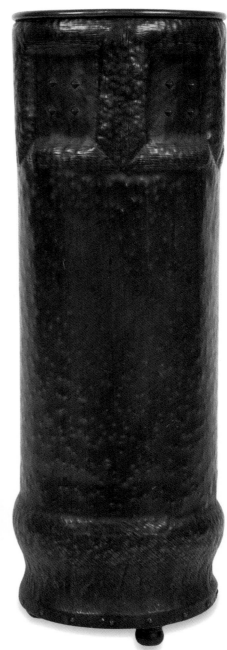

Brosi copper umbrella stand. 26" high, 8-1/2" dia. *Courtesy of a private collection, Santa Monica.*

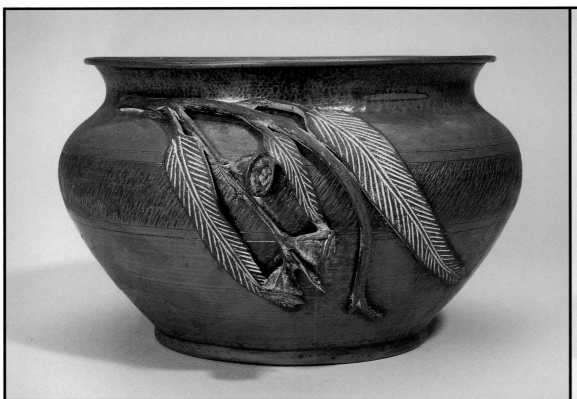

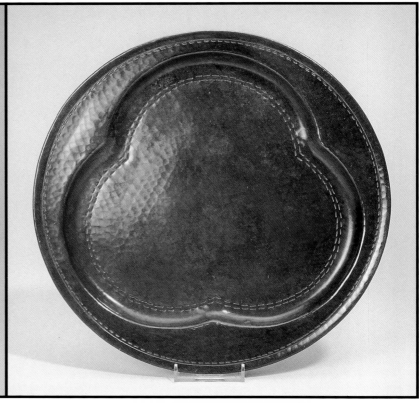

Fred Brosi, Ye Olde Copper Shoppe planter with applied eucalyptus leaf motif, 5-1/2" high. *Courtesy of Gary Keith.*

Old Mission Kopper Kraft serving tray, 10-1/2" dia. *Courtesy of Roger and Jean Moss.*

94

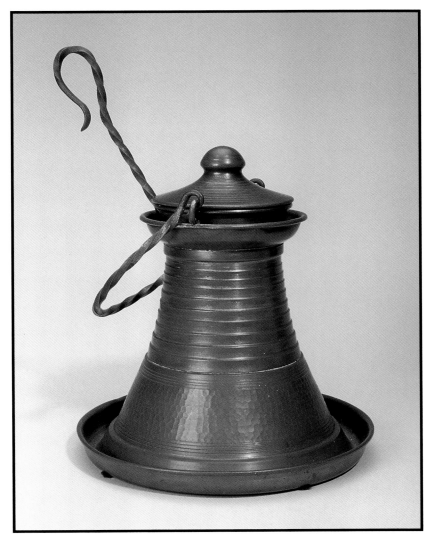

Old Mission Kopper Kraft fireplace starter, three pieces, marked with Old Mission logo, 9" high. *Courtesy of Clare Carlson Porter.*

Heintz Art Metal Shop

Otto and Edwin Heintz, brothers, joined the Art Crafts Shop, a jewelry business, at the turn of the century. By 1906 they owned the business and changed its name to Heintz Art Metal Shop. It was well known for its copper and bronze work, especially with the sterling inlay shown here. They made bowls, vases, lamps, desk sets, trophies, and picture frames as well as jewelry. Production ended in the early years of the Depression.

Heintz sterling on bronze vase, 12-1/2" high, marked (cat. no.) 3809A. *Courtesy of a private collection, Santa Monica.*

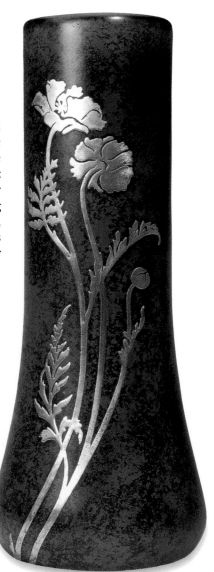

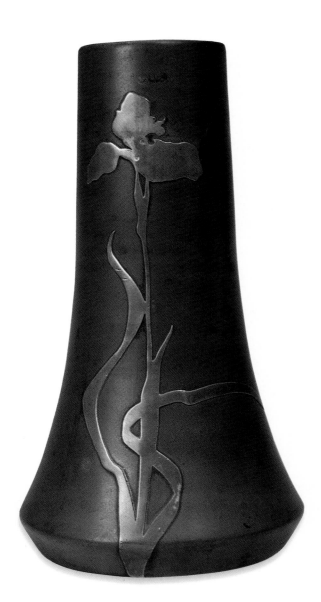
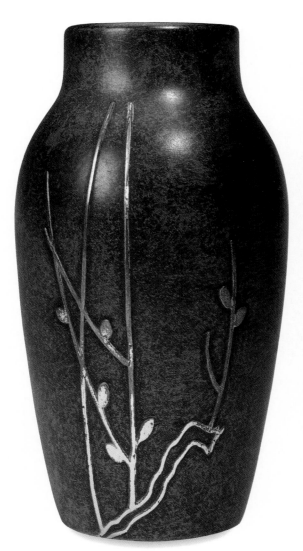
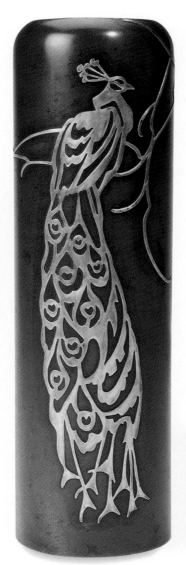

Left: Heintz sterling on bronze vase, 8-3/4" high, marked (cat. no.) 3595. *Courtesy of a private collection, Santa Monica.*
Center: Heintz sterling on bronze vase, 7" high, marked (cat. no.) 3662C. *Courtesy of a private collection, Santa Monica.*
Right: Heintz sterling on bronze peacock vase. 10" high. *Courtesy of Caro Tanner Macpherson.*

The Jarvie Shop

Robert R. Jarvie was a prominent Chicago metalsmith interested in candlesticks and lanterns, as well as copper bowls. By 1906 his candlesticks were in outlets in ten states.

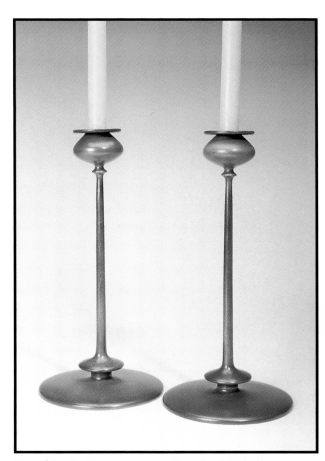

Pair of Jarvie-Beta copper candlesticks, 13" high. *Courtesy of Jim & Jill West, Circa 1910 Antiques.*

Tiffany Studios

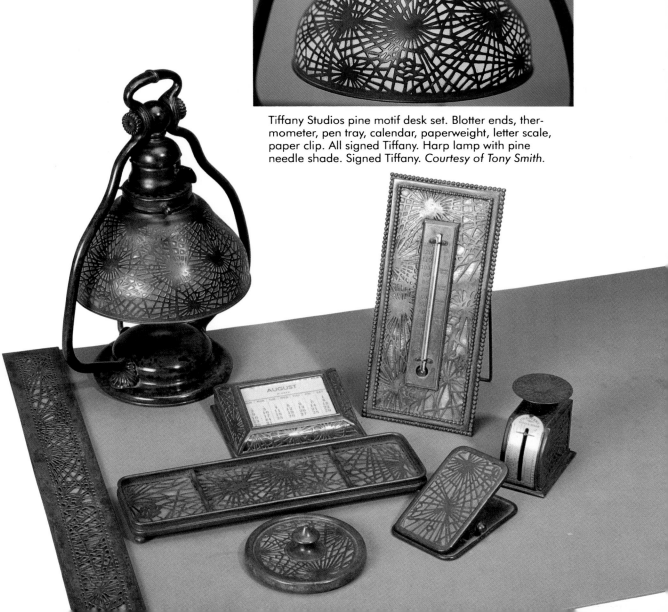

Tiffany Studios pine motif desk set. Blotter ends, thermometer, pen tray, calendar, paperweight, letter scale, paper clip. All signed Tiffany. Harp lamp with pine needle shade. Signed Tiffany. *Courtesy of Tony Smith.*

Carence Crafters

This little known company is identified with Chicago Arts and Crafts. It produced copper, brass, and silver vessels with natural designs acid etched into the surface.

Harry Saint John Dixon

Born in 1890, Dixon studied with van Erp in 1908. For several years he worked for various metal shops before opening his own in 1920. He used natural design motifs, marking them with a stamp of a man forging a bowl.

Carence Crafters copper frame, acid etched, stylized roses. *Courtesy of Gary Keith.*

Harry Dixon copper vase, 7-1/2" high, 7" dia. *Courtesy of a private collection, Santa Monica.*

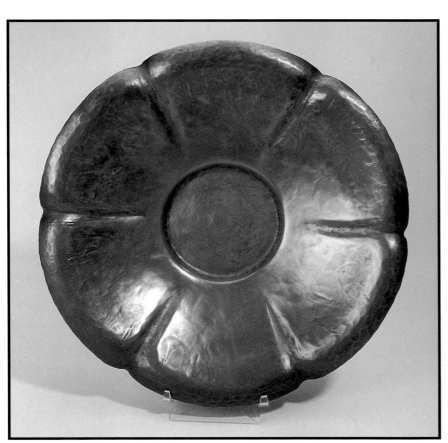

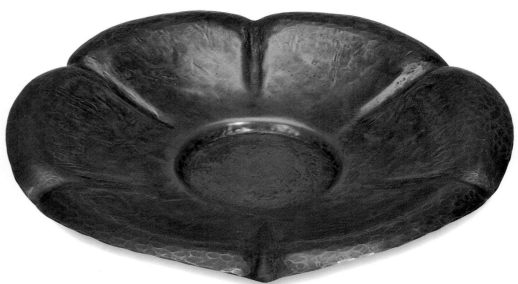

Harry Dixon poppy shaped low bowl, copper, 14"
dia., marked Harry Dixon, cartouche, San
Francisco. *Courtesy of Caro Tanner Macpherson.*

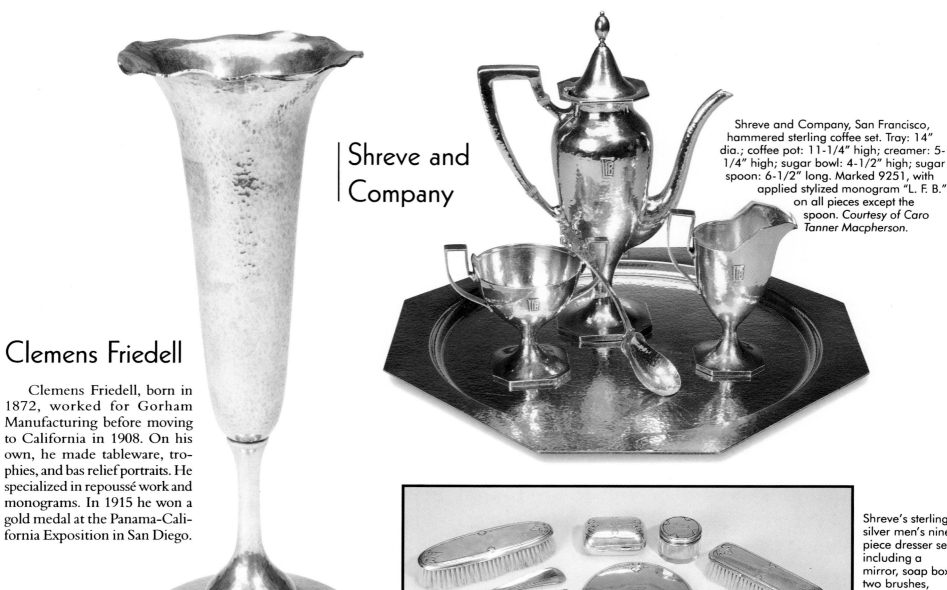

Shreve and Company

Shreve and Company, San Francisco, hammered sterling coffee set. Tray: 14" dia.; coffee pot: 11-1/4" high; creamer: 5-1/4" high; sugar bowl: 4-1/2" high; sugar spoon: 6-1/2" long. Marked 9251, with applied stylized monogram "L. F. B." on all pieces except the spoon. *Courtesy of Caro Tanner Macpherson.*

Clemens Friedell

Clemens Friedell, born in 1872, worked for Gorham Manufacturing before moving to California in 1908. On his own, he made tableware, trophies, and bas relief portraits. He specialized in repoussé work and monograms. In 1915 he won a gold medal at the Panama-California Exposition in San Diego.

Friedell sterling vase, Pasadena, California. 10" high. *Courtesy of Voorhees Craftsman.*

Shreve's sterling silver men's nine piece dresser set, including a mirror, soap box, two brushes, comb, shoehorn, nail file, buffer, hair pomade jar, monogrammed "M" or "N". *Courtesy of Caro Tanner Macpherson.*

Joseph Heinrichs

Heinrichs was active in New York City around 1910.

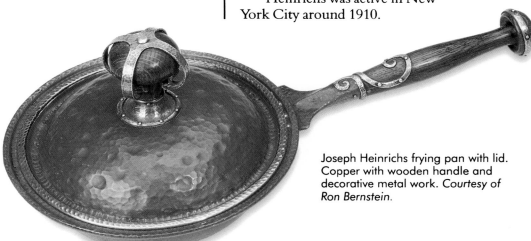

Joseph Heinrichs frying pan with lid. Copper with wooden handle and decorative metal work. *Courtesy of Ron Bernstein.*

Albert Berry's Craft Shop

Having exhibited in Boston in 1899, Berry moved to Alaska where he lived until 1918. Moving to Seattle he then started the Albert Berry Craft Shop, making unusual, high quality copper goods, many of which incorporated other natural materials. He was active until about 1930.

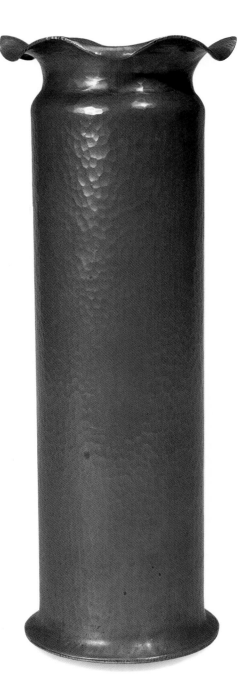

Cylindrical copper vase, 11-1/2" high, marked Berry's Craftshop, Seattle. *Courtesy of Voorhees Craftsman.*

Other Manufacturers

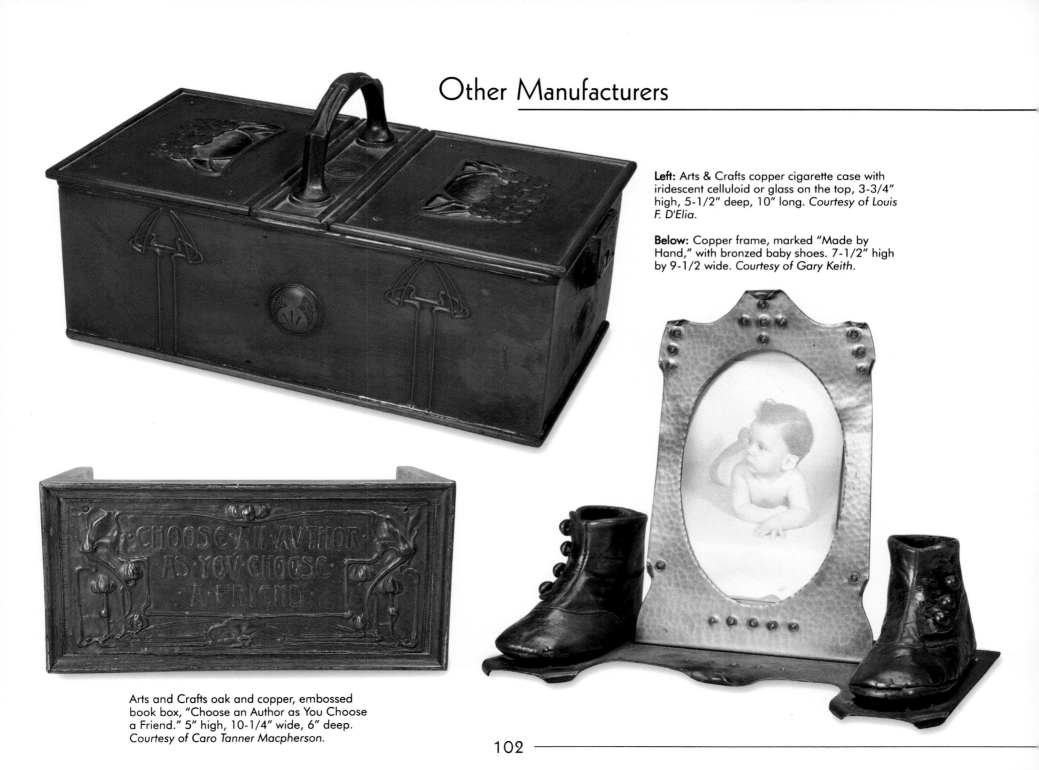

Left: Arts & Crafts copper cigarette case with iridescent celluloid or glass on the top, 3-3/4" high, 5-1/2" deep, 10" long. *Courtesy of Louis F. D'Elia.*

Below: Copper frame, marked "Made by Hand," with bronzed baby shoes. 7-1/2" high by 9-1/2 wide. *Courtesy of Gary Keith.*

Arts and Crafts oak and copper, embossed book box, "Choose an Author as You Choose a Friend." 5" high, 10-1/4" wide, 6" deep. *Courtesy of Caro Tanner Macpherson.*

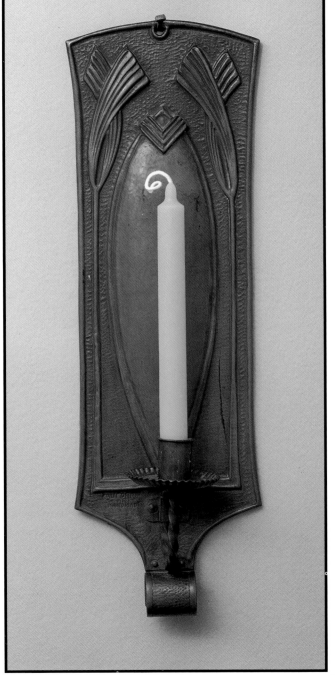

California Art hand made copper candle sconce. 19" high, 6" wide. *Courtesy of Jack Moore's Pasadena Antiques.*

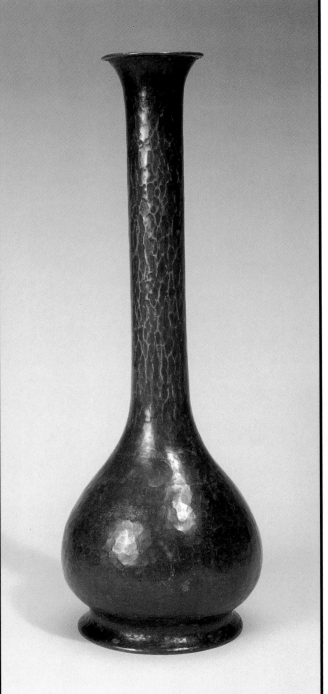

Armenac Hairenian tall-necked copper vase with original red brown/green patina. 14-1/2" high, marked on bottom. *Courtesy of Caro Tanner Macpherson.*

Chapter 3
POTTERY & CERAMICS

The growth of Art Pottery at the end of the nineteenth century is one of the most highly valued expressions of the Arts & Crafts Movement. Ironically it was also one of its most purely "artistic" expressions. Up until this time the pottery made in America was strictly utilitarian: stoneware crocks, bottles, candleholders, tableware; redware dishes, cups, baking ware; yellow ware mixing bowls and pitchers. While many of the pieces were intrinsically beautiful, often showing the creative flair of their makers, they were meant for everyday use in the kitchen or dining room. In a sense this early American pottery was the precursor of the Arts & Crafts Movement.

This is not to say that there was not an ample supply of artistic pottery. Prior to 1870, imports from England, Germany, France, and Asia could be found in nearly every respectable home. Their purpose was more decorative than utilitarian, and often they expressed the same sort of gaudiness that was evidenced in Victorian furniture.

But soon an indigenous Art Pottery movement began to develop: Alexander and Hugh Robertson, Chelsea Keramic Studio, Boston, 1872; Mary Louise McLaughlin, Losanti, Cincinnati, 1877; Mary Longworth Nichols, Rookwood, Cincinnati, 1880; George Ohr, Beloxi, Mississippi, 1880; T.J. Wheatley, Cincinnati, 1880; Alexander Robertson and Linna Irelan, Roblin Art Pottery, San Francisco, 1884; William Gates, Terra Cotta, Illinois, 1886; Theolphilus Brouwer, Long Island, New York, 1894; William Grueby, Boston, 1894. These and many more potters began experimenting with clays, glazes, and forms to create a pottery that would be truly an artistic expression of their own creativity.

By the end of the nineteenth century it became clear to many art educators that there was a need for an American art pottery. Schools began adding pottery programs to their curricula. Charles Binns came from England to direct the pottery program at the Trenton Technical School of Science and Art and supervise the operations of its sponsor, the Ceramic Art Company, later to become Lenox China. When Alfred University began the New York School of Clayworking and Ceramics in 1900 they called Binns as its first director.

From that position he would have a far reaching influence on a generation of potters, enhanced even more by his seminal writings in the field. Other schools followed suit, including Newcomb College in New Orleans, the Art Institute of Chicago, The Pratt Institute, and the Pennsylvania Museum School of Industrial Art among others.

In 1904 Dr. Herbert Hall opened a sanatorium in Marblehead, Massachusetts for those suffering from mental illness. As one of the therapies, which he also hoped would help finance the hospital, he opened a pottery, led by Arthur Baggs, a student of Binns. Other health and social institutions followed suit: Arequipa Pottery in Northern California, initially directed by Frederick Rhead; Halycon Pottery headed by Alexander Robertson, and part of a utopian community in Pismo Beach, California; The Saturday Evening Girls, of Boston, directed by Thomas Nickerson.

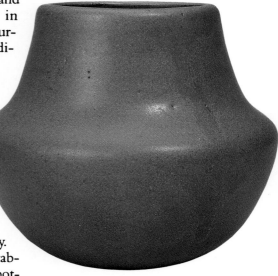

Many more small potteries would be born in the early years of the twentieth century, most with direct connections back to these earlier times. These include Ernest Batchelder of Batchelder Tile, William V. Bragdon and Chauncey R. Thomas of California Faience, Artus van Briggle, Abraham Fulper of Fulper Pottery. They and many others helped establish a tradition in American art pottery that continues to this day.

Arequipa pot. 5" high. *Courtesy of Roger and Jean Moss.*

Arequipa

Fairfax, California

Dr. Philip King Brown began the Arequipa Tuberculosis Sanitorium at Fairfax, California, in 1911, as a nursing facility for young women. To help them pass the long hours of recuperative time creatively, he began programs of therapy that included basket weaving, loom weaving, typing, and other activities, none of which proved entirely satisfactory. Hearing of the programs at Marblehead (Marblehead Pottery) and in the North End of Boston (the Saturday Evening Girls), Brown decided that a pottery might provide the outlet he needed, and produce some income for the continuance of the Sanatorium.

He brought Frederick H. Rhead to help organize the program. Rhead had been trained as a potter by his father in England before coming to work in a number of American potteries, including Avon, Weller, Roseville, and Jervis. He set up the pottery and trained the young women to do every task that their strength allowed. It was good therapy, but not profitable. Rhead left in 1914, being replaced by Albert L. Solon, who moved the pottery closer to success. He was followed by F.H. Wilde, who reorganized the pottery and put it on a better footing. Just when success seemed at hand, World War I placed its demands on the economy and the pottery closed its doors in 1918. The Sanitorium continued in operation until 1957.

Most Arequipa pottery was made from local clays in kilns using fuel. Pieces were thrown, pressed, or cast. Some were glazed and some had incised or raised designs. Pieces had a thick, sturdy look.

Arequipa vase with embossed grapevine design. Mark 259/19, 7" high. *Courtesy of Roger and Jean Moss.*

California Faience

Berkeley, California

California Faience was the final incarnation of the enterprise of William V. Bragdon and Chauncey R. Thomas. Bragdon received his training in ceramics at Alfred, and worked at University City Porcelain Works in St. Louis before going west. Thomas specialized in metalwork and was a teacher. Their initial partnership was Bragdon and Thomas, founded in Berkeley in 1916. In 1922 the shop moved to a new site and was renamed *The Tile Shop*, though they made art pottery as well as tile. In 1924 the name was changed to *California Faience*, though the impression mark *"California Faience"* had already been in use.

They made handpress-molded tiles with polychrome decorations and pottery that was cast and generally covered with monochrome matte glaze.

Production of art pottery ended around 1930. In the late thirties Bragdon purchased Thomas's interest and ran the pottery as a studio for local artists and decorators. He sold the business in the mid-1950s. He died in 1959.

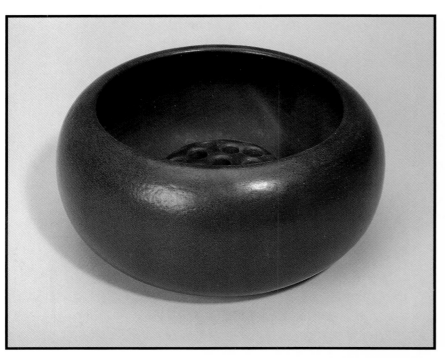

California Faience vase with frog inside. *Courtesy of Brandon Allen.*

California Faience tea tile with iris design, matte finish. 5-1/2" dia. *Courtesy of Caro Tanner Macpherson.*

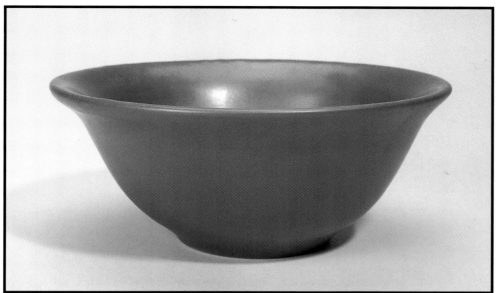

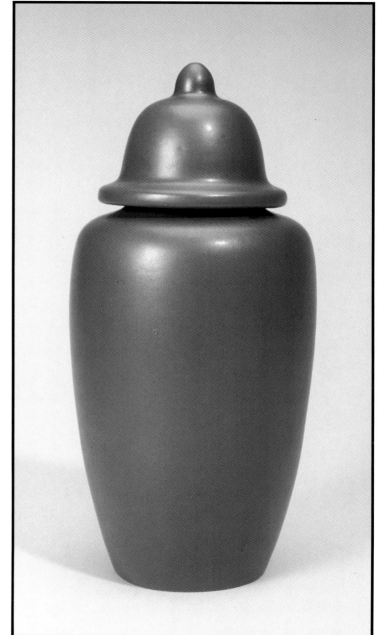

Above: California Faience matte finish bowl. 3-1/4" high, 7-3/4" wide. *Courtesy of Brandon Allen.*

Right: California Faience pot, matte gold. 3-1/2" high, 5" wide. *Courtesy of Caro Tanner Macpherson.*

Far right: California Faience temple jar with lid. 10" high. *Courtesy of Brandon Allen.*

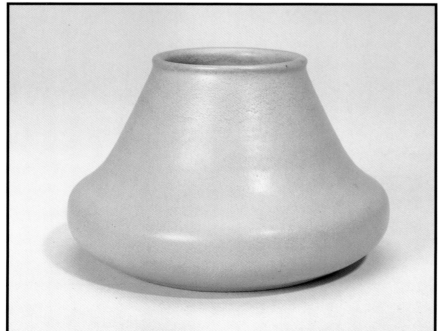

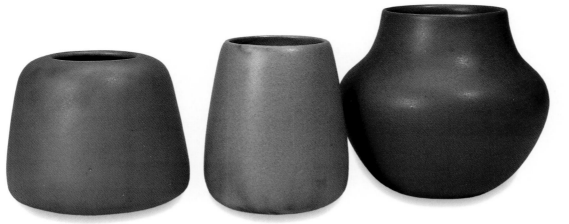

Left:
Left: California Faience red-brown pot. 4-1/4" high, 4-3/4" wide.
Center: California Faience brown pot. 4-3/4" high, 4" wide.
Right: California Faience red-brown pot. 5-1/2" high, 6" wide. *Courtesy of Brandon Allen.*

Below: California Faience tile. 6" x 6". *Courtesy of Tony Smith.*

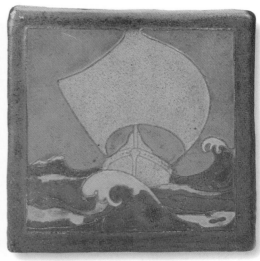

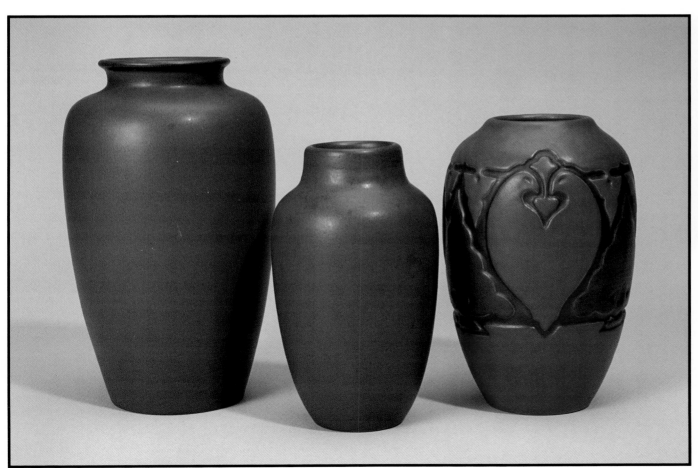

Left:
Left: California Faience blue vase. 8" high, 4-1/2" wide. *Courtesy of Gary Keith.*
Center: California Faience blue vase. 6" high, 3-1/2" wide. *Courtesy of Brandon Allen.*
Right: California Faience, decorated vase. 6-1/2" high, 4" wide. *Courtesy of Brandon Allen.*

Chelsea Keramic Art Works

Chelsea, Massachusetts

Established in 1866 by Alexander W. Robertson in Chelsea, Massachusetts, who was later joined by his brother, Hugh Cornwall Robertson in 1868, and his father and brother, George, in 1872. Hugh was to continue the company after Alexander moved to California in 1884. He was also behind many of the innovative glazes that came out of CKAW, including the renowned Oxblood glaze (Sand de Bouef), along with other experimental glazes. Despite these innovations CKAW failed to be profitable, and closed its doors in 1889. Robertson went to work for the Low Tile Company, an art tile company owned by John G. Low, who had once worked for CKAW. He stayed only a short time, going to Morrisville, Pennsylvania, in 1890 to help his brother, George, start the Robertson Art Tile Company. In 1891 a group of businessmen in Boston established the Chelsea Pottery U.S., and brought Hugh back to manage it. In 1895 the pottery moved to Dedham, Massachusetts, and changed its name to the Dedham Pottery. He continued to develop glazes, perfecting the craquelle glaze that he used on many of his wares, including the blue-in-glaze border decorations for which Dedham is recognized.

Hugh Robertson died in 1908.

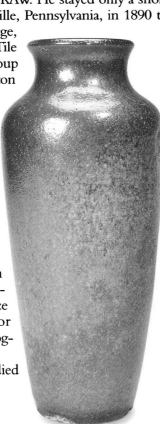

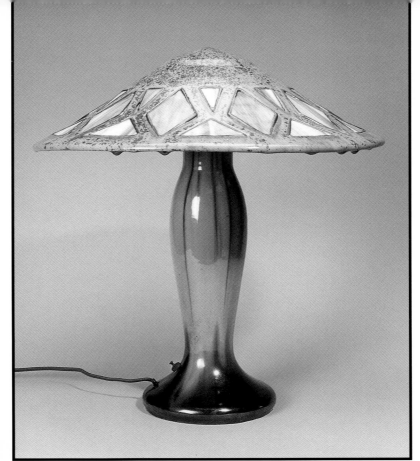

Above: Fulper blue flambe lamp with ceramic and glass shade. Shade: 18" dia.; Base: 19-1/2" high. *Courtesy of Jack Moore's Pasadena Antiques.*

Left: Chelsea Keramic Art Works oxblood vase. 8-1/4" high. *Courtesy of Gary Keith.*

Fulper Pottery

Flemington, New Jersey

Abraham Fulper bought Samuel Hill's drain tile pottery in 1860. Fulper continued Hill's basic line before diversifying into earthenware and stoneware. When the senior Fulper died in 1881, his sons, George W., William H., and Edward B. continued the pottery. At first, Fulper made only drain tiles, but soon produced earthenware and stoneware. Vinegar jugs, pickling jars, bottles, beer mugs, butter churns, bowls, and "drinking fountains for poultry" were also produced at the pottery.

The firm was under the direction of William H. Fulper II, Abraham's grandson, by the early 1900s. Martin Stangl became Fulper's ceramics engineer in 1911, and helped invent a group of famille rose glazes, including ashes of roses, deep rose, peach bloom, old rose, and true rose. Stangl left in 1914 or 1915 to work for Haeger in Dundee, Illinois. The Fulper Pottery won several awards at the 1915 San Francisco Panama Pacific International Exposition.

The Vasekraft line was produced using classical and oriental shapes. The firm made lamps (after 1910), pottery lampshades (often set with glass), ashtrays, cigarette boxes, vases, bowls, and other giftwares. The firm also made the "Fulper Germ Proof Filter," a set of jars that held cold drinking water. They even made dolls' heads for a short time. In 1920, the firm introduced the first solid-colored glazed dinnerware produced in the United States; green was the only color used for the dinnerwares until 1930, when other colors were added.

The Fulper Pottery continued to expand, and in 1926 acquired the Anchor Pottery Company of Trenton, New Jersey. A fire in 1929 destroyed the Fulper buildings in Flemington, and the firm decided to move most of its operations to the Trenton plant. Artware was still made on a small scale in Flemington until 1935.

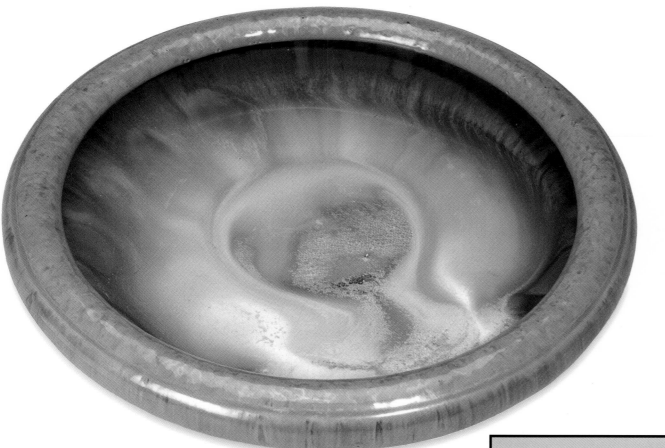

Fulper bowl, flambe with black crystalline glaze. 15-3/4"
dia. *Courtesy of Caro Tanner Macpherson.*

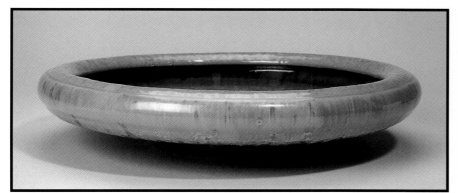

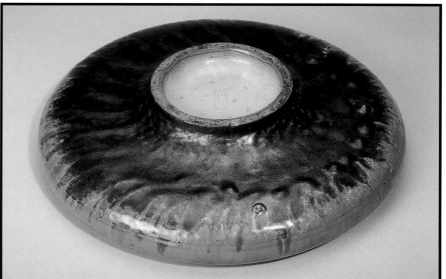

Gates Potteries

Terra Cotta, Illinois

William Day Gates was a Chicago attorney when he began the American Terra Cotta and Ceramic Company in 1886. Specializing in architectural tiles and decorative bricks, it was to be the firm foundation of Gates's entry into the art pottery field. Over the years he undertook several experiments in glazes and forms, with some pieces registered as early as 1895. In 1901, he introduced a line of art pottery he called Teco Ware, derived from Terra Cotta.

Teco Ware was produced in molds, which Gates, the practical businessman, saw as being essential for the viability of the line. Gates did much of the initial design, but also drew upon the talents of other artists and architects. They included F. Albert, W. J. Dodd, Blanche Ostertog, and Max Dunning.

Early glazes included browns, buff, and various shades of red. In 1904 a matte green glaze was added, similar to those of other potteries and advertised as a "cool, peaceful, healthful color—a tone not easily classified." This green became the predominant color in the Teco line for nearly a decade. As demand for the green began to fade in the 1910s, Gates introduced other colors, including brown, yellow, blue, rose, grey, purple, and other green tones. By 1911 there were over 500 designs in the Teco line.

The production of Teco Ware ended in the early 1920s. The company was sold to George A. Berry in 1929, and the name was changed.

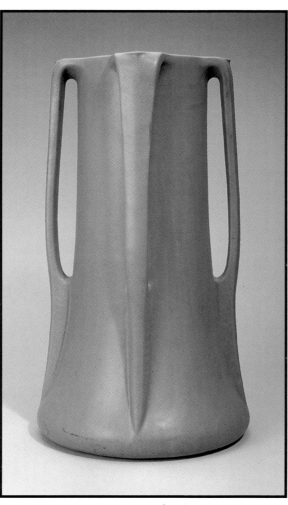

Gates Pottery Teco Ware vase, four handles, 17" high. *Courtesy of Voorhees Craftsman.*

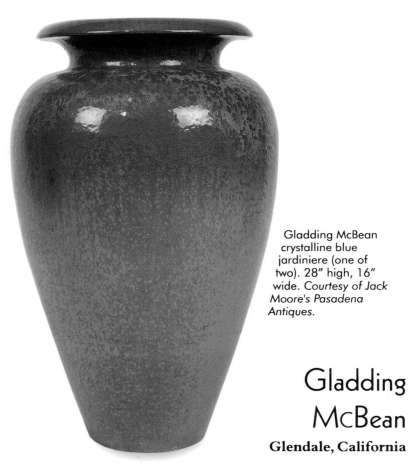

Gladding McBean crystalline blue jardiniere (one of two). 28" high, 16" wide. *Courtesy of Jack Moore's Pasadena Antiques.*

Gladding McBean

Glendale, California

Having discovered deposits of clay in Placer County, California, Charles Gladding, Peter McBean, and George Chambers established Gladding, McBean and Company, a producer of sewer tiles. In 1884 the business expanded to include architectural ceramics, eventually turning to household ceramics, culminating in the Franciscan Pottery line, which they introduced in 1934. Located in Glendale, California, the company was purchased by Wedgwood Limited. In 1984 the Glendale factory closed and all manufacturing moved to England.

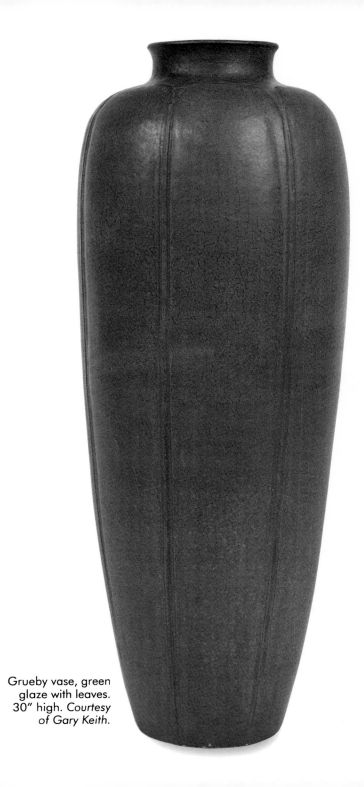

Grueby Faience Company

Boston, Massachusetts

William Grueby founded the Grueby Pottery in 1894 at the age of 27. He had received his training at the J. and J.G. Low Art Tile Works in Chelsea. After ten years he left Low to form his own business focusing on architectural terra cotta and decorative tiles. In 1897 the Grueby Faience Company was incorporated, bringing on board the design expertise of George Prentiss Kendrick, who along with William H. Graves was a partner in the new entity. With Kendrick's designs, known for their rich organic forms, and the innovative matte glazes, the genius of Grueby art pottery was recognized almost at once. Many pieces went directly from the studio to the museums. Others found their way into Tiffany lamp bases or as tiles in Gustav Stickley furniture. Grueby closed his art pottery operations in 1911, and ended operations completely upon its sale to C. Pardee Works of Perth Amboy, New Jersey in 1919.

Grueby vase, green glaze with leaves. 30" high. *Courtesy of Gary Keith.*

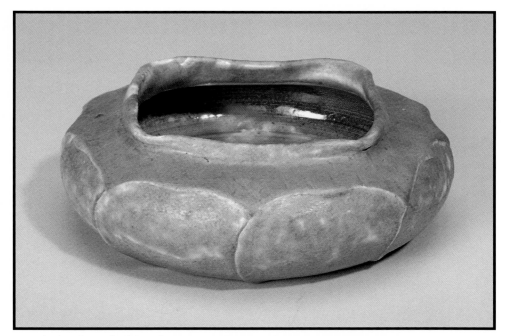

Grueby bowl, marked Grueby Faience, Boston, USA. 1-7/8" high, 5-3/4" wide. *Courtesy of Brandon Allen.*

Halcyon Art Pottery

Halcyon, California

Halcyon Art Pottery grew out of a utopian community in Halcyon, California, founded in 1903. Known as the "Temple of the People," these Theosophists created the pottery in 1910 under the direction of Alexander W. Robertson. Robertson had previously founded the Chelsea Keramic Art Works in Massachusetts in 1866. He left that in the hands of family members in 1884 and moved to San Francisco where, in 1899, he founded the Roblin Art Pottery. The Halycon Pottery's purpose was to raise money for the community, but in 1913 it closed its doors.

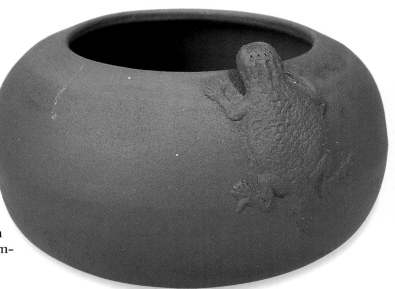

Halcyon vase, marked Halcyon. 2" high, 3-1/4" wide. *Courtesy of Brandon Allen.*

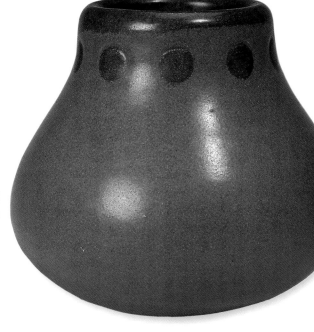

Marblehead bulbous pot. 4" high, 4-1/4" wide. *Courtesy of Brandon Allen.*

Marblehead Pottery

Marblehead, Massachusetts

Marblehead Pottery was founded in 1904 by Dr. Herbert J. Hall as one of several therapeutic activities for his patients in his Marblehead, Massachusetts sanatorium. He brought in Albert E. Baggs to run the operations. This 19-year old man from Alfred University, New York, was recommended by Charles Binns, the first director of the New York School of Clayworking and Ceramics at the University. Under Baggs's direction the Marblehead Pottery grew until, by 1908, its production reached 200 pieces per day. It had, in fact, outgrown its original purpose of providing therapy, and professional artisans were brought in to augment the patient help. By 1915 it had grown to such a size that it became disassociated from the sanatorium and came under the sole ownership of Baggs. Though its professional staff was more productive, the pottery remained small, producing hand thrown and glazed pots throughout its existence. Only six people worked at the factory in 1916. It closed its doors in 1936. Baggs began teaching at Ohio State University in 1928 and continued until his death in 1947.

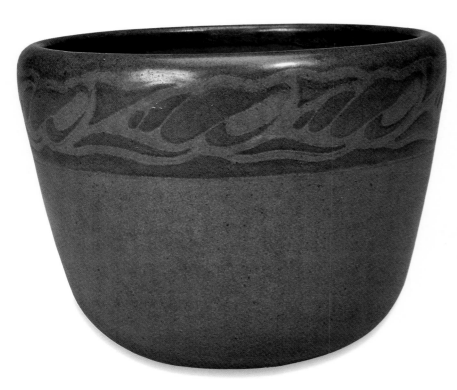

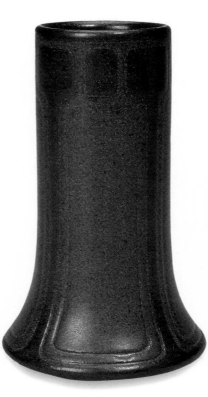

Marblehead vase, 4-1/2" high. *Courtesy of Brandon Allen.*

Above: Marblehead conch shell motif bowl, 4-3/4" high, 6-1/4" wide. *Courtesy of Brandon Allen.*

Right: Marblehead bowl, 3" high, 6" wide. *Courtesy of Brandon Allen.*

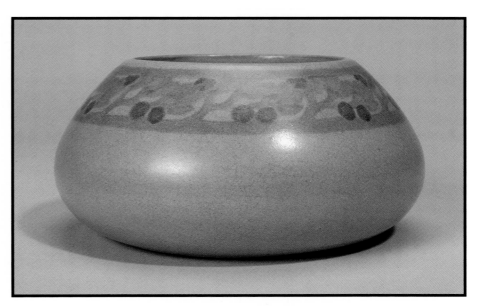

Marblehead bowl, abstract
repeating pattern at top.
3" high, 4-1/2" wide.
Courtesy of Brandon Allen.

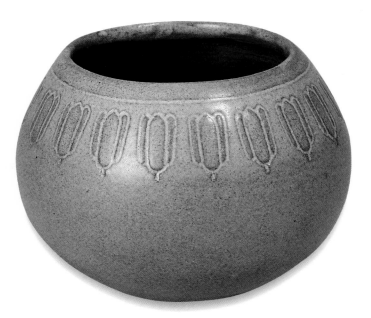

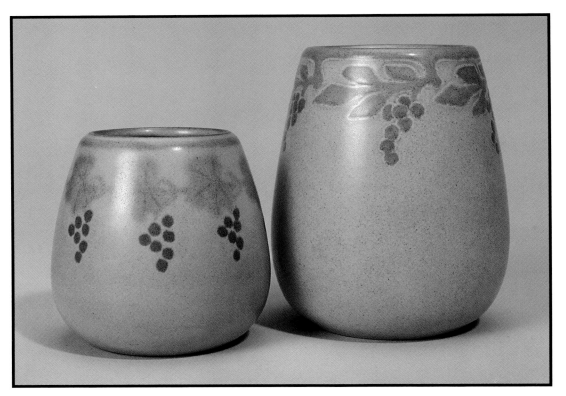

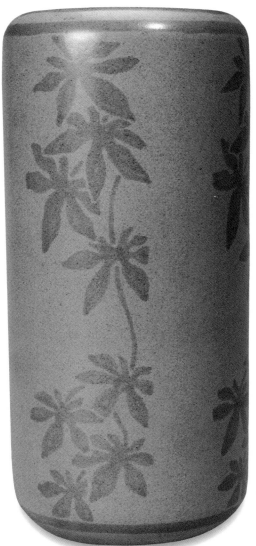

Above: Marblehead vase with foliage
design. 8-1/2" high, 4" wide.
Courtesy of Brandon Allen.

Left: *Left:* Marblehead vase, 3-1/2"
high, 3-1/4" wide.
Right: Marblehead vase, 4-1/2" high,
4-3/4" wide. *Courtesy of Brandon
Allen.*

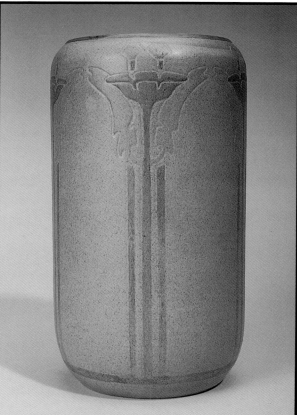

Right: Marblehead vase with flower design. 9-1/2" high, 5-1/4" wide. *Courtesy of Brandon Allen.*

Below: Marblehead bowl. 3" high, 6-1/2" wide. *Courtesy of Brandon Allen.*

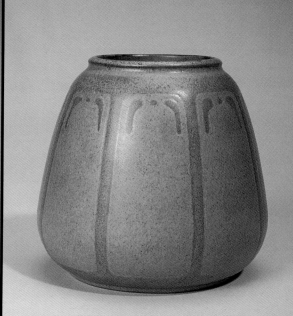

Left: Marblehead vase. 4-1/2" high, 4-1/2" wide. *Courtesy of Brandon Allen.*

Below: *Left:* Marblehead vase with moth design, 7-1/2" high, 5-1/4" wide. *Right:* Marblehead vase with wisteria design, 7-1/2" high, 5-1/4" wide. *Courtesy of Brandon Allen.*

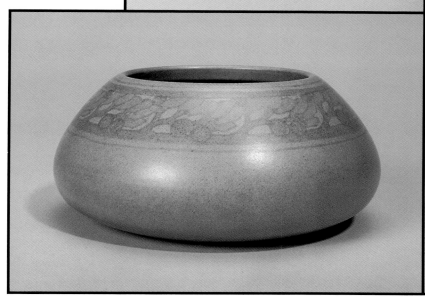

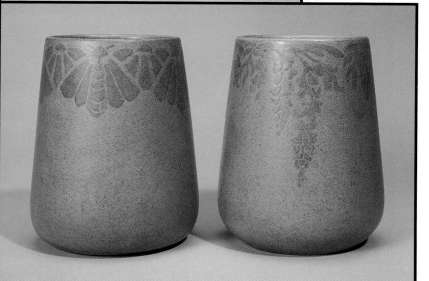

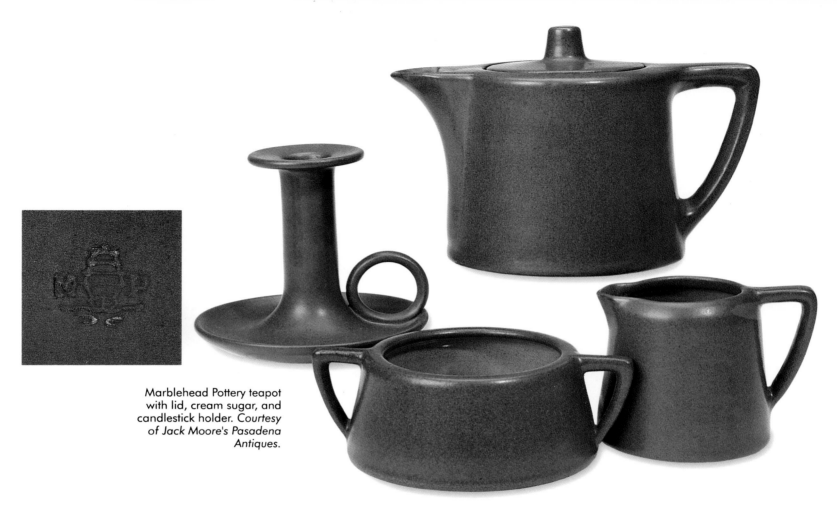

Marblehead Pottery teapot with lid, cream sugar, and candlestick holder. *Courtesy of Jack Moore's Pasadena Antiques.*

 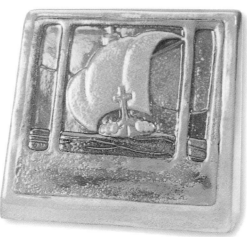

Marblehead Pottery "Ship" book blocks. 5-1/2" x 5-1/2". Marblehead mark and paper sticker on back. *Courtesy of Jack Moore's Pasadena Antiques.*

Newcomb Pottery

New Orleans, Louisiana

Newcomb Pottery was developed as part of the program at Sophia Newcomb Memorial College for Women, New Orleans, in 1895. The brainchild of Ellsworth Woodward, it was an attempt to introduce practical, marketable art education so the students would be able to find productive, meaningful work. Mary G. Sheerer, an experienced ceramicist familiar with Rookwood, was hired as co-director, and made Newcomb her life's work. Joseph Fortune Meyer was hired to run the clay shop. He would throw all the pots to Sheerer's specifications. The young women would then add the decoration. The pottery closed in 1939, though the Newcomb Guild continued to use the mark until 1948.

Newcomb College vase, high glaze, marked N inside C, S.E. Wells, UU100. 8" high. *Courtesy of Brandon Allen.*

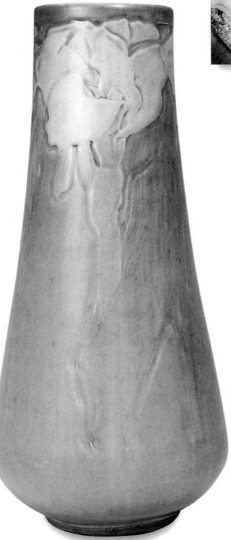

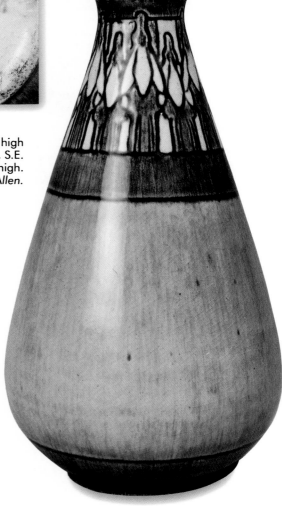

Newcomb College vase with matte floral design, incised mark N C B C, glaze mark E Y. 39, 11" high. *Courtesy of Brandon Allen.*

Paul Revere Pottery
Saturday Evening Girls

Boston, Massachusetts

In 1906 a group of Boston philanthropists, seeking to improve the lot of underprivileged young women, established The Paul Revere Pottery. Edith Brown a librarian in the North End of Boston, was the first director. At the beginning the girls gathered in the basement of an old house, and were known as the "Saturday Evening Girls." Mrs. James R. Storrow, one of the original benefactors, bought a building near Old North Church for the group, equipped with a large kiln and all the supplies that were necessary. The Saturday Evening Girls grew to about 200 young women.

The pottery that they produced had an international market, but it never produced a sustaining level of profit. Continued support Mrs. Storrow and others allowed it to remain in operation, though in 1915 the size was reduced as it moved to Brighton. In 1942 the pottery closed.

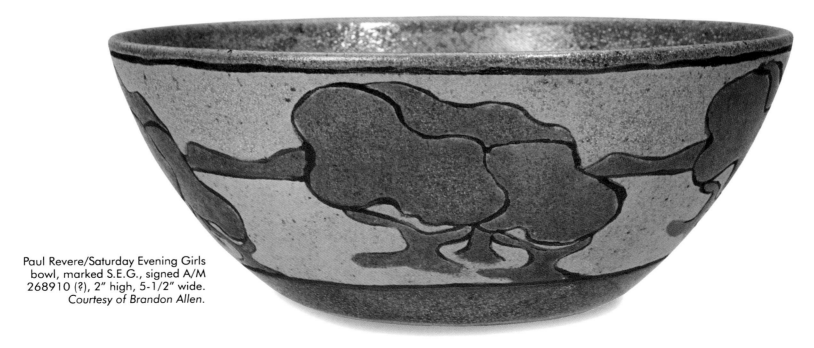

Paul Revere/Saturday Evening Girls bowl, marked S.E.G., signed A/M 268910 (?), 2" high, 5-1/2" wide. *Courtesy of Brandon Allen.*

Rhead Pottery

Santa Barbara, California

Frederick H. Rhead left Arequipa Pottery in 1913 and began a pottery in Santa Barbara with his wife. They produced large garden wares, bowls, and vases, many showing a Chinese influence. Rhead exhibited a great deal of artistic prowess, but lacked the business acumen to keep the pottery going. It closed in 1915, but Rhead continued to be an educational force in the pottery world for many years. He died in 1942.

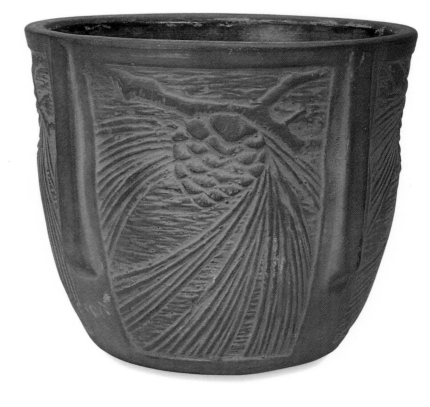

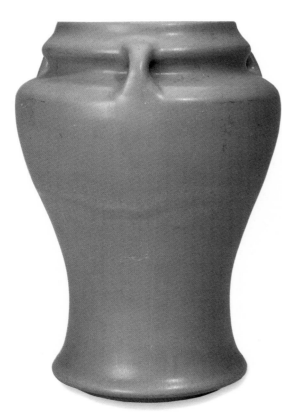

Right: Rhead vase. 8" high, 3 small handles. *Courtesy of Gary Keith.*

Above right: Rhead "acorn" vase. 5" high. *Courtesy of Louis F. D'Elia.*

Lower right: Potera & Rhead, dragonfly motif, bowl. 2" high, 6" wide. *Courtesy of Jack Moore's Pasadena Antiques.*

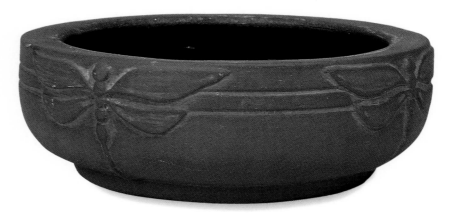

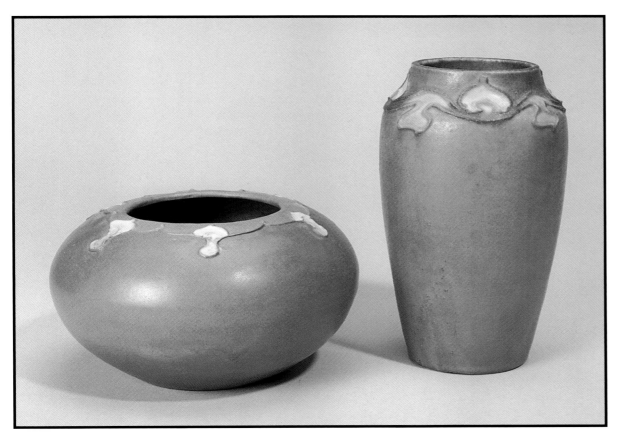

Rhead Santa Barbara bowl. 3-1/2" high, 6-1/2" wide. Rhead
Arequipa grey vase. 6" high, 3-1/2" wide. *Courtesy of Brandon
Allen.*

Rhead vase, beige glaze, carved
leaves. 8" high, 4-3/4" wide.
Courtesy of Gary Keith.

Rookwood Pottery

Cincinnati, Ohio

Rookwood hand painted ceramic bowl, marked 346B, signed W. P. McD. *Courtesy of Brandon Allen.*

Rookwood humidor jar, marked 812. 6-1/4" high. *Courtesy of Brandon Allen.*

Maria Longworth Nichols (Storer) was born in Cincinnati, Ohio, into one of the richest and most prestigious families in the region. In her twenties she studied china painting with Maria Eggers at the University of Cincinnati School of Design, of which her first husband, George Ward Nichols, was one of the founders. Having exhibited at the Centennial in Philadelphia, Nichols attended the exhibit. She was taken with the French and Japanese exhibits, and returned to Cincinnati inspired to experiment with different clays and glazes, including underglaze slip decoration. She and M. Louise McLaughlin set up studios at the Frederick Dallas Pottery, but found the kilns too hot for their delicately rendered decoration.

Her father purchased an abandoned schoolhouse, which Nichols converted into a studio, and on Thanksgiving day, 1880 Rookwood Pottery was born, named after the family homestead. Rookwood was Ohio's first art pottery. Its first full-time decorator was Albert M. Valentien, who with his wife Anna Marie, also a Rookwood artist, later established the Valentien Pottery in San Diego, California.

Despite its creativity, the pottery depended upon the Longworth family largesse for its early survival. In 1883, William Taylor took over the management of the pottery, and over the next five years moved it toward profitability. In 1890 he took over ownership of Rookwood, as Maria remarried after her first husband's death and lost interest in the business.

Taylor encouraged the talented artists of Rookwood, including Laura Fry, Artus Van Briggle, Katara Shiragyamadani, the Valentiens, William McDonald, and Matt Daly. New glazes were developed as were new techniques for underglaze slip decoration.

In 1889, the pottery was internationally recognized with a gold medal at the Exposition Universelle in Paris, first prize gold metal at the Exhibition of American Art Industry in Philadelphia, and numerous other honors over the following decade.

Taylor died unexpectedly in 1913. As the demand for hand decorated art pottery dried up after 1920, the company found a market for molded pottery, keeping it going until the pressures of the Depression forced the layoffs of most of the decorators. The company limped along, declaring bankruptcy in 1941. After changing hands several times, Rookwood's production finally ceased in 1967.

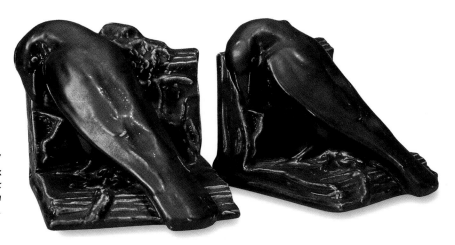

Rookwood "Rooks" bookends. 6" x 6" x 6". *Courtesy of Jack Moore's Pasadena Antiques.*

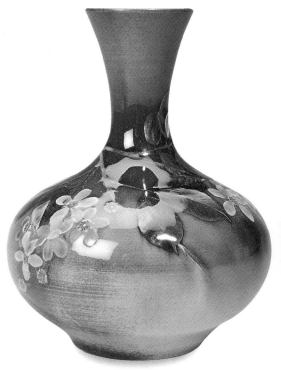

Above: Rookwood small vase, marked 509W. 5" high. *Courtesy of Brandon Allen.*

Right: Rookwood Blue Galleon dinnerware, ca. 1923. Dinner plate, salad, bread and butter, bowl and saucer, cup and saucer. *Courtesy of David DeLucca.*

Rookwood Blue Galleon slender coffee with lid, larger coffee with lid, teapot with lid, larger cream and sugar lid, small cream and sugar without lids. *Courtesy of David DeLucca.*

Rookwood scenic tile, ca. 1915. 10-1/2" x 7-1/2" with oak frame. *Courtesy of Life Time Gallery.*

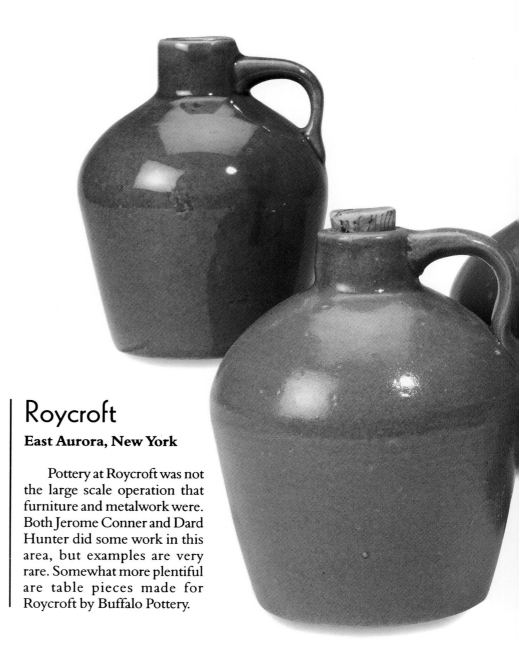

Roycroft

East Aurora, New York

Pottery at Roycroft was not the large scale operation that furniture and metalwork were. Both Jerome Conner and Dard Hunter did some work in this area, but examples are very rare. Somewhat more plentiful are table pieces made for Roycroft by Buffalo Pottery.

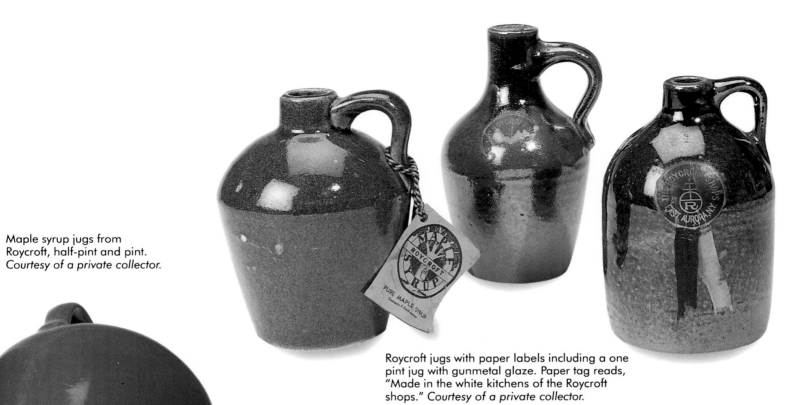

Maple syrup jugs from
Roycroft, half-pint and pint.
Courtesy of a private collector.

Roycroft jugs with paper labels including a one
pint jug with gunmetal glaze. Paper tag reads,
"Made in the white kitchens of the Roycroft
shops." *Courtesy of a private collector.*

Roycroft blue, gold and brown bean pots.
4-1/4" high. *Courtesy of a private collector.*

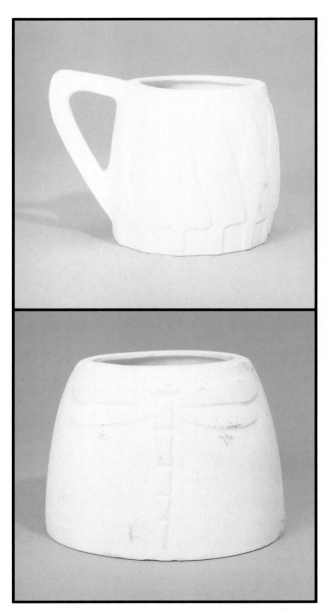

Dard Hunter unfired clay mug and clay dragonfly vase. Mug: 4-3/4" high; vase: 4-1/2" high, marked 1906. *Courtesy of Dard Hunter III.*

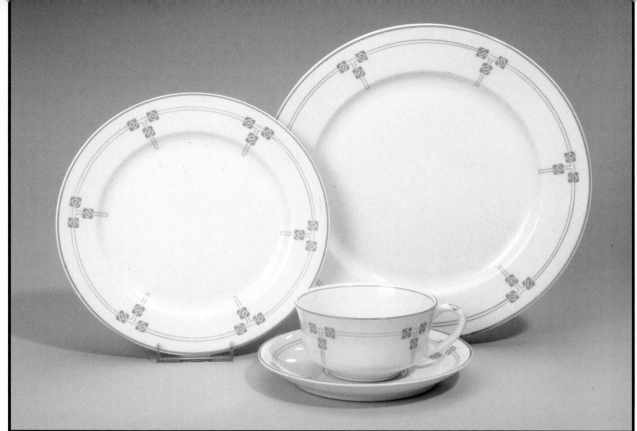

Roycroft china, "Tudor Rose" pattern, Onondaga Pottery Company. Dinner plate: 8-3/4" dia.; salad: 7" dia., coffee cup and saucer: 5-1/4" dia. *Courtesy of David DeLucca.*

Detail.

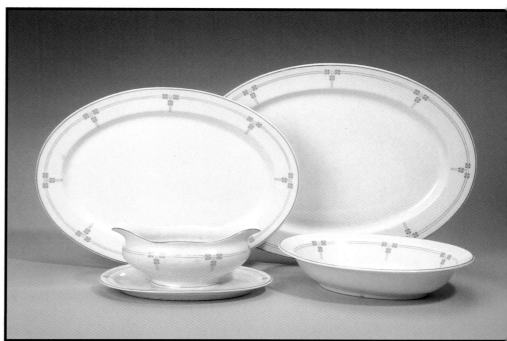

Roycroft "Tudor Rose" pattern. Two platters, 16" and 14" wide; gravy boat and tray, oval serving dish. *Courtesy of David DeLucca.*

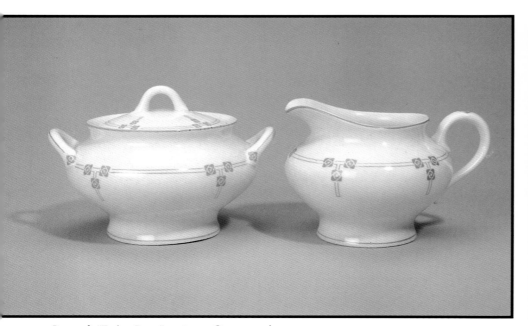

Roycroft "Tudor Rose" pattern. Cream and sugar, 4" high. *Courtesy of David DeLucca.*

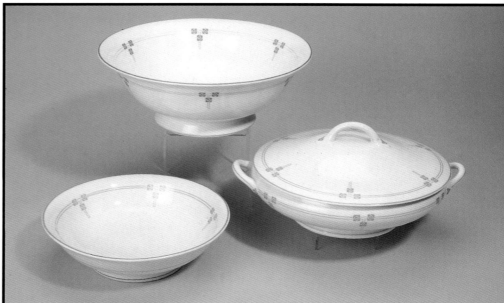

Roycroft "Tudor Rose" pattern. Covered serving dish: 8-3/4" dia., 5" high; two round serving bowls: 9-3/4" dia., 3-1/2" high and 7-3/4" dia., 2-1/4" high. *Courtesy of David DeLucca.*

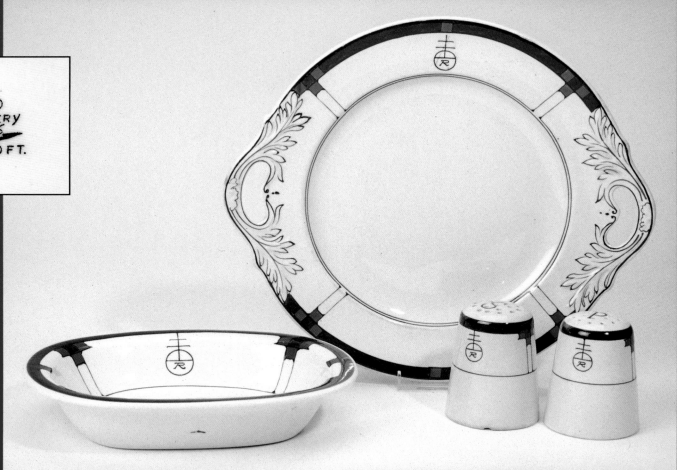

Roycroft china by Buffalo Pottery. Serving dish (left), 8" with 1926 Buffalo Pottery mark; cake dish with Buffalo Pottery mark, 11-1/4" wide, salt and pepper shakers. Courtesy of a private collector.

Other Buffalo Pottery marks.

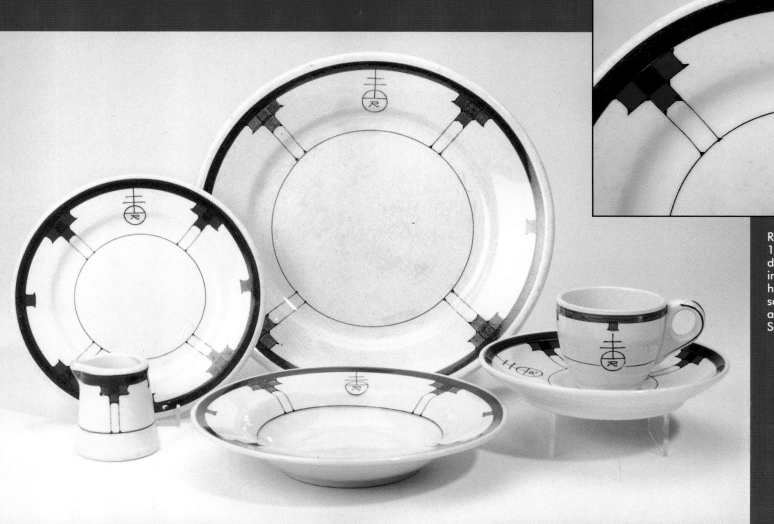

Roycroft china. Dinner plate: 9-1/2" dia.; bread dish: 6-1/4" dia.; fruit dish: 7-1/4" dia.; individual creamer: 2-1/4"; high; demitasse: 2-1/4" high; saucer, 5-7/8" dia. Courtesy of a private collector and Tony Smith.

Tiffany

Corona, New York

Louis Comfort Tiffany's pottery operated from 1904 to 1917. Though never a major part of his work, he did exhibit examples of pottery in 1904. In 1905 his wares were featured in his father's new Fifth Avenue store in New York.

Tiffany floral favrile pottery vase . 10" high. Marked P719 LCT (interwoven letters). *Courtesy of Brandon Allen.*

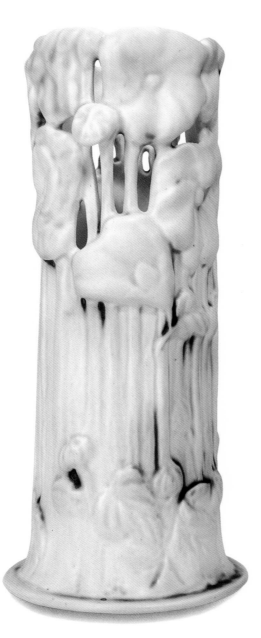

Valentien Potteries

San Diego, California

Anna Marie Bookprinter joined Rookwood while a student at the Cincinnati Academy of Art in 1884. There she met Albert Valentien, another graduate of the school, who had started at Rookwood in 1881 as its first full time decorator. They took a leave from the pottery to study in France, including some work with Auguste Rodin. They returned to Rookwood.

In 1907 they moved to San Diego, California, so Albert could pursue a commission, and in 1911 began the Valentien Potteries. Their cast pieces had matte or vellum glazes, some with a slip decoration in a floral or geometric pattern. One shape book shows they made 43 plain shapes and 48 designs with molded low relief decoration. Valentien Potteries closed in 1913, though Albert and Anna continued to work in the area.

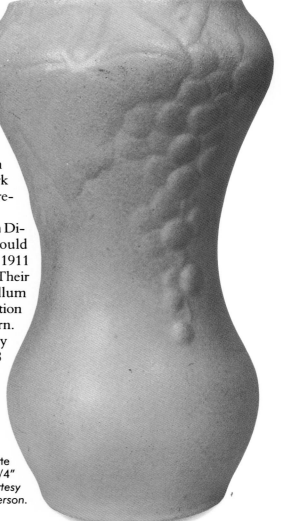

Valentien vase, matte finish, grape motif. 8-1/4" high, 4-3/4" wide. *Courtesy of Caro Tanner Macpherson.*

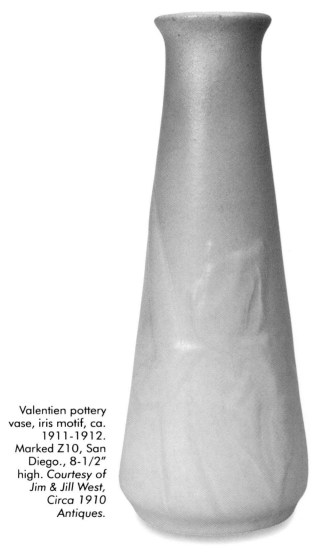

Valentien pottery vase, iris motif, ca. 1911-1912. Marked Z10, San Diego., 8-1/2" high. *Courtesy of Jim & Jill West, Circa 1910 Antiques.*

Two Valentien vases, brown and light green. 9" and 9-1/4" high. *Courtesy of Isak Lindenauer.*

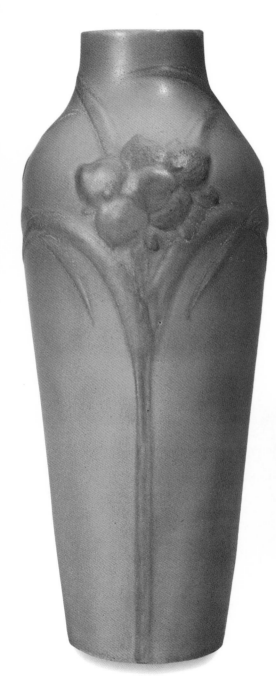

Valentien vase with blue daffodil at top. Marked Z17 at bottom. 8-3/4" high, 8-1/2" wide. *Courtesy of Brandon Allen.*

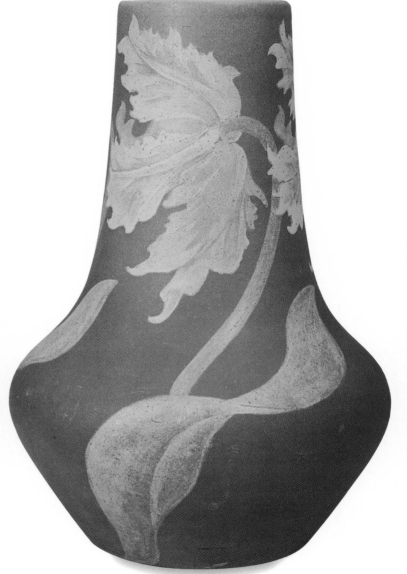

Valentien vase, brown with yellow flower. Bottom marked incised pottery mark and initials, A. R. V. #33. 11" high, 8" wide. *Courtesy of Brandon Allen.*

Van Briggle Pottery

Colorado Springs, Colorado

Artus Van Briggle was one of many young artists of the Art Academy of Cincinnati to go to work for Rookwood. He joined the company in 1887 and by 1894 had attained the status of senior artist. Rookwood sent him to Paris to study at the Académie Julian. There he met his wife, Anne, to whom he became engaged in 1895. In 1896 he returned to Rookwood and spent the next three years as an underglaze artist and experimented with a new matte glaze. In 1899, suffering from tuberculosis, he was forced to seek a healthier climate. With Maria Nichols Storer's financial assistance he opened a pottery in Colorado Springs, Colorado, in 1899. His fiancée joined him in 1900 and by 1901 the Van Briggle Pottery was in full operation. Artus married Anne in 1902 and she worked with him at the pottery until his death in 1904 at the age of 35. Anne then took over the management of the pottery, overseeing a time of physical and creative growth. In 1908 she remarried and in 1912 she left the pottery to resume her painting.

The pottery produced a variety of forms including glazed terra cotta architectural tiles, roof tiles, wall fountains, garden decorations, flower pots, and lamp bases.

The years that followed saw two changes in ownership and a serious fire, but the pottery continued. In 1920 it was purchased by I.F. and J.H. Lewis, who controlled it until 1969. The Van Briggle Pottery continues to this day.

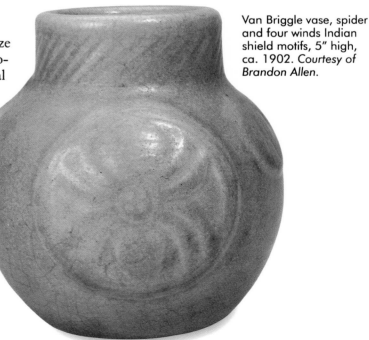

Van Briggle vase, spider and four winds Indian shield motifs, 5" high, ca. 1902. *Courtesy of Brandon Allen.*

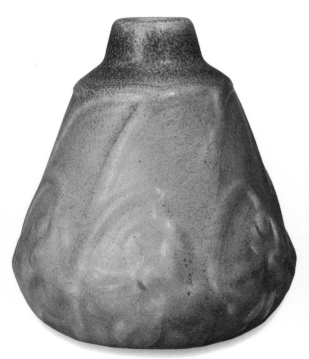

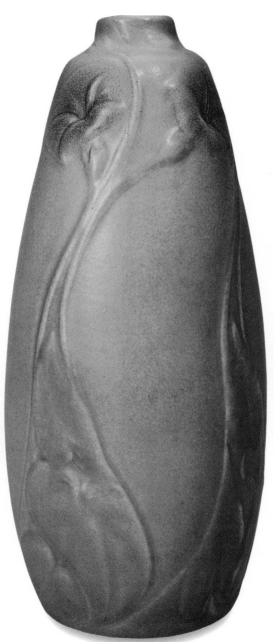

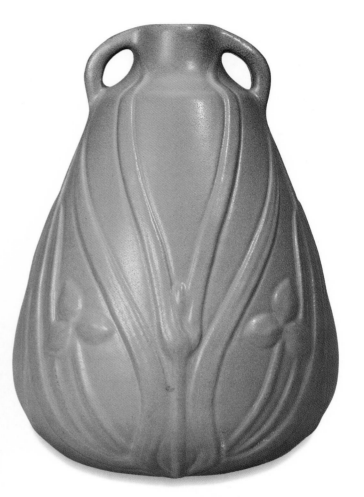

Above: Van Briggle vase, marked 181, floral motif, 1903. 4-3/4" high, 4-1/4" wide. *Courtesy of Brandon Allen.*

Right: Van Briggle vase, 1903, red flower (morning glory?) and descending leaves. 12" high, 5-1/2" wide. *Courtesy of Brandon Allen.*

Van Briggle vase, marked 1903 and 182 with potter's mark; organic motif. 8-3/4" high, 7" wide. *Courtesy of Brandon Allen.*

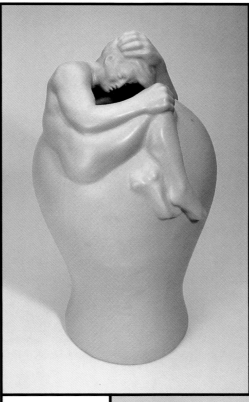

Van Briggle vase, "Despondency." 16-1/2" high. Marked Van Briggle, Colo Spgs, CO. *Courtesy of Patricia Knop and Zalman King.*

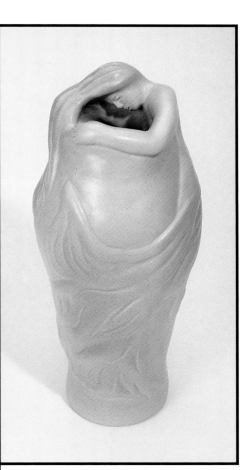

Van Briggle vase, "Lorelei," 11" high. Marked Van Briggle, Colo Spgs, CO, and "S". *Courtesy of Patricia Knop and Zalman King.*

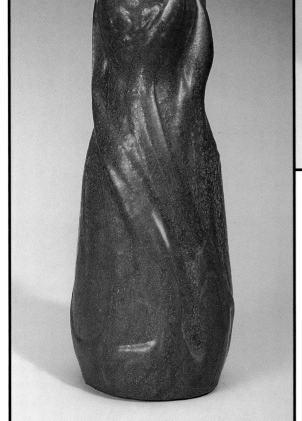

Van Briggle vase, floral motif, 1905. 10-1/2" high, 4-1/2" wide. *Courtesy of Brandon Allen.*

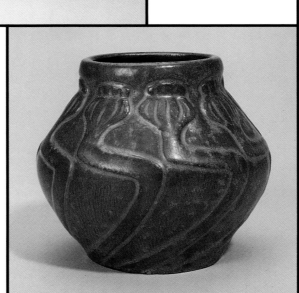

Van Briggle poppy vase, 4" high, 1905. *Courtesy of Brandon Allen.*

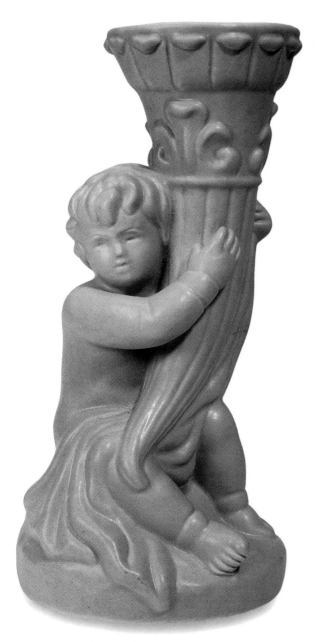

Van Briggle vase, boy with cornucopia, 9-1/4" high. *Courtesy of Marjorie Newland.*

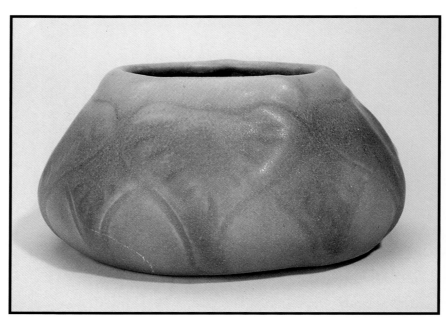

Left: Van Briggle bowl, leaf pattern. Marked Van Briggle, Colo Spgs, CO. *Courtesy of Patricia Knop and Zalman King.*

Below: *Left to right:* Van Briggle vase, daffodil pattern, 10" high, marked USA. Van Briggle vase, small leaf pattern, 4-1/2" high, marked Van Briggle, Colo Spgs, CO. Van Briggle vase, Bird of Paradise pattern, 4" high, marked Colo. Spgs. *Courtesy of Patricia Knop and Zalman King.*

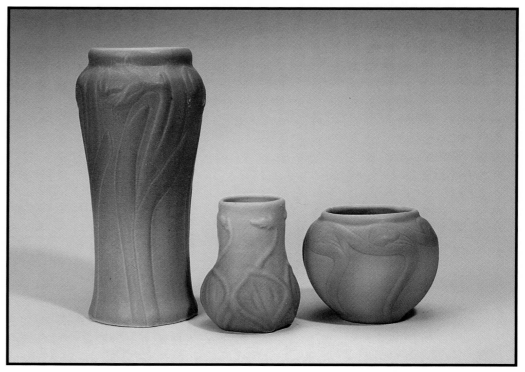

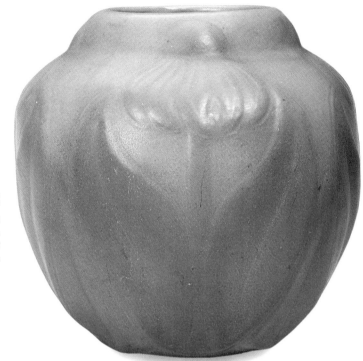

Van Briggle large vase, sunflower pattern, 9" high, marked Van Briggle, Colo Spgs, CO. *Courtesy of Patricia Knop and Zalman King.*

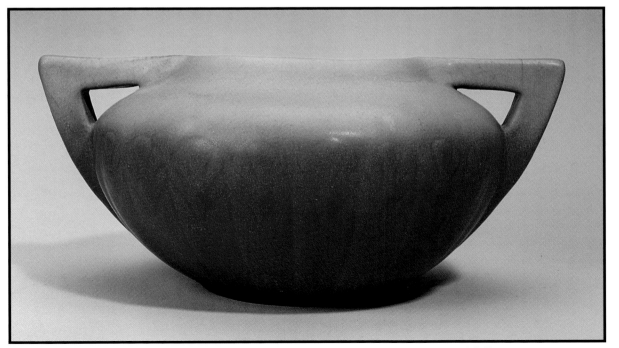

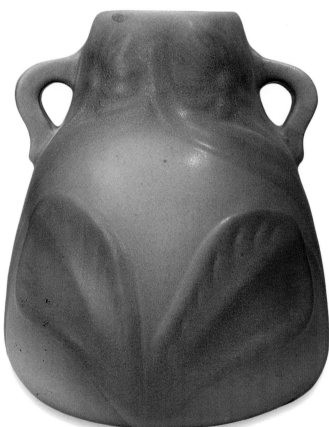

Above: Van Briggle two-handled vase, leaves and daisy pattern, 10" high, marked Van Briggle, Colo Spgs, CO. *Courtesy of Patricia Knop and Zalman King.*

Left: Van Briggle two-handled vase, floral pattern, 6" high, 12" wide, marked Van Briggle, Colo Spgs, CO. *Courtesy of Patricia Knop and Zalman King.*

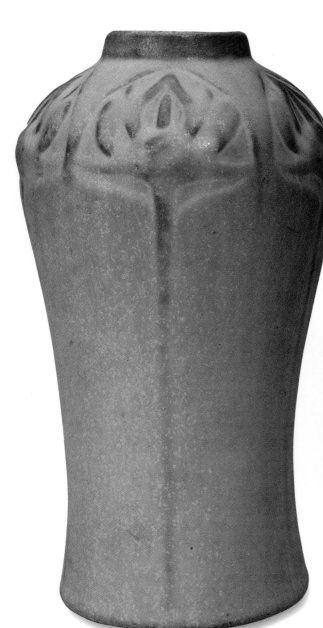

Van Briggle blue floral vase, marked 1907. 7-3/4" high. *Courtesy of Brandon Allen.*

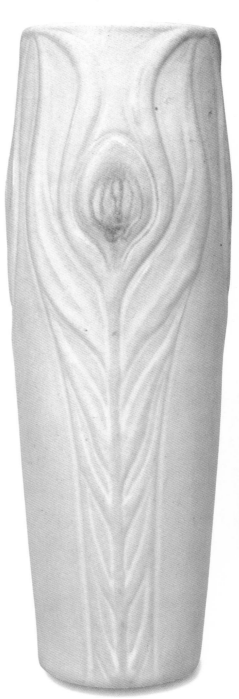

Van Briggle vase, marked 1903. 11" high. *Courtesy of Brandon Allen.*

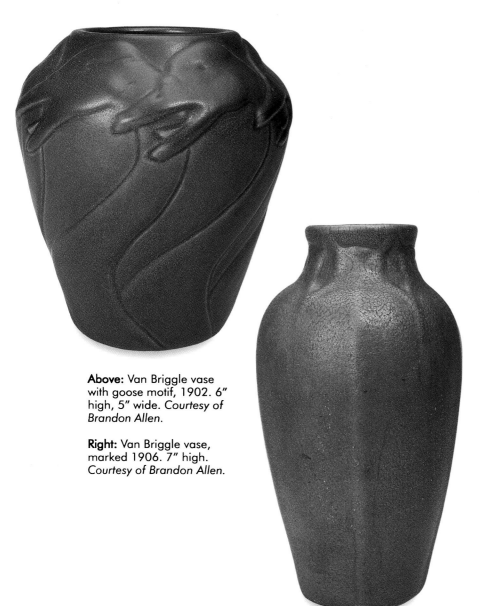

Above: Van Briggle vase with goose motif, 1902. 6" high, 5" wide. *Courtesy of Brandon Allen.*

Right: Van Briggle vase, marked 1906. 7" high. *Courtesy of Brandon Allen.*

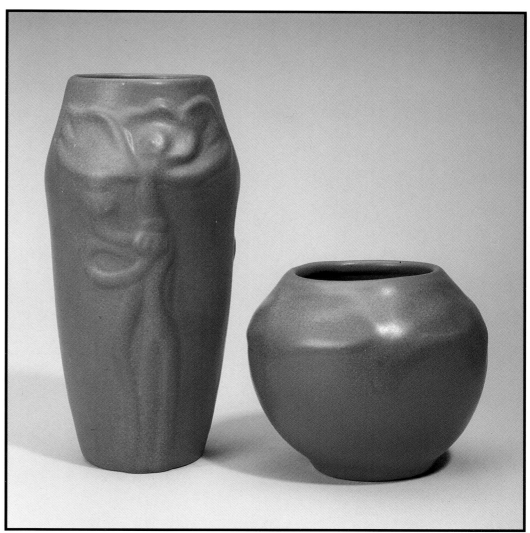

Left: Van Briggle vase, brown and green, 8-1/4" high, marked VB USA. **Right:** Van Briggle vase, brown and green, 4-1/4" high, marked Colo Spgs. *Courtesy of Patricia Knop and Zalman King.*

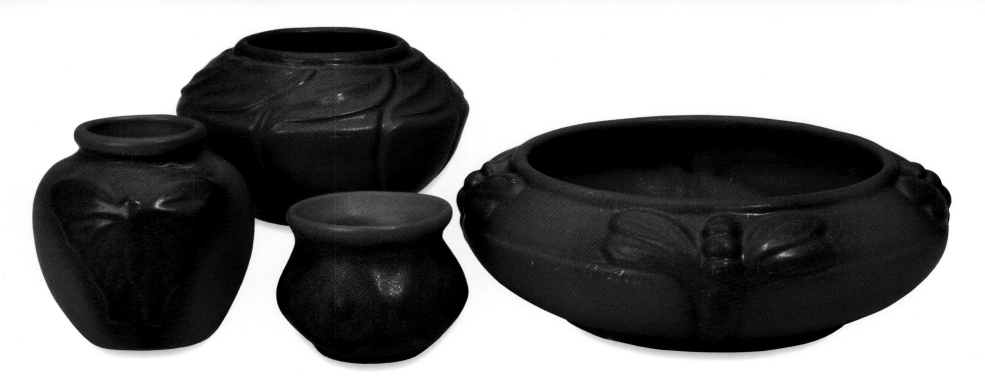

Van Briggle blue on purple ware. **Left:** vase with butterfly pattern, 4" high, Van Briggle, Colo Spgs. **Top center:** low bowl, leaf pattern, 3-1/2" high, 5-1/2" wide, marked VB. **Bottom center:** vase, lotus pattern, 2-1/2" high, 3" wide, marked Van Briggle, Colo Spgs. **Right:** low bowl, dragonfly pattern, 3" high, 8-1/2" wide, marked Van Briggle, Colo Spgs. *Courtesy of Patricia Knop and Zalman King.*

Walrath

Rochester, New York

The Walrath Pottery was more of a studio than a pottery. Frederick E. Walrath, born in 1871, founded it around 1903 in Rochester, New York. It continued in operation until 1918. Walrath taught pottery at the Mechanical Institute of Rochester. His work was featured in a 1912 issue of *The Craftsman* magazine. He became the chief ceramist at Newcomb College Pottery in 1918 and served there until his death in 1920, at age 49.

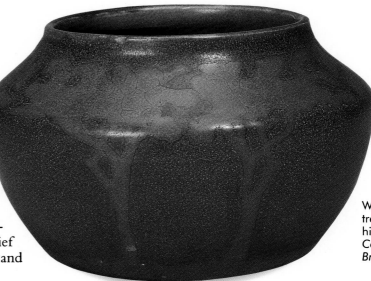

Walrath bowl with trees motif. 3-1/4" high, 5-1/4" wide. *Courtesy of Brandon Allen.*

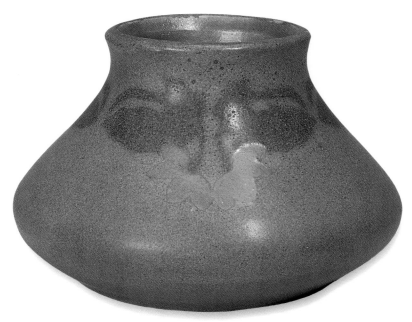

Walrath bowl, orange flower at top, hand inscribed marks on bottom. 3-1/4" high, 5" wide. *Courtesy of Brandon Allen.*

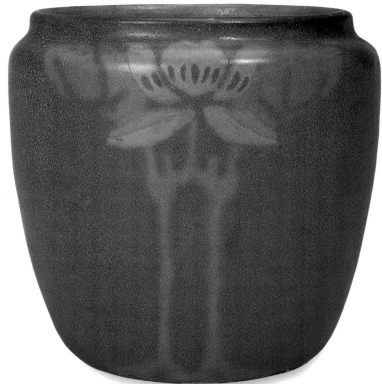

Walrath vase with flower design. 5-1/2" high, 5-3/4" wide. *Courtesy of Brandon Allen.*

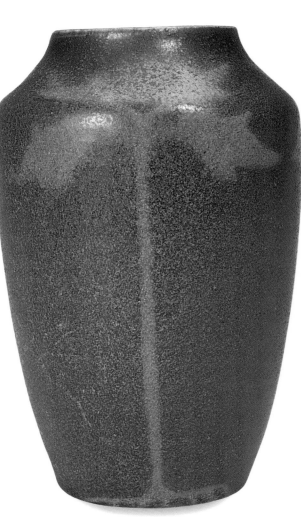

Walrath vase with foliage design. 6-1/2" high, 4" wide. *Courtesy of Brandon Allen.*

Wheatley Pottery Company

Cincinnati, Ohio

Thomas J. Wheatley was born in 1853 and is remembered for his work in underglaze pottery. He received a patent for a method of applying underglaze colors, but was unable to enforce it. He helped form the Cincinnati Art Pottery in 1879 with Frank Huntington and began his own company, T.J. Wheatley & Company, in 1880. His association with the first and the operations of the second both ended in 1882. Wheatley opened a new venture, the Wheatley Pottery Company, in 1903. A fire in 1910 virtually ended the company's operations, though it continued in some fashion until 1927.

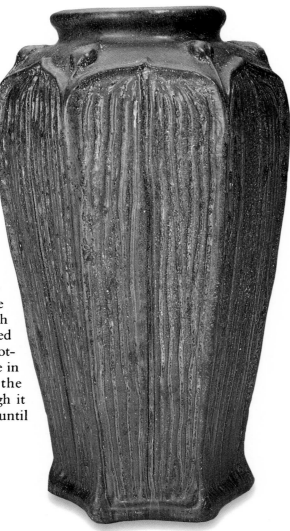

Wheatley vase with green leaf design. 18" high. *Courtesy of Jack Moore's Pasadena Antiques*

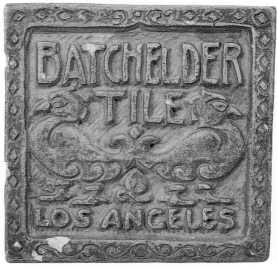

3" square Batchelder advertising tile featuring birds. Los Angeles. *Courtesy of Robert W. Winter.*

Batchelder Tiles

Robert W. Winter

The following essay on Batchelder Tiles was written by Robert W. Winter, and is used with his permission and the author's thanks.

Ernest Batchelder (1875-1957) was a major figure in the American Arts and Crafts Movement. He wrote two books on design theory and frequently published articles in Gustav Stickley's *Craftsman* magazine. A trip to England in 1905 put him in touch with Birmingham School of Arts and Crafts and with Charles R. Ashbee at Chipping Campden. In the same year he helped found the Minneapolis Handicraft Guild where he spent several summers teaching metal work.

His move to Pasadena had come in 1901 when he was asked to join the department of design at the Throop Polytechnic Institute, now Cal Tech. At Throop the reigning philosophy that the head, the heart and the hand should work together meant that it emphasized manual training as well as the humanities and sciences. But as the mood changed to a scientific emphasis, Batchelder saw the handwriting on the wall and began to take leaves of absence from Throop.

The real break was in 1905 when he made his trip to England. After

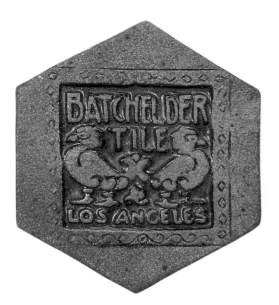

Batchelder hexagonal advertising tile. 3-3/4" wide, Los Angeles. *Courtesy of Robert W. Winter.*

Batchelder tile, 3-1/2" square. "Greater Southern California Straight Ahead / Batchelder Tiles." *Courtesy of Robert W. Winter.*

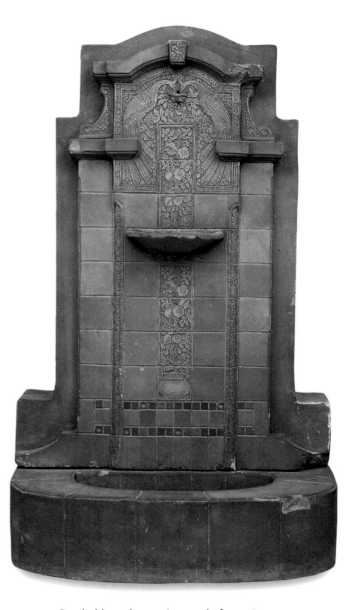

Batchelder salesman's sample fountain, two pieces, 32" high, 18-1/2" wide, 13-1/2" deep. *Courtesy of Gary Keith.*

that he continued his interest in the Stickney School of Art, associated with Throop, and began talking about opening a new school of arts and crafts somewhere along the Arroyo Seco. His larger dreams were never realized, but by 1909 he bought the property on Arroyo Drive and moved his works and his school to it. He built the shack — he called it *"The Birthplace"* — and the house, and, in 1910, began designing and turning out decorative tiles in a single kiln.

After a year or so, artistic and business success, coupled with neighbor's complaints about too much smoke, forced him to find new quarters on Broadway (now Arroyo Parkway). Finding that the four kilns would not accommodate the demand for his tiles, in 1920 Batchelder bought an acre of land on Artesian Street in central Los Angeles and converted an old barn into a factory that by 1925 had expanded into a modern building with eleven kilns.

With the help of business-minded friends, Batchelder's enterprise flourished, but in 1932 the Great Depression did it in. He retired to a life of good works being at one time or another a member of the Pasadena Library Board, the Pasadena Planning Commission and, for twenty of its best years, President of the Pasadena Playhouse Association.

Apparently Batchelder's interest in ceramics came from his friendship with

the Harvard professor and Arts and Crafts apostle, Denman W. Ross, who had made designs for the Dedham Pottery in Dedham, Massachusetts, and whose theory of design Batchelder had frankly followed in his own two books. These books also show an acquaintance with the Grueby Tile Company. But from evidence around Batchelder's house, especially around the fireplace, his fondness for Mercer tile from the Moravian Tile Works in Doylestown, Pennsylvania, is explicit and the hexagonal tile in both the breakfast room and the guest house also shows the Mercer influence.

His first designs were the stock and trade of the contemporary craftsman in tile — Viking ships, animals, foliage, and scenery. Knights and other medieval figures delighted him. Like all true arts and crafts enthusiasts he had an eye for Byzantine themes and similarly Japanese linearity. In the 1920s he experimented with Spanish and Pre-Columbian designs and toward the end of his tile-making he got into Art Deco, being responsible for many lavender and black bathrooms.

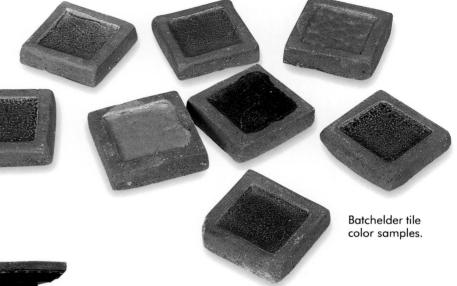

Batchelder tile color samples.

He was by no means the only designer for the firm. One of his workmen, F.L. Compton, stated that one of Batchelder's young students, Ann Harnett, designed most of the tiles in Batchelder's own fireplace. He also identified the *"musician"* corbels, which are shown, as Ann's work. In 1925 in a short history of his company, Batchelder himself volunteers that *"very much of the distinctive character of Batchelder Tiles is due to the sympathetic interpretation of the designs at the hands of Mr. and Mrs. Ingels."* There were no doubt others who participated in the design process.

At first most of the clay that Batchelder used came from the Alberhill-Corona district in western Riverside County, one of the three main clay-producing areas in California. In the twenties additional clay was supplied by the Lincoln Clay Products Company in Placer County. He also used red clay from Ione, Amador County, and a small amount of clay from near Santa Monica. Batchelder obtained bentonite from a deposit near Amboy in San Bernardino County. In such large commissions as the Fine Arts Building (1924) in downtown Los Angeles, his firm cast large figures in terra cotta.

Batchelder salesman's sample fireplace with brass fire dogs, 20" high, 29-1/4" wide, 11" deep. *Courtesy of Jack Moore's Pasadena Antiques.*

Batchelder Tiles, Los Angeles. Miniature planter advertising pot, 2" high, 5" wide, dated 1926. *Courtesy of Adrienne and Steve Fayne.*

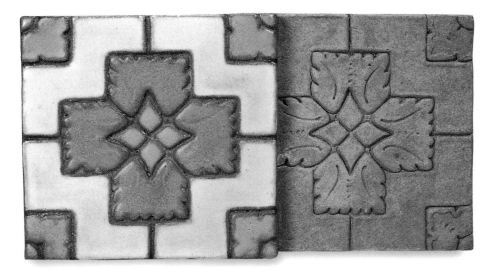

Two Batchelder tiles, glazed and unglazed. 5" square. *Courtesy of Robert W. Winter.*

Both early and late, Batchelder loathed high glazes, strongly preferring what is technically known as a matte finish, an underglaze slip that was sprayed on and then colored by hand. The result is a soft, muted surface, very understated. They harmonized beautifully with woodsy Craftsman architecture. His tiles were usually in somber browns touched with blue, but he came to like color. He used strongly after employing a young graduate of the University of Illinois who was an expert on the latest catalogs; his palette of colors greatly expanded.

After his business failed, Batchelder's interest in ceramics continued. In the late 1930s he rented a kiln in the Kinneloa district of eastern Pasadena and began turning out very thin slip-cast vases and bowls, so fragile that most of them have been destroyed. They were usually marked *"Batchelder, Pasadena"* or sometimes *"Batchelder, Kinneloa"* with the design number added.

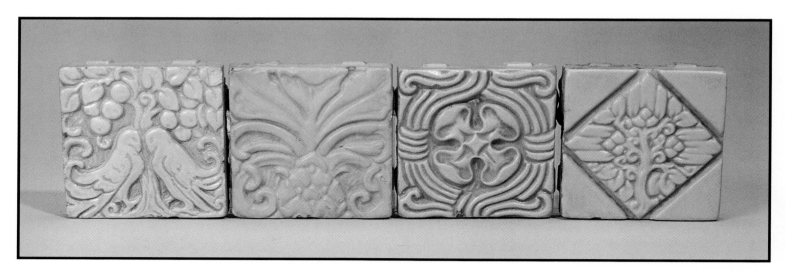

3" square tiles. **Left:** love birds, ; **left center:** yellow, pineapple top; **right center:** blossom design; **right:** abstract tree design. *Courtesy of Robert W. Winter.*

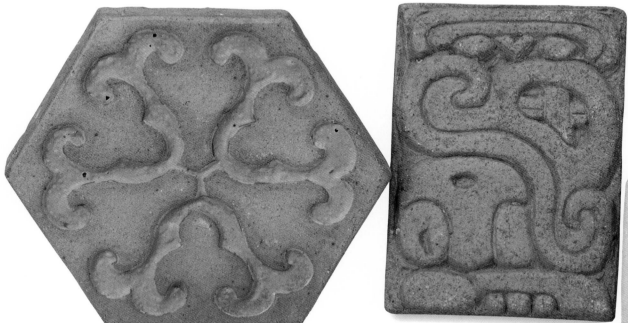

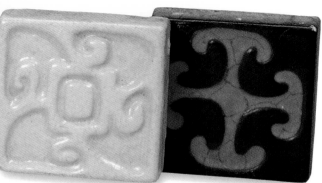

Left: hexagonal design, 3-1/2" wide; **left center:** lion influence, 3-3/4" x 2-3/4"; **right center and right:** 2" square tiles. *Courtesy of Robert W. Winter.*

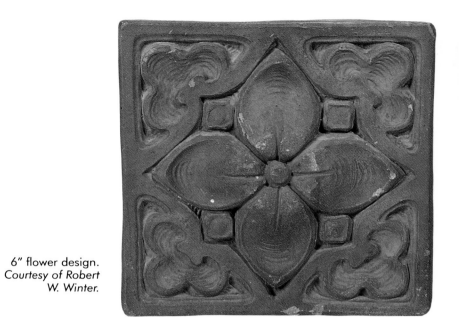

6" flower design.
Courtesy of Robert
W. Winter.

Stylized flower
design. 6" square.
Courtesy of Robert
W. Winter.

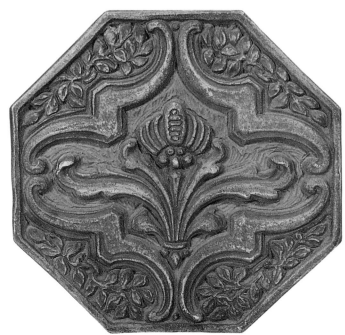

Octagonal flower
tile. Courtesy of
Robert W. Winter.

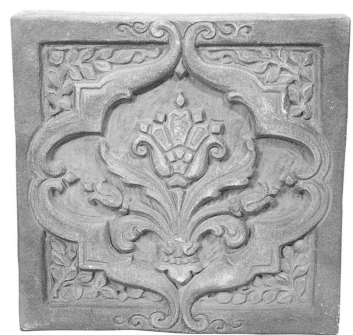

Stylized flower
design. 6" square.
Courtesy of Robert
W. Winter.

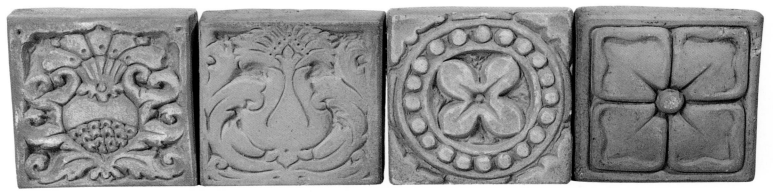

Left: foliage and thistle, 3" squares; left center: thistle; right center: blossom; right: blossom. *Courtesy of Robert W. Winter.*

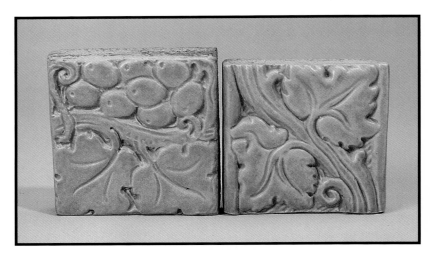

Grapevine motif tiles. 3" square. *Courtesy of Robert W. Winter.*

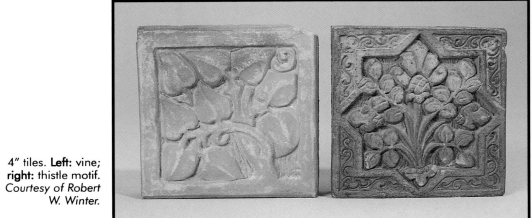

4" tiles. Left: vine; right: thistle motif. *Courtesy of Robert W. Winter.*

Adjoining tiles, 3-3/4" square, depicting a planter and tree. *Courtesy of Robert W. Winter.*

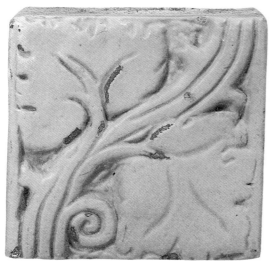

2-1/2" x 2-1/2" tile, vine and leaf design. *Courtesy of Robert W. Winter.*

Frieze tile, 5" high, 10" long, grapevine motif. *Courtesy of Robert W. Winter.*

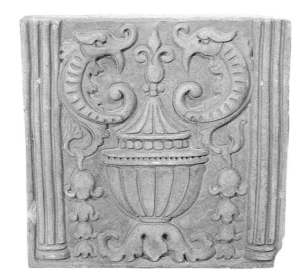

Outside corner tile, 8" square, in an urn and foliage motif with pillars. *Courtesy of Robert W. Winter.*

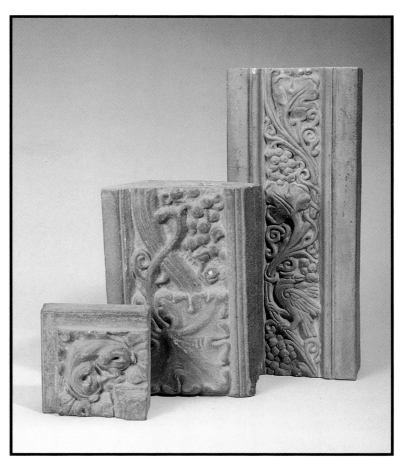

Decorative tiles. **Left:** Batchelder foliage motif, 4-1/2" high, 3-1/2" wide; **center:** 5" high, 8" wide; **right:** 12" high, 5" wide. *Courtesy of Robert W. Winter.*

Small corbels. 3" x 3" x 2".
Courtesy of Robert W. Winter.

Small corbels, stylized scallop motif. 3" x 3" x 2".
Courtesy of Robert W. Winter.

These three Batchelder tiles form a triptych. **Left:** medieval horseman (Sir Lancelot?); **center:** a castle; **right:** a village scene across the water. All 4" square. *Courtesy of Robert W. Winter.*

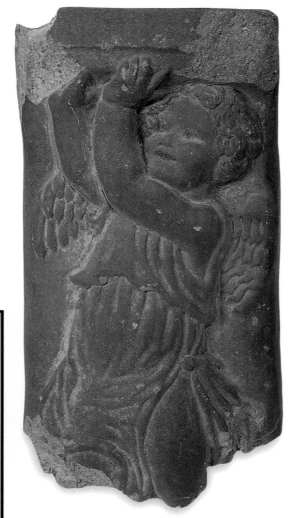

Corbels. **Left:** 3″ x 5″ x 5″; right: 3″ x 3″ x 3″. *Courtesy of Robert W. Winter.*

Above: Batchelder post top with angel. 6″ x 9″ x 3″. *Courtesy of Robert W. Winter.*

Right: Scenic tile with castle. 12″ high, 18″ wide. *Courtesy of Jack Moore's Pasadena Antiques.*

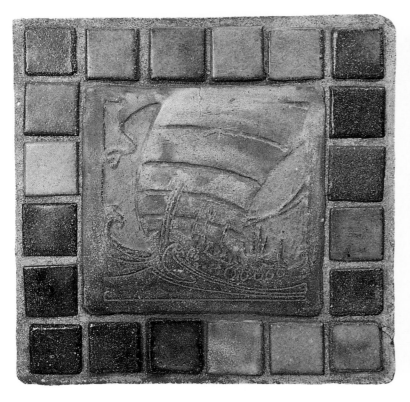

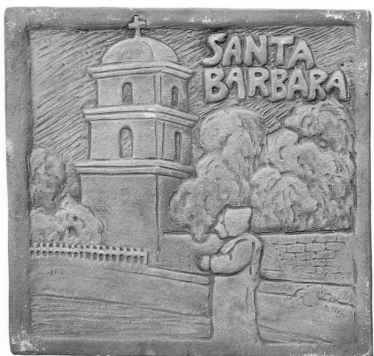

Far left: An assembly of Batchelder tiles embedded in concrete. Overall size: 13-3/4" square. *Courtesy of Robert W. Winter.*

Left: 8" Santa Barbara Mission tile. *Courtesy of Robert W. Winter.*

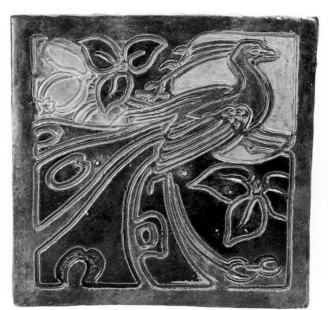

Far left: Batchelder tile advertising Smith and Brandt Architects. 4" square. *Courtesy of Robert W. Winter.*

Left: Batchelder peacock tile. 10" square. *Courtesy of a Tony Smith.*

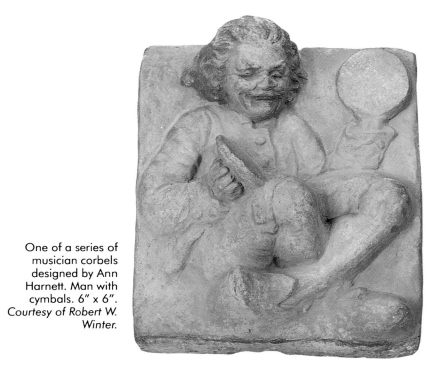

One of a series of musician corbels designed by Ann Harnett. Man with cymbals. 6" x 6". *Courtesy of Robert W. Winter.*

Corbel, man with a lute. 6" x 6". *Courtesy of Robert W. Winter.*

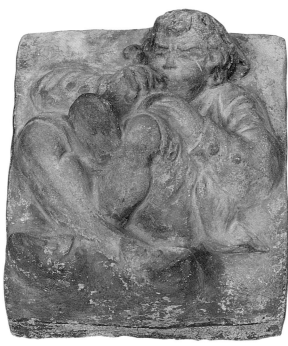

Corbel, boy with horn. 6" x 6". *Courtesy of Robert W. Winter.*

Corbel, singer with book. 6" x 6". *Courtesy of Robert W. Winter.*

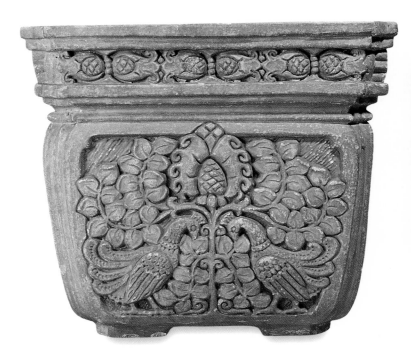

Batchelder planter, peacock design. 12" x 12-1/2". *Courtesy of Gary Keith.*

Batchelder planter. 4" x 4" x 4". Marked P227. *Courtesy of Robert W. Winter.*

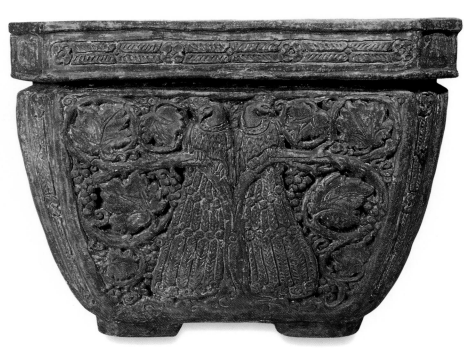

Batchelder planter, peacock and leaf motif. 12-1/2" x 16-1/2". *Courtesy of Jack Moore's Pasadena Antiques.*

THE PRINTER'S ART

In the 1960s Marshall McLuhan made popular the phrase "The medium is the message." This was certainly the case in the Arts & Crafts Movement. The two major figures in the Movement in America, Elbert Hubbard and Gustav Stickley, both published extensively, following the example of their English predecessor, William Morris. Indeed Hubbard began the whole Roycroft enterprise with the purpose of establishing a printing press which would be an outlet for his writings as well as those of others. The furniture, metalwork, and other endeavors were offshoots of the printing press.

Stickley went to press to promote his furniture and the philosophy behind it. *The Craftsman*, a monthly magazine, chronicled of the progress of the Movement across the country and around the world, while at the same time making the creative output of Stickley's company known to the world.

Between 1895 and 1910 over fifty private presses were started in America, ranging from Massachusetts to California. They were notable not only for their content, but for the beauty and thoughtfulness of their design and execution.

The Rubaiyat of Omar Khayyam, suede binding, copyright 1906, Elbert Hubbard. Courtesy of Michael Trotter.

Roycroft

Books

Publishing was at the heart of the Roycroft community. Upon his return from his English pilgrimage to William Morris's Hammersmith community, Hubbard set about trying to create its counterpart in America. He had already been published both pseudonymously (*The Man* in 1891, under the name of Aspasia Hobbs), and under his own name ("One Day," a short story published in 1893, and *Forbes of Harvard*, a novel published in 1894). As a writer, it was natural for him to wish to build his own publishing enterprise.

In 1895 he founded the Roycroft Printing Shop in East Aurora, New York. Its first book, published in 1896, was *The Song of Songs: Which is Solomon's; Being a Reprint and a Study by Elbert Hubbard*. The type was hand set and the book printed on a manual Washington press. The style reflected the care and concern for detail that he had seen in Morris's Kelmscott Press. He was to have a significant influence on American printing that would last through the Arts and Crafts era and beyond.

Various books published by Roycroft. *The Dogs of Flanders*, by Ouida, 1906. *The Law of Love,* by Wm. Marion Reedy, 1905. *Justinian and Theodora*, by Elbert and Alice Hubbard, 1906. *Courtesy of Ann and Andre Chaves.*

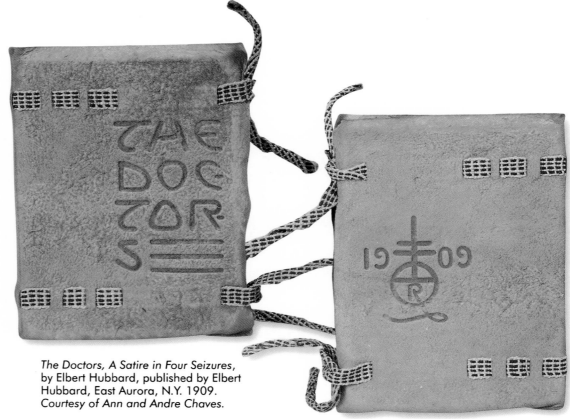

The Doctors, A Satire in Four Seizures, by Elbert Hubbard, published by Elbert Hubbard, East Aurora, N.Y. 1909. *Courtesy of Ann and Andre Chaves.*

158

Left: *Manhattan*, by Joseph I.C. Clark, and *Henry Hudson*, by Elbert Hubbard. Dard Hunter designed the cover. Roycroft, 1910. *Courtesy of Ann and Andre Chaves.*

Center: *A Message to Garcia*, suede bound, 1914. *Courtesy of Ann and Andre Chaves.*

Right: *Elbert Hubbard's Scrap Book*, 1923. *Courtesy of Michael Trotter.*

Note Book of Elbert Hubbard, 1927. *Courtesy of Michael Trotter.*

Little Journeys books by Elbert Hubbard. Eight books from various publishers. They include (left to right): *Little Journeys to the Homes of American Statesmen* (Putnam); *Great Musicians*, Vol. 1; *Great Scientists*, Vol. 17; *Little Journeys to the Homes of English Authors*; *Little Journeys to the Homes of the Elect* (Wise); *Great Scientists* Vol. 1; *Little Journeys* (Roycroft); *Little Journeys Good Men and Great* (Wise). *Courtesy of Ann and Andre Chaves.*

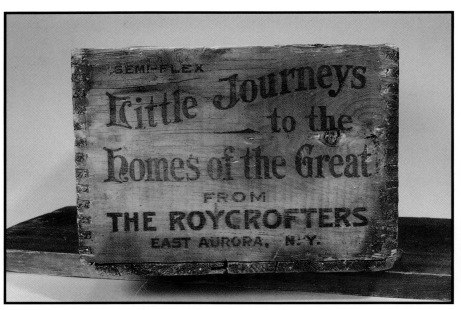

Left & lower left: Hubbard's *Little Journeys* books in original crate. Roycrofters, East Aurora, N.Y., ca. 1928. *Courtesy of Ann and Andre Chaves.*

Below: In addition to periodicals and books, the Roycrofters published a collection of mottoes. Framed Elbert Hubbard motto, "Society is Very Tolerant: It Forgives Everything but Truth." *Courtesy of a private collector.*

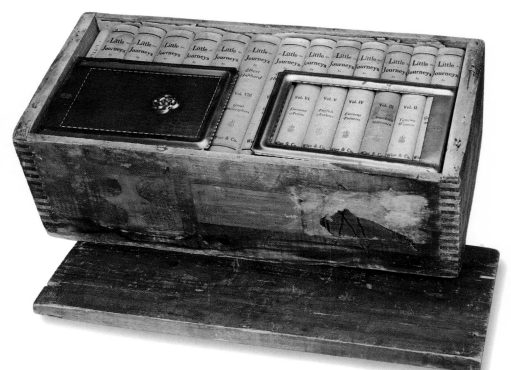

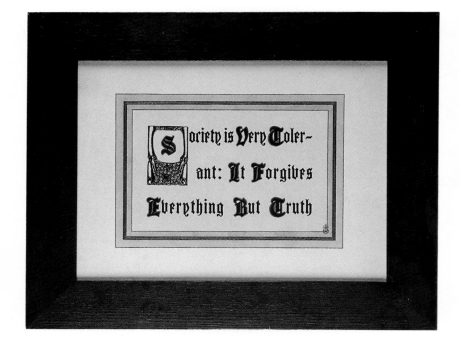

Periodicals

The Philistine was the first magazine published by Elbert Hubbard, beginning with the June, 1895, edition and continuing until Hubbard's death in 1915. The largest portion of the magazine was made up of Hubbard's own work, but there were also guest writers, including Stephen Crane.

The second periodical produced by the Roycroft presses was the *Roycroft Quarterly*, which was first published in May, 1896, and only had three issues in total, May, August, and November. The first issue was devoted to the work of Stephen Crane and the second to George Bernard Shaw's essay "On Going to Church."

Next in the line-up of Hubbard periodicals was a monthly magazine called *Little Journeys*, which contained biographical sketches of various famous personages. These were later gathered into a very popular series of books. In the early years, from 1894 to 1900 it was published by G.P. Putnam, moving to the Roycroft presses in 1900. It continued as a periodical until 1909.

The fourth magazine was *The Fra*, a monthly, which was published from April, 1908, to August, 1917. Though on a larger format, it was much like the earlier *Philistine*, reflecting much of Hubbard's philosophy and literary style. In fact the title itself was Hubbard's nickname, "The Fra." The popularity of the magazine and its general format made it attractive to national advertisers and allowed it to serve as an important outlet for information about Roycroft products.

Other magazines were introduced after Hubbard's death. They include the *Roycroft* introduced in September, 1917, and edited by Elbert Hubbard II. It was produced until March, 1926. Two months later (the only two months when Roycrofters did not publish a periodical) the *Roycrofter* was introduced. It was issued bi-monthly and ended publication in September, 1932.

The Philistine: A Periodical of Protest, 1906-1908, four issues. Published by Elbert Hubbard. *Courtesy of Michael Trotter.*

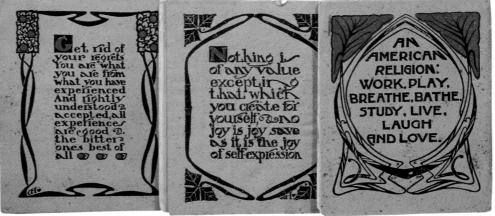

Far left: *The Roycroft Quarterly,* May, 1896, Volume 1, No. 1. Includes sketch by Stephen Crane. *Courtesy of Ann and Andre Chaves.*

Left: *Little Journeys to the Homes of Famous Women* by Hubbard, published by G.P. Putnam's Sons, New York. This issue includes a visit to Mary W. Shelley, Dec., 1897. *Courtesy of Ann and Andre Chaves.*

Left: *The Fra Exponent of the American Philosophy*, published monthly by Elbert Hubbard, East Aurora, Erie County, N.Y., Vol. VI, No. 6, March, 1911. This magazine succeeded *The Philistine*. Courtesy of Ann and Andre Chaves.

Center: *The Fra Exponent of the American Philosophy*, Vol. VII, No. 1, April, 1911. Courtesy of Ann and Andre Chaves.

Right: *The Fra Exponent of the American Philosophy*, Vol. VII, No. 2, May, 1911. Courtesy of Ann and Andre Chaves.

Roycroft, August and September double issue, 1924 and the January, 1926 issue. Courtesy of Ann and Andre Chaves.

Left: *The Roycrofter*, Vol 3, No. 5, March, 1929. Right: Vol.7, No. 1, September, 1932. Courtesy of Ann and Andre Chaves.

Roycroft Alumni

Several writers were among the anonymous ranks of Roycroft creators, many of whom went on to be recognized on their own. Sadakichi Hartmann was a Japanese-German poet, playwright, and art critic. He married Lillian Bonham, a Roycroft illustrator.

Michael Monahan started his own periodical, *The Papyrus*, in 1903. It was similar to Roycroft's *Philistine,* and, indeed, had a positive view of Hubbard and his work. For a time following 1913, Monahan went to work for Hubbard, but soon had a falling out. He returned to his own publishing enterprises with *The Phoenix,* and a very different view of the Roycroft endeavors.

Japanese Art, by Sadakichi Hartmann. Boston: L.C. Page and Co., 1903. Courtesy of Ann and Andre Chaves.

Left: *The Stylus.* Edited by. Sadakichi Hartmann. Published February, 1910, Vol. 1, No. 3. *Courtesy of Ann and Andre Chaves.*

Center: *The Papyrus,* 1912, edited by Michael Monahan. *Courtesy of Ann and Andre Chaves.*

Left: *The Phoenix,* October, 1915, edited by Michael Monahan. *Courtesy of Ann and Andre Chaves.*

Gustav Stickley

While not actually involved in printing as Hubbard was at Roycroft, Stickley's *The Craftsman* magazine had a strong influence on the Arts and Crafts Movement, becoming the most important of all the American journals of the style. In addition to articles about the English roots of the movement and its current practitioners, *The Craftsman* provided house plans and instructions, and even information for furniture do-it-yourselfers. *The Craftsman* was in published from 1901 to 1916. In Stickley's 1912 catalog, he describes the purposes of the magazine are to give "the broadest and most comprehensive expression to the Craftsman idea." He continues:

The magazine was first published in October, 1901, as an exponent of the ideals of craftsmanship in this country. It has grown steadily, until today it is recognized as the creator of a movement in America toward the development of a style of architecture which shall be the true expression of the character and needs of the American people.

In addition to this devotion to the democratic spirit in architecture, *The Craftsman Magazine* is an ardent advocate of a national art for this country. It has worked from the beginning for better housing and better planning for cities and towns. It advocates the restoration of small farming according to modern improved methods. It seeks steadily to increase the interest in rural living; it gives practical encouragement to the revival of handicrafts, and practical craft workers will find in it information and suggestions of real importance. Among the other valuable features are articles about planting, gardening, protection of birds and conservation of national resources. Its fiction and poetry are modern, realistic, always with the underlying humanitarian purpose.

In addition to the magazine, Stickley produced several books of house designs and catalogs of his furniture.

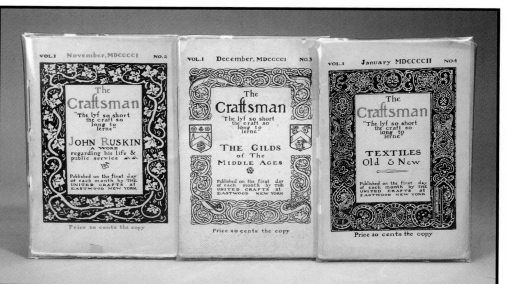

The Craftsman, Numbers 2, 3, and 4 of Volume 1, November, December, January, 1901-02. Published by the Gustav's Stickley's United Crafts at Eastwood, New York, to promote his philosophy and work. Courtesy of Ann and Andre Chaves.

Craftsman Furniture by Gustav Stickley. Illustrated catalog from July, 1910. Courtesy of Ann and Andre Chaves.

Craftsman Homes, by Gustav Stickley. Large book with case, 1909. Courtesy of Ann and Andre Chaves.

Stickley Alumnus: George Wharton James

The California Birthday Book, George Wharton James, editor, Arroyo Guild Press, Los Angeles, 1909. *Courtesy of Ann and Andre Chaves.*

Arroyo Craftsman, Oct. 1909. Published by the Arroyo Guild, Los Angeles. This is the only issue of this magazine to be published. Its editor was George Wharton James, a writer who had served as associate editor of Stickley's *The Craftsman* magazine from 1904 to 1905. *Courtesy of Ann and Andre Chaves.*

California Romantic and Beautiful, by George Wharton James. Page Co., 1914. *Courtesy of Ann and Andre Chaves.*

Other Periodicals

The Land of the Sunshine, published by the Pattee Company, March, 1895. Courtesy of Ann and Andre Chaves.

Far left: *The Land of the Sunshine, The Magazine of the California of the West.* Land of Sunshine Publishing Co., June, 1901. *Courtesy of Ann and Andre Chaves.*

Left: *The Chap-Book,* Oct, 1895, published by Stone and Kimball, Chicago. *Courtesy of Ann and Andre Chaves.*

Right: *The Bibelot,* "A reprint of poetry and prose for book lovers..." 1903, Vol. 9, No. 10. *Courtesy of Ann and Andre Chaves.*

Far right: *The Lark,* No. 19, November, 1896. Published by William Doxey, San Francisco. Hand printed on rag paper. *Courtesy of Ann and Andre Chaves.*

Overland Monthly, March, 1907.
Courtesy of Ann and Andre Chaves.

The Idler, "A Monthly Magazine of ideas for idle people. Perpetrated and published by Robert J. Shores." January, 1911. Courtesy of Ann and Andre Chaves.

The Touchstone, May, 1917. Published by the Touchstone House, New York. Courtesy of Ann and Andre Chaves.

The Honey Jar, Vol. 3, "A receptacle for literary preserves." Collected editions from Nov. 15, 1899 to April, 1900. edited by D.C. Sapp. The magazine was published monthly at the Champlain Press in Columbus, Ohio. Courtesy of Ann and Andre Chaves.

Other Books

Architecture

Impressions of Japanese Architecture and the Allied Arts, by Ralph Adams Cram, published by The Baker and Taylor Company, 1905. Cram, a Boston architect, was especially known for his religious structures. He also promoted the revival of guilds for the continuation of crafts. In 1914 he was appointed the head of the School of Architecture at the Massachusetts Institute of Technology. *Courtesy of Ann and Andre Chaves.*

Chapters in the History of the Arts and Crafts Movement, by Oscar Lovell Triggs, published by The Bohemia Guild of the Industrial Art League, 1902. Triggs, a professor of English at the University of Chicago, was secretary of the Industrial Art League, which provided tools, shops, and materials for the use of guilds of artists and craftsmen, as well as a place for them to market their creations. *Courtesy of Ann and Andre Chaves.*

Left: Two of the *The Artistic Crafts Series of Technical Handbooks: Bookbinding and the Care of Books*, by Douglas Cockerell, 1931, and *Writing and Illuminating and Lettering*, by Edward Johnston, 1927, both published by Pitman. **Right:** *Arts and Crafts Essays*, 1893. *Courtesy of Ann and Andre Chaves.*

Right: *Bungalows,* by Saylor, published 1913. *Courtesy of Ann and Andre Chaves.*

Right center: *The Half-Timber House,* by Allen W. Jackson, published by MacBride, Nast, and Co., 1912. *Courtesy of Ann and Andre Chaves.*

Above: *Hewers of Wood,* by William G. Puddefoot and Isaac Ogden Rankin, published by Pilgrim Press, 1903. *Courtesy of Ann and Andre Chaves.*

Left: *Line and Form,* by Walter Crane, 1900. *Courtesy of Ann and Andre Chaves.*

Far left: *The Hardwood Finisher,* by Fred T. Hodgson, published by David McKay, 1892. *Courtesy of Ann and Andre Chaves.*

Nature

Bird Notes Afield, by Charles Keeler,
published Paul Elder and Co., San Francisco
and New York, second edition, 1907.
Courtesy of Ann and Andre Chaves.

Left: *Cactus*, by A.J. van Laren, published by Abbey San Encino
Press, 1935; **Right**: *Succulents*, by A.J. van Laren, Abbey San Encino
Press, 1934; *Art in California* published by Bernier, San Francisco,
1906. *Courtesy of Ann and Andre Chaves.*

Three Wonderlands of the American West, by Thomas D. Murphy, pictures by Thomas Moran, 1913. *Courtesy of Ann and Andre Chaves.*

The Two Oldest Trees One Dead One Living as told by Rufus Janvier Briscow, Published by the Press of Young and McCallister Inc., 1914. *Courtesy of Ann and Andre Chaves.*

Conspicuous California Plants, by Ralph D. Cornell, 1938, Published by San Pasqual Press, Pasadena, CA. *Courtesy of Ann and Andre Chaves.*

California

Some Strange Corners of Our Country, Charles F. Lummis. Century Co., N.Y., 1892. *Courtesy of Ann and Andre Chaves.*

The Land of Poco Tiempo, by Charles F. Lummis. Charles Scribner's Sons, N.Y., 1897. Charles Fletcher Lummis (1859-1928) was educated at Harvard with training as a journalist. Coming to California, he was the city editor of the Los Angeles Times. Recuperating from a severe illness, he traveled extensively in the Southwest, writing about what he saw and encouraging its preservation. In 1895 he formed the California Landmarks Club. *Courtesy of Ann and Andre Chaves.*

Above: *Los Angeles, Eine Blume aus dem goldenen Lande,* by Ludwig Louis Salvator, an Austrian arch duke, published by Heinrich Mercury in Prague, 1878. The first book about L.A. with 12 plates of Southern Californian scenes. *Courtesy of Ann and Andre Chaves.*

Left: *Pueblo Indian Folk Stories,* by Charles F. Lummis. Century Co., N.Y., 1910. *Courtesy of Ann and Andre Chaves.*

172

California and the Californians, by David Starr Jordan, published by A.M. Robertson, San Francisco, 1907. *Courtesy of Ann and Andre Chaves.*

Happy Days in Southern California, by Frederick Hastings Rindge. Cambridge, Massachusetts and Los Angeles, 1898, reprinted 1972. *Courtesy of Ann and Andre Chaves.*

Above: *California the Beautiful,* by Western Artists and Authors. A book of poetry and tipped in illustrations, compiled by Paul Elder. Paul Elder and Co., San Francisco, 1911. *Courtesy of Ann and Andre Chaves.*

Left: *The Garden Book of California,* by Belle Sumner Angier, Paul Elder and Co. San Francisco, 1906. *Courtesy of Ann and Andre Chaves.*

Other Books, Poems, and Essays

Christina Rossetti Poems, illustrated by Florence Harrison. Blackie and Son, London. *Courtesy of Ann and Andre Chaves.*

The Critic In the Occident, by George Hamlin Fitch, published by Paul Elder and Co. San Francisco, 1913. *Courtesy of Ann and Andre Chaves.*

Representative Men, by Ralph Waldo Emerson. Hurst and Co. *Courtesy of Michael Trotter*

Songs of Content, by Ralph Erwin Gibbs, 1903. *Courtesy of Ann and Andre Chaves.*

In the Hands of the Malays, by Henty, 1928. *Courtesy of Ann and Andre Chaves.*

Songs of Bohemia, by Daniel O'Connell. A.M. Robertson, San Francisco, 1900. *Courtesy of Ann and Andre Chaves.*

Essays of Elia, by Charles Lamb. Foulis, 1904. *Courtesy of Ann and Andre Chaves.*

Mosaic Essays, by Paul Elder. Paul Elder and Co. 1906. *Courtesy of Ann and Andre Chaves.*

The Social Rubaiyat of a Bud, by Mrs. Ambrose Madison Willis, 1913. *Courtesy of Ann and Andre Chaves.*

Cookbooks

Three Meals a Day, ca. 1900. Courtesy of Ron Bernstein.

Midnight Feasts, in a box, 1914. Courtesy of Ron Bernstein.

Above: *Lowney's Cook Book, illustrated. 1921. Courtesy of Ron Bernstein.*

Left: *Pride of Rome Brand, Soups, Salads, and Desserts. Good Housekeeping, 1924. Courtesy of Ron Bernstein.*

Right: *The Science of Food and Cookery, 1921. Courtesy of Ron Bernstein.*

Far right: *Mrs. Beeton's, All About Cookery, 1913. Courtesy of Ron Bernstein.*

An Easier Day's Work, ca. 1921. An advertising cook book promoting gas cooking. Courtesy of Ron Bernstein.

Right: *The Art of Cooking and Serving, 1929. Proctor and Gamble Company. Courtesy of Ron Bernstein.*

Far right: *Useful Household Helps and Hints, Recipes, 1916. Courtesy of Ron Bernstein.*

Top left: *Tinned Foods and How to Use Them, Australia and New York. Courtesy of Ron Bernstein.*

Above: *Practical Cooking and Serving, 1905. Courtesy of Ron Bernstein.*

Left: *A Manual of Canning and Preserving, 1919. Courtesy of Ron Bernstein.*

Left to right: *Warnes Model Cookery, 1893; Household Discoveries and Mrs. Curtis's Cook Book, 1908, More Recipes for Fifty, 1921. Courtesy of Ron Bernstein.*

Far left: *Good Meals and How to Prepare Them,* Good Housekeeping Institute, 1927. Courtesy of the California Heritage Museum.

Left: *Chocolate and Cocoa Recipes,* 1909. Courtesy of Ron Bernstein.

Pillsbury Cook Book, 1913. Courtesy of Ron Bernstein.

Right: *Delicious Desserts and Candies,* 1923. Courtesy of Ron Bernstein.

Far right: *Knox Gelatine, Dainty Desserts Salads-Candies,* paperback, 1927. Courtesy of the California Heritage Museum.

Practical Recipes from the Globe Mills. Courtesy of the California Heritage Museum.

Reliable Recipes, Calumet Baking Powder Co., paperback, 1922. Courtesy of the California Heritage Museum.

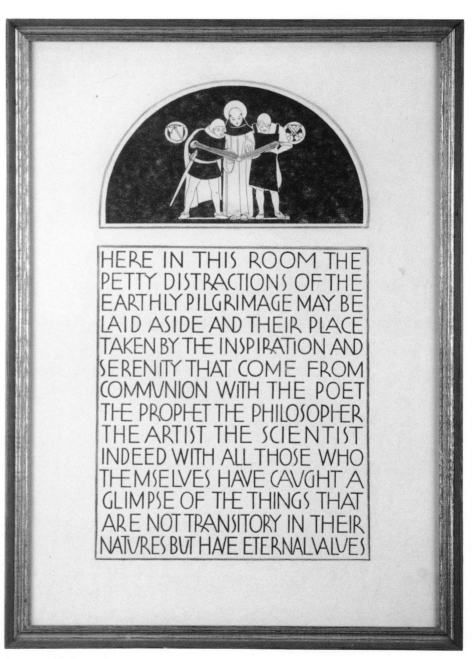

HERE IN THIS ROOM THE PETTY DISTRACTIONS OF THE EARTHLY PILGRIMAGE MAY BE LAID ASIDE AND THEIR PLACE TAKEN BY THE INSPIRATION AND SERENITY THAT COME FROM COMMUNION WITH THE POET THE PROPHET THE PHILOSOPHER THE ARTIST THE SCIENTIST INDEED WITH ALL THOSE WHO THEMSELVES HAVE CAUGHT A GLIMPSE OF THE THINGS THAT ARE NOT TRANSITORY IN THEIR NATURES BUT HAVE ETERNAL VALUES

Arts & crafts framed motto, ca. 1920. Courtesy of Michael Trotter.

Chapter 5
FINE ART

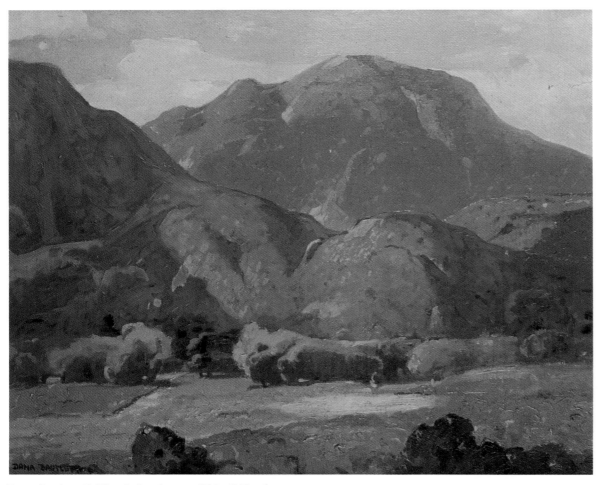

Dana Bartlett, California landscape, 20" x 24", oil on canvas. *Courtesy of Adrienne and Steve Fayne.*

One of the primary principles of the Arts & Crafts Movement was the elimination of the distinction between the fine arts and the practical arts. This was accomplished not by diminishing the importance of painters and sculptors and their work, but by elevating the role of the designer, cabinet maker, architect, potter, embroiderer, and metalworker to that of the artist. The definition of art was broadened to encompass a wide range of creative efforts.

In the English Movement, Edward Burne-Jones, an artist in the Pre-Raphaelite tradition and a close friend of William Morris, was among the leading designers of the movement, turning his art from the canvas to tapestry, stained glass, and wallcoverings. The influence of the early Renaissance painters is evident in his work.

The American Movement had very little interest in the Gothic past. While it, too, struggled with the impact and implications of the Industrial Revolution, its ideals were found in the frontier, a natural, pristine world, unsullied by a human presence. It is this simple, idealized world that is reflected in the primitive elegance of the furniture designs. It is seen, too, in the open architecture with wide horizontal spaces and large glass vistas on the world. And it is evident in the visual arts of the era with their concentration on mountain ranges, sea shores, and mighty oaks. The natural world was the ideal and these artists captured its beauty and power for the age.

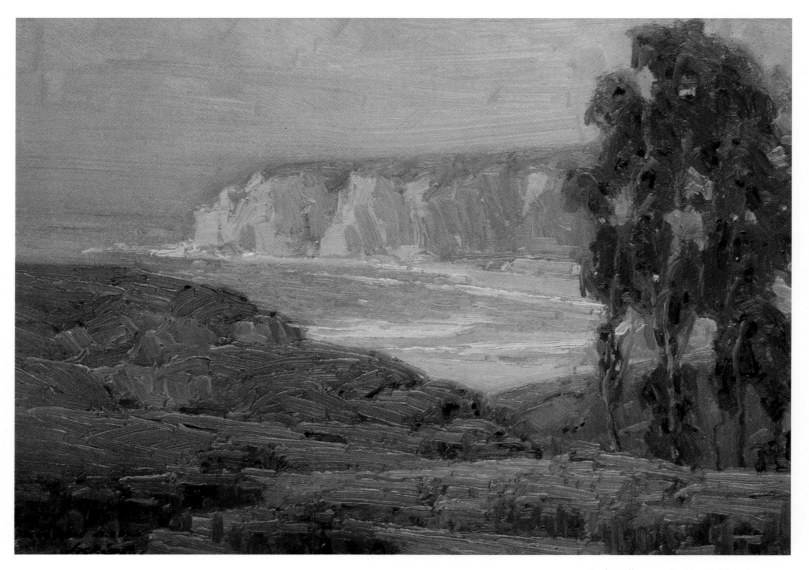

Jack Wilkinson Smith, California
coastline, 16" x 12", oil on canvas.
Courtesy of Adrienne and Steve Fayne.

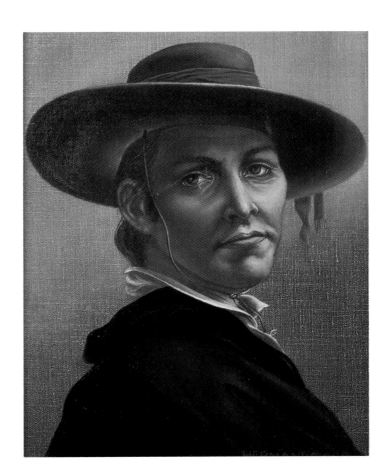

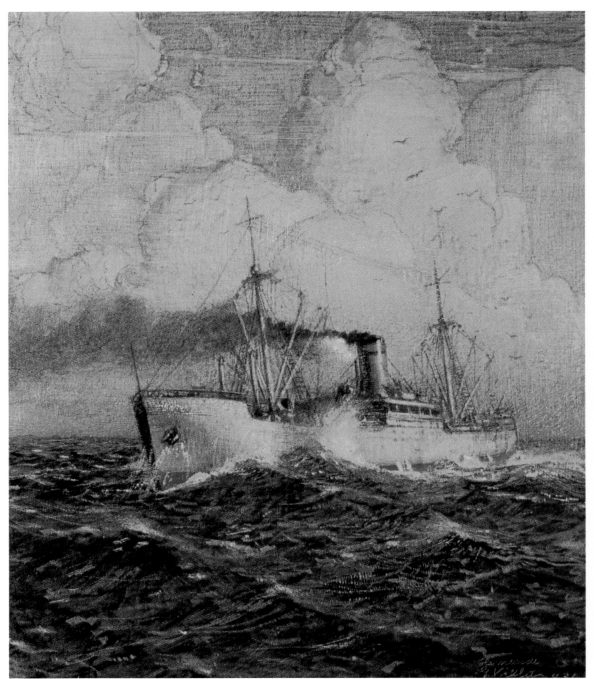

Above: Hernando Villa, *Self Portrait*, 11" x 14", oil on canvas, ca. 1905. *Courtesy of Life Time Gallery.*

Right: Hernando Villa, *Steamer*, oil on board, 20" x 15-1/2", ca. 1931. *Courtesy of Life Time Gallery.*

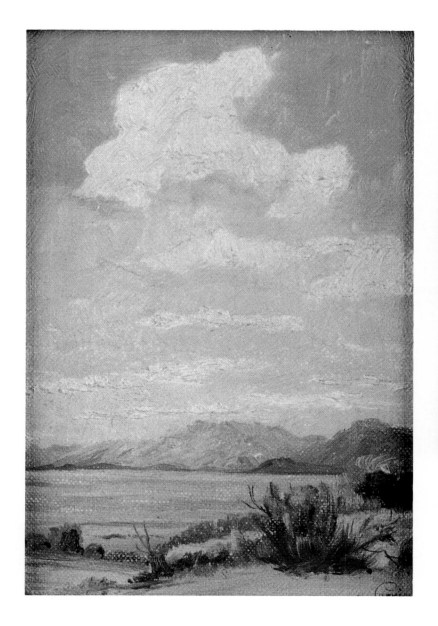

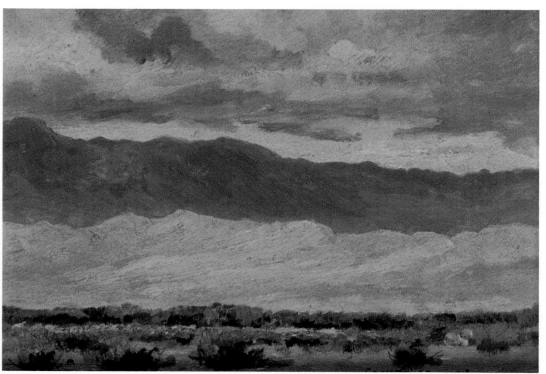

Above: Edward Langley, desert scene, 6-1/2" x 8", oil on canvas, ca. 1920. *Courtesy of Life Time Gallery.*

Left: C.B Currier, desert scene, 6-1/2" x 4-1/2", oil on canvas, ca. 1920. *Courtesy of Life Time Gallery.*

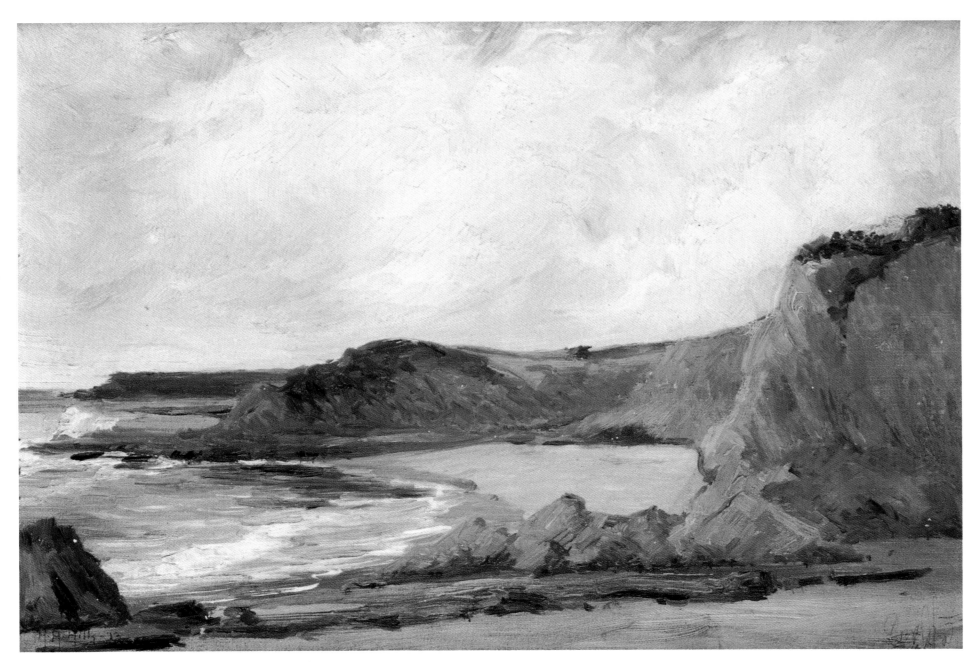

Anna Hills, seascape, 10" x 13-1/2", oil on
canvas. *Courtesy of Adrienne and Steve Fayne.*

Martin Jackson, lake scene, 30" x 25", oil on canvas, 1915. *Courtesy of Life Time Gallery.*

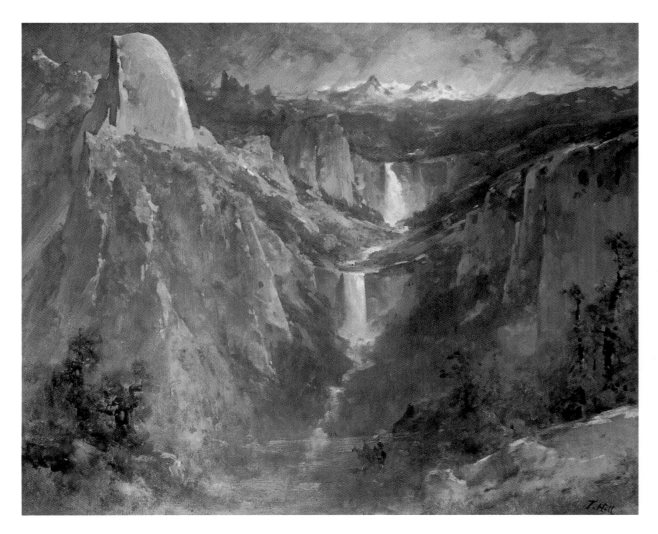

Thomas Hill, view of Yosemite Valley,
25" x 30", oil on canvas, ca. 1880.
Courtesy of Life Time Gallery.

H.C. Best, Yosemite scene, mixed media,
7" x 9". *Courtesy of Roger and Jean Moss.*

Above: A. Guptill, cats, ink drawing, 11" x 5". *Courtesy of Roger and Jean Moss.*

Left: Mary DeNeale Morgan, landscape, watercolor. 5-1/2" x 11". *Courtesy of Roger and Jean Moss.*

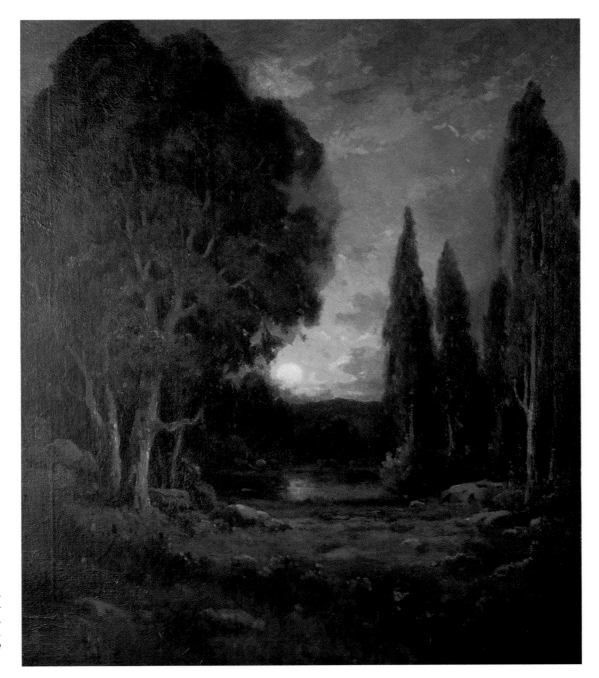

Alexis Podcherikoff,
*California Moon-
light*, oil on canvas,
30" x 25", 1919.
*Courtesy of Life Time
Gallery.*

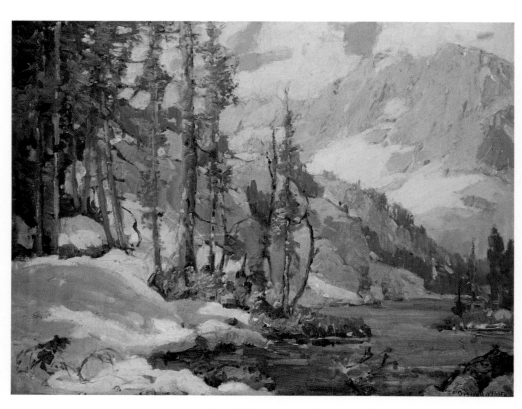

Orrin White, mountain scene, oil on canvas, 22" x 24".
Courtesy of Adrienne and Steve Fayne.

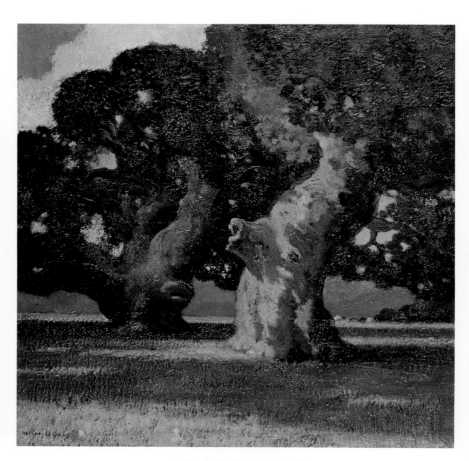

W.H. Bull, *Oak Trees*, oil on canvas, 20" x 19",
ca. 1920. *Courtesy of Roger and Jean Moss.*

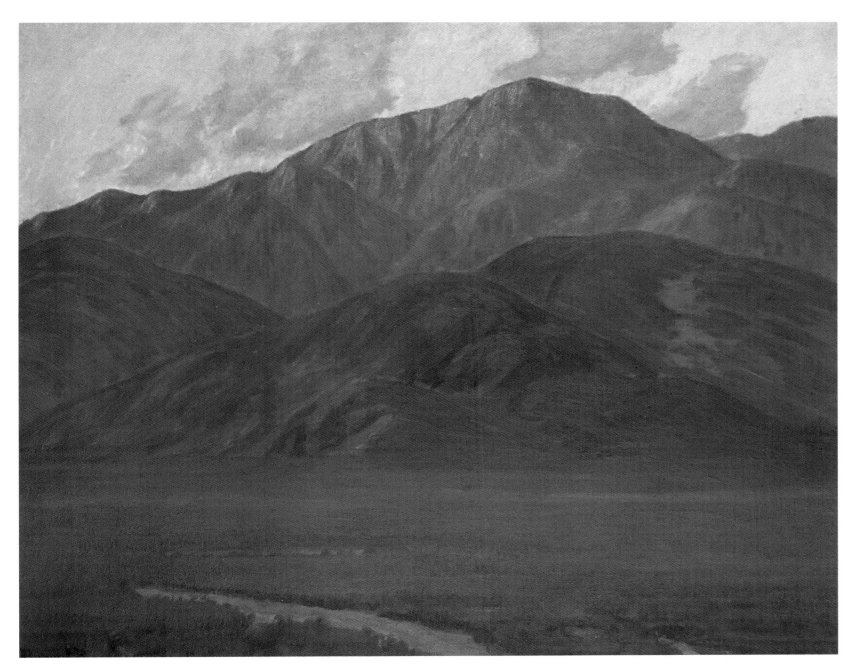

Ernest Browning Smith, *Mount San Jacinto Sunset,* oil on canvas, 24" x 29", ca. 1925. Quartersawn oak frame. *Courtesy of David Nunley and Carol Davis.*

BIBLIOGRAPHY

Altman, Seymour and Violet. *The Book of Buffalo Pottery*. Atglen, PA: Schiffer Publishing, Ltd., 1987

Anderson, Timothy J., Eurdorah M. Moore, and Robert W. Winter. *California Design 1910*. Salt Lake City: Peregrine Smith Books, 1980 (reprint of the 1974 edition published by California Design Pubications, Pasadena, CA)

Cathers, David M. *Furniture of the American Arts and Crafts Movement*. New York: Turn of the Century Editions, 1996.

Current, Karen. *Greene & Greene: Architects in the Residential Style*. Fort Worth: Amon Carter Museum of Western Art, 1974.

Hamilton, Charles F. *Roycroft Collectibles*. New York: A.S. Barnes & Company, 1980.

Henzke, Lucile. *Art Pottery in America*. Atglen, PA: Schiffer Publishing Ltd., 1996.

Johnson, Bruce. *The Official Identification and Price Guide to Arts and Crafts: The Early Modernist Movement in American Decorative Arts: 1894-1923*. New York: House of Collectibles, 1992.

Kardon, Janet, general editor. *The Ideal Home 1900-1920: the History of Twentieth Century Craft in America*. New York: Harry N. Abrams, Incorporated, 1993.

Kovel, Ralph and Terry. *Kovel's American Art Pottery*. New York: Crown Publishers, Inc. 1993.

Limbert, Charles, and Company. *Limbert Arts and Crafts Furniture: The Complete 1903 Catalog*. New York: Dover Publications, Inc., 1992.

Makinson, Randell L. *Greene & Greene: Architecture as a Fine Art*. Salt Lake City: Peregrine Smith, Inc., 1977.

Mayer, Barbara. *In the Arts & Crafts Style*. San Francisco: Chronicle Books, 1993.

McConnell, Kevin. *Heintz Art Metal: Silver-On-Bronze Wares*. Atglen, PA: Schiffer Publishing, Ltd., 1990.

_____. *Roycroft Art Metal*, 2nd Edition. Atglen, PA: Schiffer Publishing, Ltd., 1990.

_____. *More Roycroft Art Metal*. Atglen, PA: Schiffer Publishing, Ltd. 1995.

Poesch, Jessie. *Newcomb Pottery*. Atglen, PA: Schiffer Publishing, Ltd., 1984.

Royka, Paul. *Mission Furniture: From the American Arts & Crafts Movement*. Atglen, PA: Schiffer Publishing, Ltd., 1997.

_____. *Fireworks: New England Art Pottery of the Arts & Crafts Movement*. Atglen, PA: Schiffer Publishing, Ltd., 1997.

Roycrofters, The. *Roycroft Furniture Catalog, 1906*. New York: Dover Publications Inc., 1994.

Snyder, Jeffrey B. *Franciscan Dining Services*. Atglen, PA: Schiffer Publishing, Ltd., 1996.

Stickley, Gustav. *Craftsman Homes: Mission-Style Homes and Furnishings of the American Arts and Crafts Movement*. New York: Random House, 1995 (reprint)

_____. *Craftsman Homes: Architecture and Furnishings of the American Arts and Crafts Movement*. New York: Dover Publications Inc., 1979.

_____. *The 1912 and 1915 Gustav Stickley Craftsman Furniture Catalogs*. New York: The Athenaeum of Philadelphia and Dover Publications, Inc., 1991. (Reprint)

_____. *Stickley Craftsman Furniture Catalogs*. New York: Dover Publications Inc., 1979. (Reprint)

Stickley, L. & J.G. Early L. & J.G. *Stickley Furniture: From Onondaga Shops to Handcraft*. New York: Dover Publications Inc., 1992. (Reprint)

Trapp, Kenneth R. *The Arts and Crafts Movement in California: Living the Good Life*. The Oakland Museum. New York: Abbeville Press, 1993.

Winter, Robert. *The California Bungalow*. Los Angeles: Hennessey & Ingalls, 1980.

Wissinger, Joana. *Arts and Crafts: Pottery and Ceramics*. San Francisco: Chronicle Books, 1994.